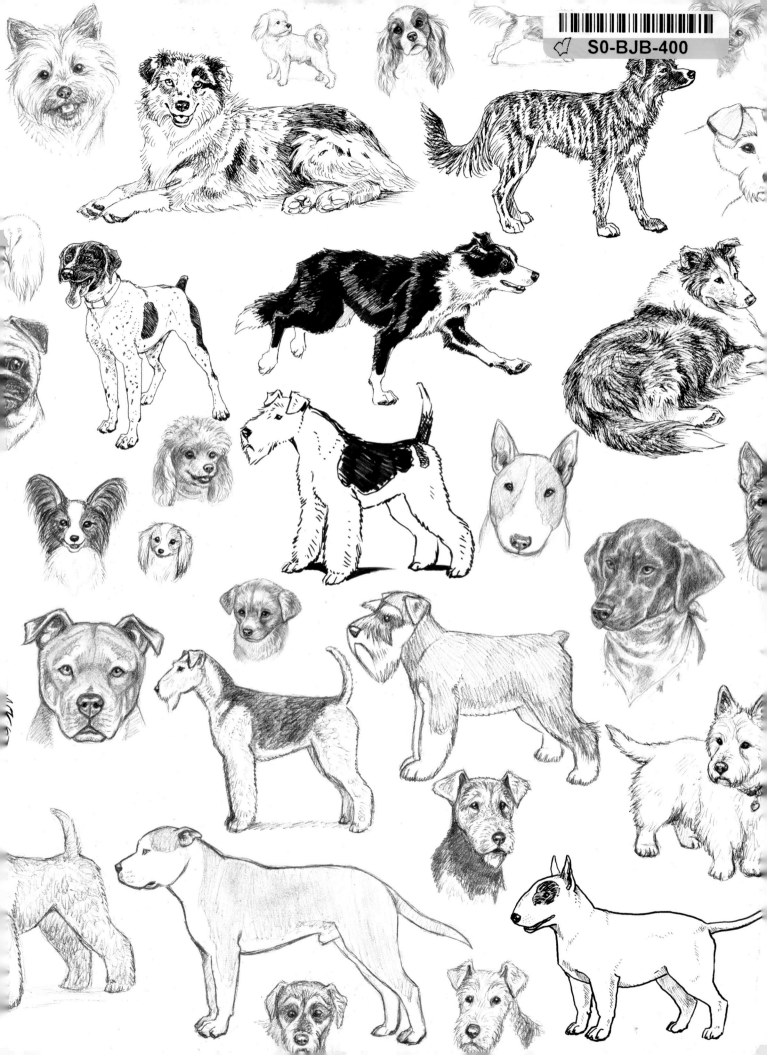

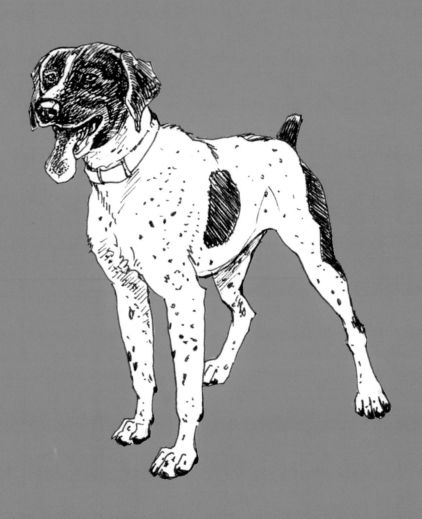

J. C. AMBERLYN

HOW TO DRAW
DOGS AND
PUPPIES

A Complete Guide for Beginners

 MONACELLI STUDIO

Copyright © 2017 J. C. Amberlyn and

THE MONACELLI PRESS

Illustrations copyright © 2017 J. C. Amberlyn

Text copyright © 2017 J. C. Amberlyn

Published in the United States by MONACELLI STUDIO,

an imprint of THE MONACELLI PRESS

Library of Congress Cataloging-in-Publication Data

Names: Amberlyn, J. C., author.

Title: How to draw dogs and puppies : a complete guide for beginners / J.C. Amberlyn.

 Description: First American edition. | New York : The Monacelli Press, 2017.

Identifiers: LCCN 2016026570 | ISBN 9781580934541

Subjects: LCSH: Dogs in art. | Puppies in art.

Classification: LCC NC783.8.D64 A43 2017 | DDC 743.6/9772--dc23

LC record available at https://lccn.loc.gov/2016026570

ISBN 978-1-58093-454-1

Printed in China

DESIGN BY JENNIFER K. BEAL DAVIS

COVER DESIGN BY JENNIFER K. BEAL DAVIS

COVER ILLUSTRATIONS BY J. C. AMBERLYN

10 9 8 7 6 5 4 3 2 1

First Edition

MONACELLI STUDIO

THE MONACELLI PRESS

236 West 27th Street

New York, New York 10001

www.monacellipress.com

Dedicated to my Mom, Den, and all the dogs who have shared this journey with me—as well as the people who love them.

ACKNOWLEDGMENTS

There are many people (and their dogs) I'd like to thank for the their help in this book, including: Marsha Tonkinson, Ron and Anna Nyberg of Alpacas of the Southwest, Kim Neiderhiser and her family, Cindy Coker Green, Stephanie Stone, Coral C. Coolahan of Cool Photography, Cindy and Brian Bridges of Pampered Puppy, Ty Rogers, Sara Miles, Tom, Mary Seng, Siv Greentea, Paula and Jim Acer, George and his lovely Golden Retrievers, Linda Jeffries, Lisa Marler, Lex Nakashima, Elin Winkler, Western Arizona Humane Society, Kensen Lee, Ally Albon, Beth Tereno, Trish Cobb, Mallory Hagan, Carol Lessard Vine, Stephanie J. Cress and friends, and the many people I met locally while out and about, at the veterinarian, or the local dog park, who generously allowed me to photograph and meet their dogs.

ABOVE: IRISH WOLFHOUND AND CHINESE CRESTED DOG

CONTENTS

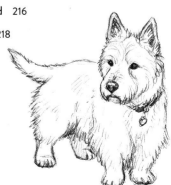

INTRODUCTION

There is something about dogs that has struck a chord with humans since before recorded history, back in the dark predawn when they were wolfish shadows flitting about at the edge of our campfires. We domesticated those wolves, or perhaps they domesticated us. They have helped us hunt and farm, guarded us, kept us warm, and provided companionship. We evolved together and there is evidence that the domestication of the dog provided a huge leap forward in human civilization and our ability to survive and expand. That timeless bond endures and today dogs share our lives across the world. They guide us, protect us (and our property), help find us when we are lost, and provide a needed smile at the end of a bad day. We feed, shelter, and at our best, we love and protect them in return. Our ancient pact remains intact and together we are stronger than we are alone.

Over the centuries humans have selected certain characteristics to aid in specific tasks and as a result hundreds of breeds have been created. Some have greater stamina, some a better sense of smell, some have natural herding or hunting instincts, and some provide gentle companionship. From the tiny Chihuahua to the tall Irish Wolfhound and from the wrinkled, short-legged Basset Hound to the graceful, elegant Saluki, there are all sizes and shapes of dog. Yet they are all the same species, *Canis lupus familiaris*.

Certain aspects of selective breeding have led to controversy, including the practice of cutting or shaping parts of tails or ears for functional or aesthetic purposes or when breeding for exaggerated physical traits, such as very short muzzles. These can affect the appearance of various breeds from country to country. For instance, cropping of ears and docking of tails are allowed in some countries and banned in others. There are also sometimes differences in show dogs and dogs of the same breed outside the show ring. For example, show dogs may have longer fur or stockier bodies while non-show dogs may be selected for working ability more than form. There are many things to learn about breeds and hopefully this book will help start artists on the journey of learning more.

ABOUT THIS BOOK

Dog breeds are often classified according to groups placed together due to some common trait, whether it is herding, hunting, or a type of dog like terriers or hounds. Sometimes, breeds don't fall into an easy category so they get grouped with names like "non-sporting." There are various dog breed associations across the world and each one has its own way of classifying dogs.

This book follows groupings according to the AKC, or American Kennel Club. It is not within the scope of this book to include every dog breed, but I have tried to include several examples of each dog group. I have represented each breed to the best of my ability but if one breed strikes your fancy I encourage you to study it and learn more details about it. Many of the dog drawings in this book are based on the pets of friends or acquaintances. This means that while each should be a good representative of its breed, it is not necessarily show quality. In the text, I included show-desirable traits for each breed but you are encouraged to do more research if you seek to draw the most show-quality dog you can. The final chapter consists of breeds that are not currently official AKC breeds (as of this writing) as well as mixed breeds.

Though all of the illustrations and text in the book are informative and instructional, I've also included more detailed, step-by-step drawing demonstrations throughout every chapter.

ART MATERIALS

When making art you can get as simple or as fancy as you like. Draw with a pencil on paper or use a tablet and computer to create a digital art piece. If you work on the computer, be sure to get one that is fast enough and has enough memory to handle the graphics-heavy programs you'll need. Using a graphics tablet instead of a mouse makes it easier to draw and color on the computer.

When it comes to traditional art supplies like pens and paper, a key phrase to look for is "acid free." Acid free artist's paper and pens will not fade as fast as non-acid-free materials. There are a variety of pens out there for artists; try some and see which ones you enjoy. I use brush pens, which give me varying line widths as well as fixed pen sizes. Paper comes in weights and types like the heavier Bristol paper that can withstand markers and heavy ink and the thinner, lighter Sketch paper, which is suited more for pencils.

Artist pencils come in varying hardness or softness. A 9H is a very hard pencil with a light stroke. Midrange pencils are the HB and the 2B—and they keep going up in number until the 9B pencil, which is an extremely soft and dark pencil. Some artists use an H pencil (I use 2H a lot) to lightly sketch and block in shapes, then a darker pencil like a 2B to place the final pencil strokes. I also use mechanical pencils and many of the drawings in this book were produced with one. An artist can also use a finger, piece of paper, or an artist's smudge stick to blend pencil lines to create a softer look, another technique that occurs frequently in this book. Finally, there are several artist's erasers available. I use a kneaded eraser, which allows me to shape the eraser into a fine point or a broad surface depending on how much I want to erase.

Chapter One

DOG ANATOMY

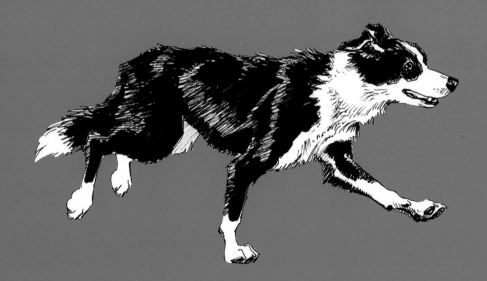

In this chapter we'll look at the basics of drawing a dog. Anatomy, fur, action, and expressions all are important parts of drawing any dog, whether purebred or mutt.

THE HEAD

In this section we'll explore the head from various perspectives—front, side, three-quarter—and will begin with drawing the basic head.

DRAWING THE BASIC HEAD

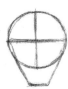 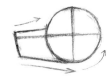 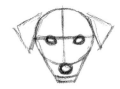 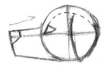

1 On the left is a simple dog head, front view. On the right, a simple dog head from the side. Begin by drawing circles and adding a plus shape to divide them in four equal parts. Add the muzzle. On the side view extend the horizontal dividing line out in front of the face, then add some width on top of it for a thicker muzzle. Note that the muzzle narrows slightly from its base to where the nose will be.

2 Put in the eyes, nose, and ears. On the front view draw the mouth. On the side view note how the front of the eye follows a similar curve just below the top of the head, arcing around to the top of the ears (shown with dotted line).

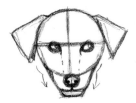 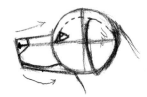

3 On the front and side views, add finishing touches, narrowing the muzzle slightly at the base as shown with the arrows. Add nostrils and the highlights in the eyes. Add details to the mouth as needed. Define the ears and how they attach to the head. Add the neck on the side view.

4 Finish the drawing by inking over or darkening the lines and erasing unneeded guidelines. Shade in the eyes and nose, leaving highlights. On the side view you may go for a simple rounded forehead if you wish, following the basic circle. For a slightly more realistic head, shave off some of the very top as shown with the arrow. A dog's head will be slightly flattened on top.

EYES

Dogs have a similar overall look to their eyes, though the coloration changes among breeds and individuals. The eye shape may be slightly different, with some breeds featuring almond-shaped eyes, some having rather round eyes, etc.

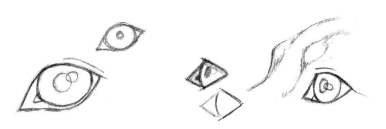

Begin by penciling in the basic shapes, including the pupil, eyelids, eye rims, and the highlight in the eye. On the left, I'm drawing an eye that is facing straight forward toward the viewer. Note the basic oval shape of the eye on the left with teardrop-like tips on either end. The inside corner of the eye is slightly larger and pointed down toward the nose (left on this drawing), whereas the outside corner sweeps slightly up. On the right is the eye of a dog facing to the side. Note how the eye can be basically drawn as a diamond shape with a curved line for the rounded eyeball. Also note that the iris around the pupil can be seen, leaving the white of the eye on the outside corner.

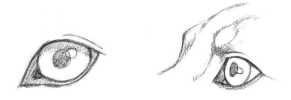

Shade in the pupil, leaving the smaller circle unshaded as the highlight, and shade in the eyelids, eye rims, and tear duct. I further darkened under the eyebrow-like ridge that appears above and just a bit toward the inside of the side view eye. I shaded the eyeball on the left where the eyelid casts shadow.

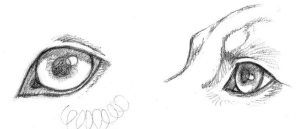

At this point I added some shading around the pupil on the left using a looped squiggly line as shown below the drawing. I also added some indication of the hair around the eye. On the right eyeball I added similar soft, looping shading around the pupil, under the top eyelid and along the iris rim. As with the eye drawing at right, I added some indication of hair around the eye.

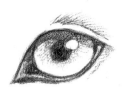

I erased the overlapping lines still showing inside the highlight of the eye. Afterward, I continued shading and darkening the pupil, the shadows under the eyelid, the eyelids, and the tear duct. I added a few more lines to indicate the fur around the eyes and darkened the area under the brow of the drawing to the right.

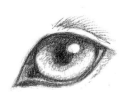 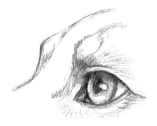

To finish, I made my way around the drawings, continuing to shade and darken areas. Adding soft, light strokes throughout a drawing helps unify it. I further defined details of the fur around the eyes.

EARS

Dog's ears come in all shapes and sizes. Here are a few of the more common types of ears. Ears consist of a lot of cartilage and are attached by muscles, skin, and an oval-shaped piece of cartilage called an ear butt.

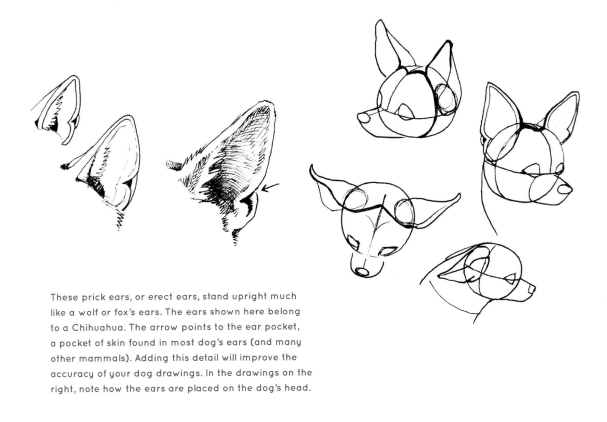

These prick ears, or erect ears, stand upright much like a wolf or fox's ears. The ears shown here belong to a Chihuahua. The arrow points to the ear pocket, a pocket of skin found in most dog's ears (and many other mammals). Adding this detail will improve the accuracy of your dog drawings. In the drawings on the right, note how the ears are placed on the dog's head.

The most common dog ear type is the drop ear, as shown in this Labrador Retriever. The ear hangs from the base, or ear butt. Note the upside-down triangle or almost heart-like shape.

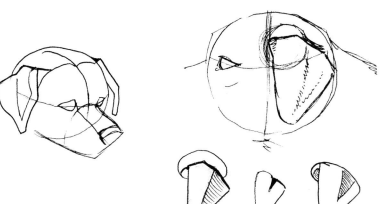

More drop ears, this time those of a Havanese.

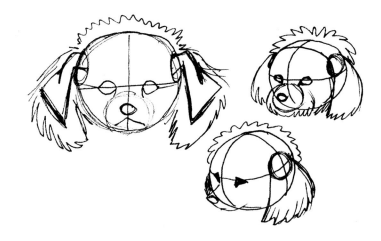

Note that the "rose ears" of a greyhound are folded back. The arrow points to the ear pocket.

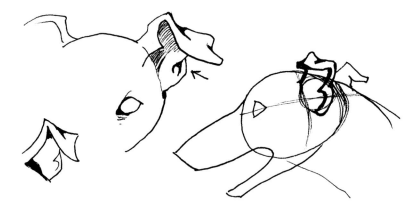

Some dogs, like this Jack Russell Terrier, have "button" or semi-erect ears. The top part of the ear folds forward to obscure much of the inside of the ear.

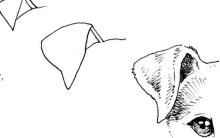

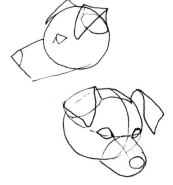

NOSE

A dog's nose consists of two nostrils surrounded by a hairless, moist pad of skin shaped a little bit like a wide heart or teardrop. Healthy dogs generally have moist noses with shiny highlights visible.

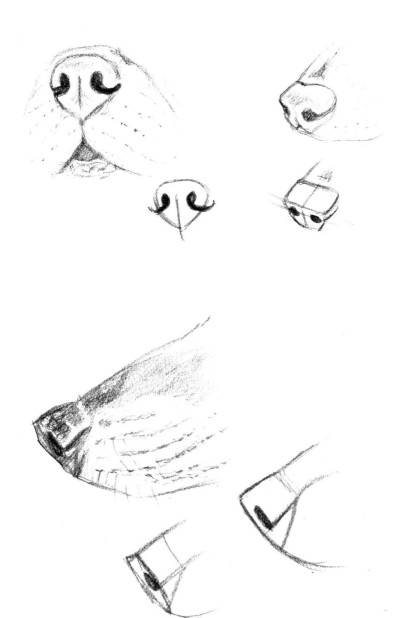

Here are several dog noses from various angles. Note the somewhat heart or teardrop shape. The top of the nose has a slight curve to its surface. The front of the nose is fairly flat, though the middle part juts out the most. Note that the bottom of the nose pad comes down to a tip that leads to the line that separates into the mouth. The fleshy pad around the nostrils may somewhat obscure that tip at certain angles (near left, top). Dog nose shapes can vary a little bit between breeds and individuals. Some breeds have noses that look a little pushed up, like the English bulldog nose, pictured top left.

A dog's nose from a side view is depicted here. Note the whisker rows. Dogs have several rows of whisker follicles behind their noses. The rows aren't always distinctive or easy to see, but usually there are about four main rows with various follicles or shorter and less obvious rows above and below. The top row of the main four is usually right behind the nostril.

DRAWING A DOG NOSE

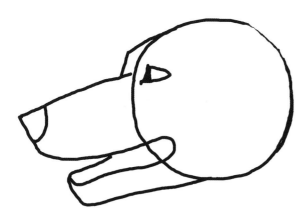

1 I first blocked in a profile view of the nose and mouth. This is the base shape I'm working with.

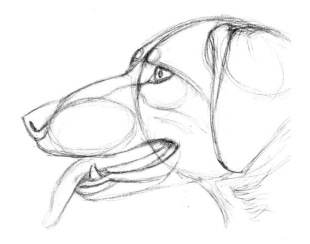

2 This is a more detailed look at the shapes I'll be working with. Here I rough in basic guidelines, including the nostrils, the tongue, and the canine tooth.

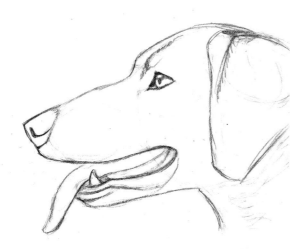

3 At this point I erased and redrew the guidelines so that I could start fresh.

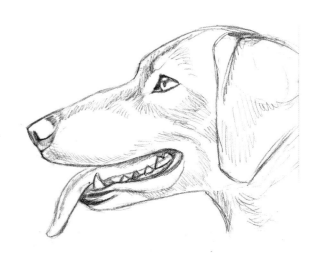

4 I began shading in the drawing, using pencil strokes to suggest the direction of fur. I added shadows on the tongue, the lip of the lower jaw, and the front of the nose pad. The other teeth were defined.

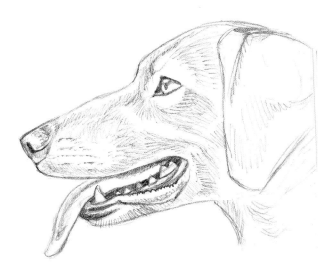

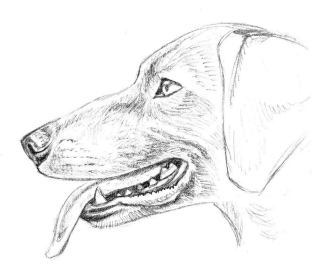

5 Continue to shade in the drawing, adding more fur through short strokes of your pencil. Define the lips and teeth, shading in the spaces between the teeth and on the tongue. Add the serrated edge of the part of the lip that hangs loose near the corner of the mouth. Draw the four main whisker rows and suggest a few more.

6 Continue shading in fur, using smaller pencil strokes to show more details and create a sense of short layers of hair. Use circular motions on the loose lips and tongue and shade in more of the lips and teeth. Define the wrinkles on the corners of the mouth.

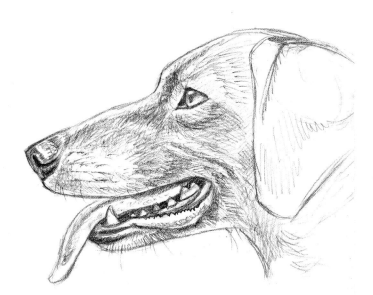

7 To finish the drawing, lightly shade in the overall area to unify it, leaving small areas of blank space for the lightest areas. Add the whiskers and define the corner of the lips.

DRAWING A DETAILED NOSE AND MUZZLE, FRONT VIEW

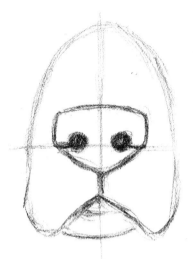

1 First, I drew the basic outline of a dog's nose and muzzle. The plus shape helps block in the features.

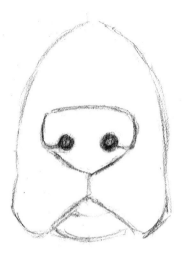

2 Next I erased the guidelines to get rid of clutter.

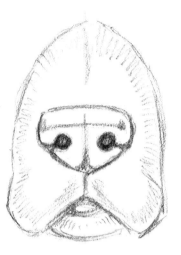

3 Begin shading some of the muzzle in, using your pencil strokes to indicate the direction of the fur. Add a plus shape on the nose pad to indicate where the top of the nose meets the front and where there is a vertical dividing line up the front of the nose in the middle. I shaded the lip with a circular stroke.

4 Draw more of the fur around the nose, using short strokes in the direction of the hair. On the nose pad, shade in the rim of the nose and nostrils. Shade the lower lip and faintly suggest whisker rows.

5 Continue shading areas and further adding details. Use small pencil strokes to indicate the fine hair along the muzzle and break up areas of longer hair. On the nose pad, shade in the top of the nose to create a blank space for the highlight and continue shading around the nostrils.

6 Finish the drawing by lightly shading in most of the area to unify it. Add whiskers. Define the moist highlights on the nose by shading the darker areas around them. The highlights can vary from an oval shape to small circular areas of light.

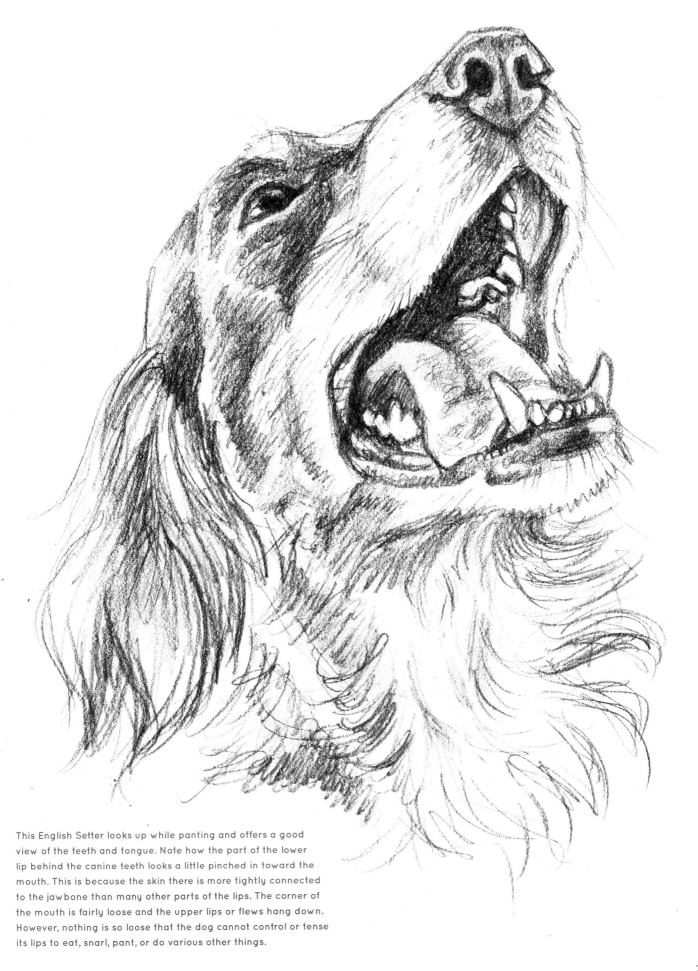

This English Setter looks up while panting and offers a good view of the teeth and tongue. Note how the part of the lower lip behind the canine teeth looks a little pinched in toward the mouth. This is because the skin there is more tightly connected to the jawbone than many other parts of the lips. The corner of the mouth is fairly loose and the upper lips or flews hang down. However, nothing is so loose that the dog cannot control or tense its lips to eat, snarl, pant, or do various other things.

SKULL STRUCTURE AND THE HEAD

Knowing the underlying skull structure of a dog's head helps one master drawing a convincing, lifelike dog head.

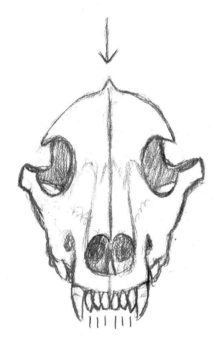

This is a dog's skull from the front view. Note the occipital crest on the top of the skull. The dog has two large canine teeth on the top (and on the bottom) of its mouth. In between the two large canine teeth are six small incisor teeth.

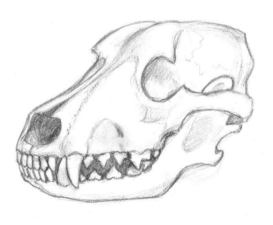

Here's a dog's skull shown from a three-quarter view.

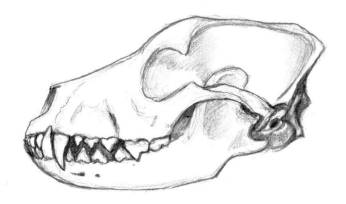

Here a dog's skull is shown from a side view.

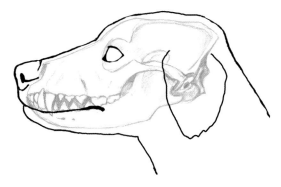

The same skull, showing how it fits in the dog's head.

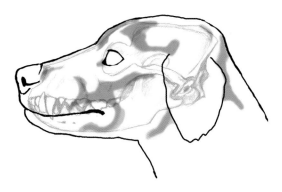

The same skull, showing some of the more shadowed, recessed areas on the head.

Knowing anatomy helps in building up a more realistic dog's head, such as this German Shorthair Pointer.

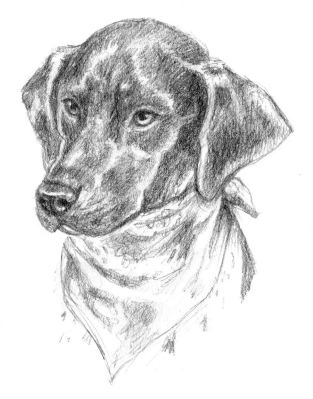

The finished drawing.

25

BODY

When drawing a dog (or anything else) it helps to know the underlying anatomy, no matter whether you intend to draw very realistically or stylize your subject. Once you know the rules you can break them a little and still produce a convincing drawing.

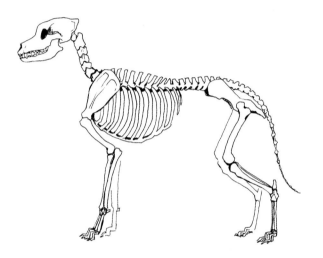

This is a dog's skeleton. Shapes and proportions vary somewhat between breeds but the skeleton otherwise stays pretty much the same.

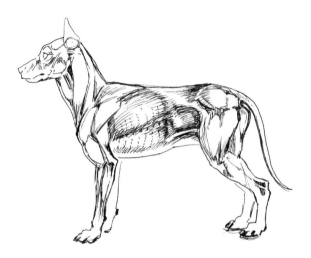

This is a dog's basic muscular structure. Knowing these shapes helps when drawing dogs, especially breeds with short coats.

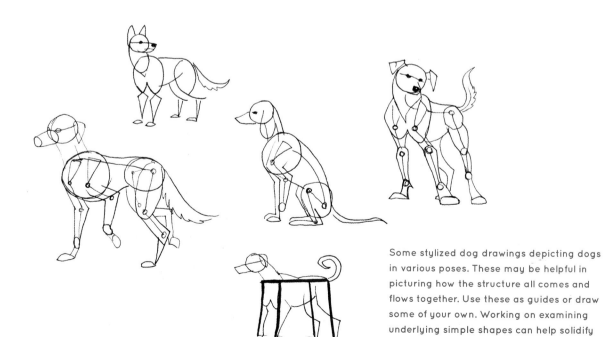

Some stylized dog drawings depicting dogs in various poses. These may be helpful in picturing how the structure all comes and flows together. Use these as guides or draw some of your own. Working on examining underlying simple shapes can help solidify anatomy in one's head.

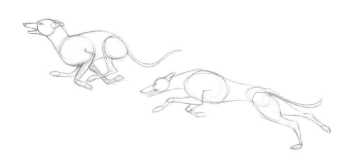

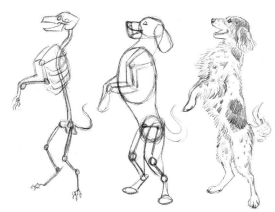

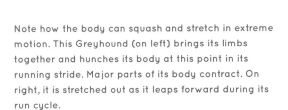

Note how the body can squash and stretch in extreme motion. This Greyhound (on left) brings its limbs together and hunches its body at this point in its running stride. Major parts of its body contract. On right, it is stretched out as it leaps forward during its run cycle.

Here is an English Setter standing on its hind legs. Note how the underlying structure of the skeleton (left) affects the muscles (middle) and the appearance of the dog (right).

FEET AND LEGS

Dogs have four toes on their feet with a pad under each toe and a claw at the end. There is a smaller vestigial toe called a dewclaw at the inside of the front foot, above the other toes but below the wrist joint. This is the underside of a dog's paw, showing the pads under each toe, under the foot, on the dewclaw (indicated by the arrow), and the small pad at the wrist joint.

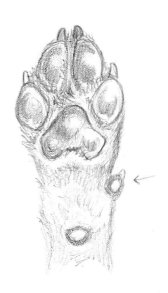

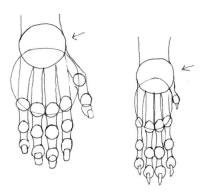

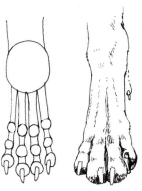

The skeletal structure is actually somewhat similar to a human's, with the dewclaw equivalent to the thumb and the toes equivalent to the fingers. The claws are like nails.

A look at a dog's left front paw (in this case a German Shorthair Pointer) showing the basic structure underneath and then the paw as it appears to the eye.

DRAWING A DOG FRONT FOOT, FRONT VIEW

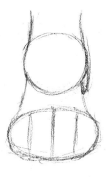

1 Begin by blocking in basic shapes, including an oval for the foot, a circle for the wrist joint, and connecting lines. Add a dewclaw and three evenly spaced vertical lines to block in the four toes.

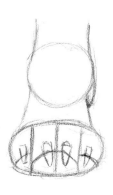

2 Add curved lines for the toe pads and nails.

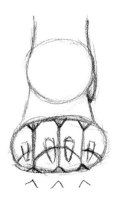

3 Further define the toes, using V-shaped lines.

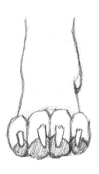

4 Finish the drawing, erasing unneeded guidelines and shading in the toe pads.

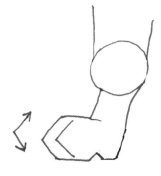

5 A simplified look at the basic shapes making up the front paw from a side view. Note how the toes can be drawn with a V shape lying on its side.

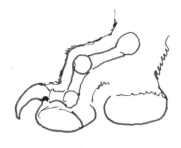

6 A closer look at the skeletal structure of the toes and placement of the paw pads on the toes and front foot.

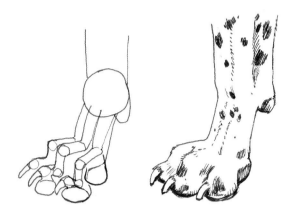

Here's a look at a Dalmatian's foot. Note the placement of the paw pads, including one at the back where the wrist joint is.

DRAWING A DOG FRONT FOOT, SIDE VIEW

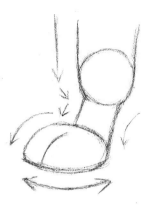

1 Block in the basic shapes, using a circle for the wrist joint, an oval for the foot that is slightly wider on bottom than top, connecting lines, and a curved line to separate the toes. I've used arrows to indicate subtle nuances in the outlines.

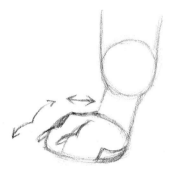

2 Define the arch of the toes and flatten the top of the foot slightly as indicated by arrows. Add claws and the bottom paw pad.

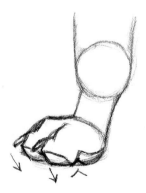

3 Define the front of the toes below the claws, slanting them down as indicated by the arrows, and define the space between the paw pad and the toes (as shown by the V-shaped arrow).

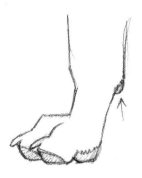

4 Finish the drawing, shading in the toe pads and erasing unneeded guidelines and adding a small pad under the wrist joint (indicated with an arrow).

FRONT LEGS

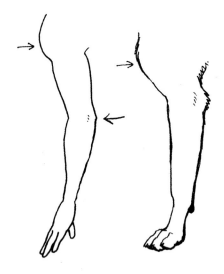

Here is a human arm (left) compared to a dog's front leg. The top arrow indicates where the shoulder is and the bottom arrow indicates where the elbow is.

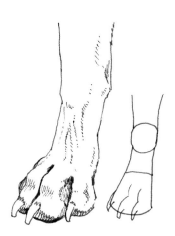

This is a view of a dog's paw from a three-quarter angle.

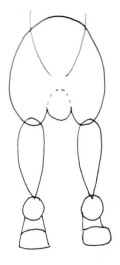 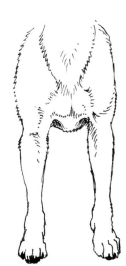

This view shows a dog's front legs and chest. I've included several different takes on the same thing, including some very stylized drawings showing some basic underlying shapes and a more realistic drawing (right).

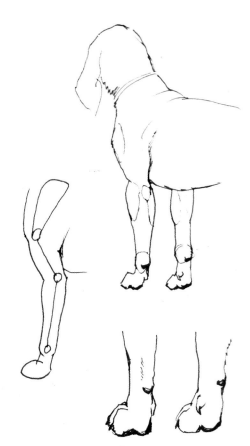

Here is a view of a dog's front legs from a three-quarter view and viewed from behind. Note the placement of the shoulders and elbows. I've also including a drawing depicting a close-up of the back of the feet showing the dewclaws and the small pad behind the wrist joint.

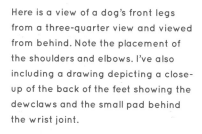

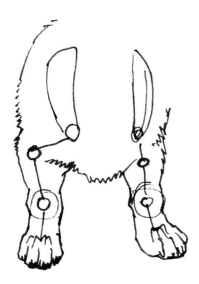

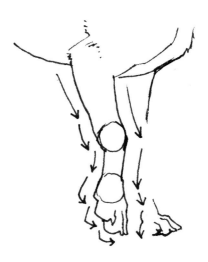

This Corgi has much shorter legs than the average dog but has the same basic skeletal structure.

This stylized drawing shows a front leg being held in the air. I've included arrows to depict the pen strokes I used in the outline.

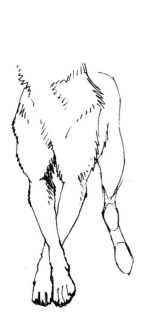

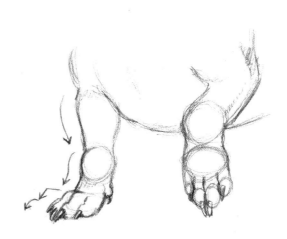

Here are some more drawings of front legs. The one on left is more realistic. Note that the dog's right front paw is held in the air as the dog walks and the dog's left front paw is the one supporting the dog's weight. The other drawing is more stylized, showing some basic structural shapes.

With the front legs of this Dachshund note how the weight is borne by the right leg and paw.

HIND LEGS

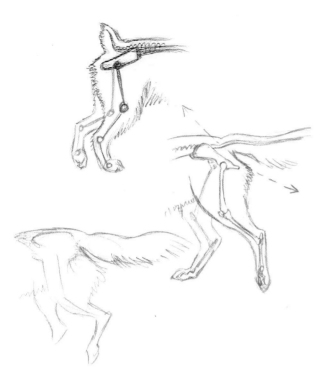

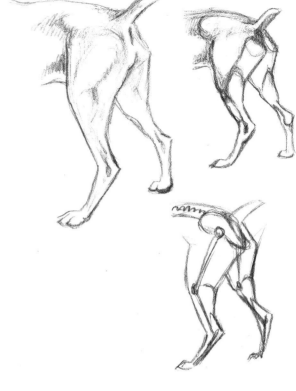

Here are some drawings of a dog's hindquarters. Note how the slant of the pelvis lends to the appearance of a flat area that angles downward from the base of the tail. The front top of the pelvis is also sometimes noticeable as a bulge on the top of the dog's hips along its back.

A German Shorthair Pointer's hindquarters are shown standing at a three-quarter view angling away. Note how the slant of the pelvis causes the dog's rear to slope down and protrude the most where it tapers and ends below the tail.

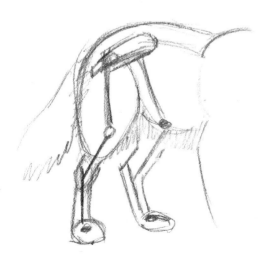

Here's a view of the basic skeletal structure of hind legs from a three-quarter view.

Some more stylized shapes showing basic structure of the hind legs. Note how some lines flow into opposite sides of the leg.

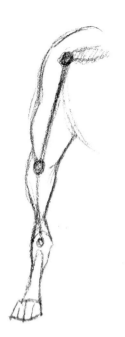
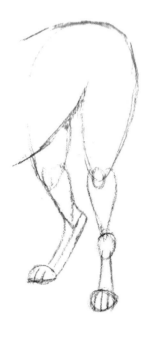
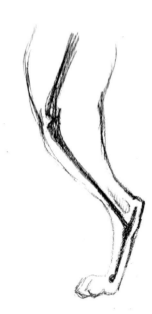

Let's look at some of the hind leg's basic structure and shapes. The hind leg on the left is viewed from the front while the hind legs on the right are viewed from a three-quarter view and somewhat from above. On the left leg, the joint of the hip, "knee," and ankle are defined with dots.

A side view of a hind leg with particular attention paid to showing some of the underlying skeletal structure. The knee can be seen on upper left and the ankle or hock at lower right. Note how part of the foot bone structure protrudes above the heel, creating a hollow pocket where skin and sinew attach the heel but there is little muscle.

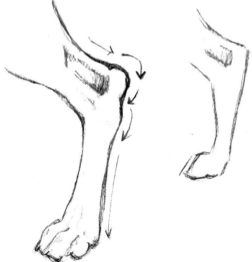
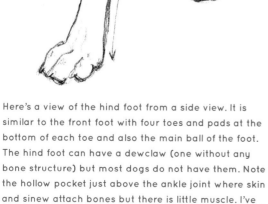
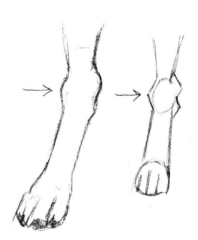

Here's a view of the hind foot from a side view. It is similar to the front foot with four toes and pads at the bottom of each toe and also the main ball of the foot. The hind foot can have a dewclaw (one without any bone structure) but most dogs do not have them. Note the hollow pocket just above the ankle joint where skin and sinew attach bones but there is little muscle. I've used arrows to indicate some of the usual bulges of the bone and sinew along the hind foot.

Let's look at a hind foot from the front. This is the left front foot of a dog facing the viewer, so the inside of the dog's leg is on the left where the arrow is. Note that the inside of the dog's ankle or hock has one large bulge (shown with the arrow), whereas the bone structure of the outside of the ankle has two. This is a simplification of the basic structure and is not always this obvious but it is something to be aware of.

33

Here is a human leg (left) compared to a dog's hind leg. Note the similarities, including the knee or stifle (top arrow) and the ankle or hock (lower arrow).

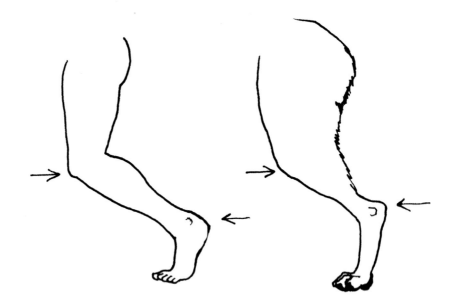

FOUR LEGS

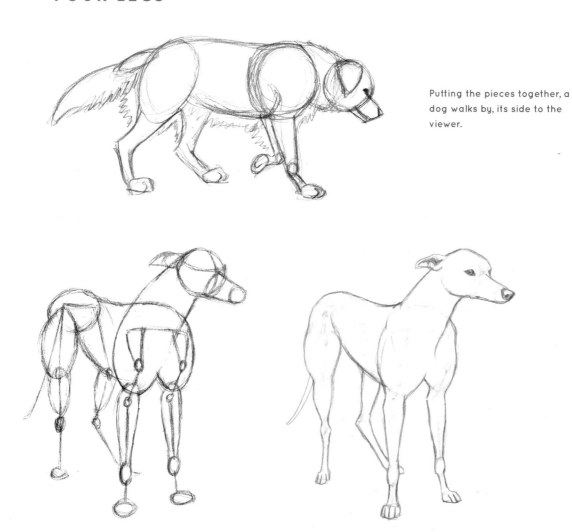

Putting the pieces together, a dog walks by, its side to the viewer.

You can see the basic structures of a Greyhound standing at a three-quarter view.

The finished Greyhound drawing.

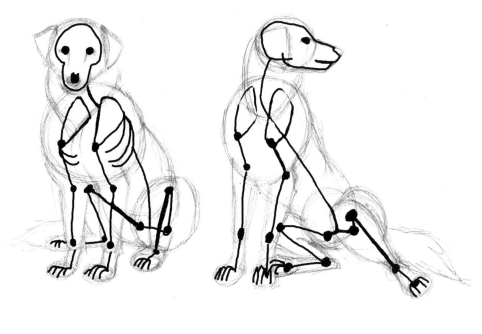

Sitting Golden Retrievers. Note the placement of the underlying skeleton. One dog is sitting with its hind legs drawn up on either side of its body (left). The other relaxes more, stretching its legs out a little.

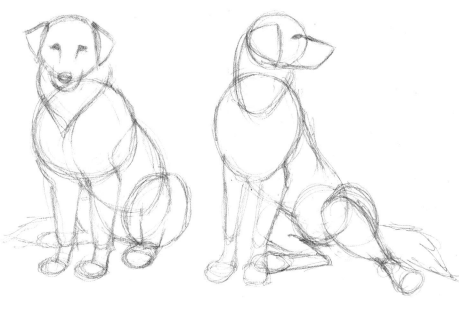

The same Golden Retrievers, but now showing the basic circular, oval, and tubular shapes that make up their bodies.

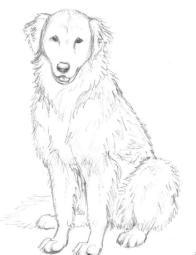
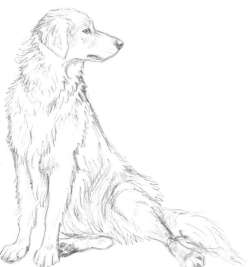

The finished drawing of the two Golden Retrievers sitting down.

COAT AND COLOR

The coat and color of a dog will vary from breed to breed as well as within breeds. In this section I'll show you how to accurately render coat and color whether you are drawing a realistic or a stylized dog.

FUR

The hair of a dog can range from long and silky to short, coarse, and stiff. A few dogs hardly have any hair at all. In this section I try to show some of the major directions and patterns that pop up in a lot of dogs, as well as provide a demonstration on how to draw dog hair.

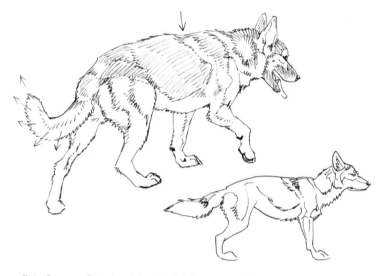

Something to be aware of regarding a dog's fur is the top or outer coat, called the guard hairs (the top layer of longer hairs), and the undercoat (bottom layer of softer and denser hair). Some breeds have a single coat that consists of only the coarser guard hair. Other dogs (including wild dogs like wolves) have the two layers. The shorter, denser undercoat insulates the dog and the guard hairs tend to be harsher and more rain and weather resistant.

This German Shepherd (top) exhibits some of the major patterns that can show in a dog's fur due to both underlying anatomy and the hair itself. Note the arrow pointing to the section of hair behind the shoulders. Wild dogs like wolves exhibit this "saddle," which consists of long guard hairs all along the shoulders and back, which helps keep out the rain and other inclement weather. Dogs descended from wolves and retain some of those same characteristics, which is especially evident in breeds like the German Shepherd. The drawing on the bottom shows some very simplified portrayals of the hair patterns that appear on some dogs.

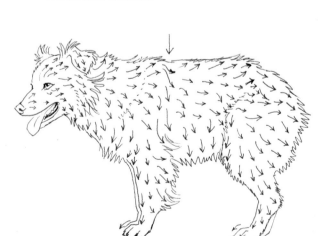

The arrows on this Australian Shepherd show some of the major directions of the hair on a dog's body. Note the large arrow above the dog over the shoulders, which points to where hair sweeps down behind the shoulders. This is a common feature on dogs.

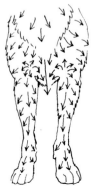

The arrows here show some of the major directions the hair flows as seen from a front view.

DRAWING FUR ON A GOLDEN RETRIEVER

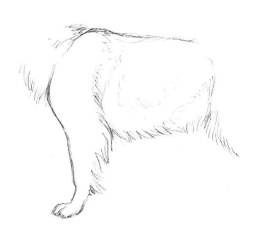

1 Start with a basic outline of the body and a quick indication of major sections of fur.

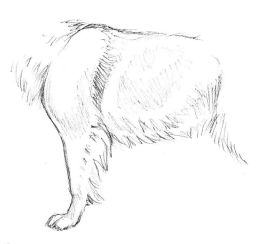

2 Begin shading in some of the larger areas of fur where it appears darker due to shadow. This shows my first pass of the entire area.

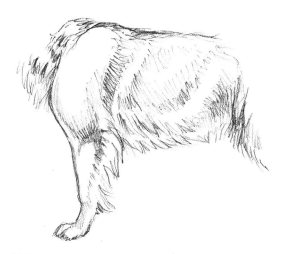

3 At this point I went back for a second pass on many of the same areas, adding darker shadows between clumps of fur or places where the body is in shadow (like where it lies slightly compressed between the shoulder and elbow).

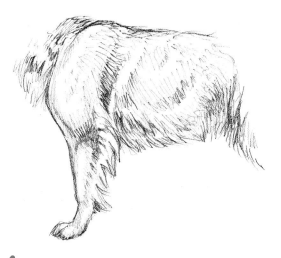

4 I shaded more areas, starting to lightly pencil in lighter sections of fur while continuing to add shadow in places I've already worked in. I began shading some medium tones like those along the very front of the shoulder.

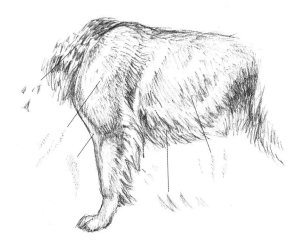

5 I went back and added some light shading to most of the fur. I added more shadow in the area of the abdomen in front of the hind leg and added details to the neck ruff. In addition, I started adding many smaller, shorter pencil strokes to bring out more details in the fur. I've indicated some of the pencil strokes I used to add these details outside the dog's body.

COAT COLOR

Dogs' coats come in many different colors and patterns. Colors range from white and black to red, tan, gray, a grayish-blue, and more. Here are some, but not all, of the more common patterns. Some patterns not pictured include harlequin, which is a pattern of ripped splotches of black on white (found in the Great Dane); spotted, which are black spots on a white coat (Dalmatian); saddle, which is a darker color across the back on top of a lighter overall body color; and sable, which indicates dark-tipped hairs. Tuxedo is similar to bicolor but the white is more concentrated as a patch on the chest and chin and white feet. Particolored is a white coat with patches of color. Roan is an even mixture of white and colored hairs.

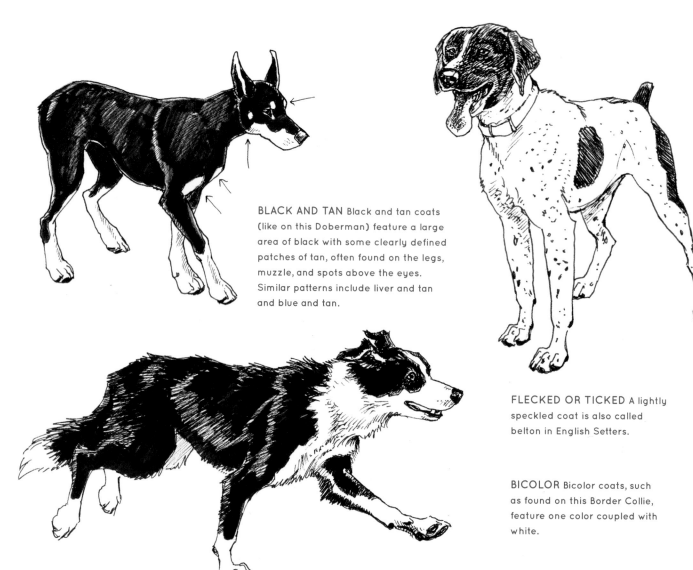

BLACK AND TAN Black and tan coats (like on this Doberman) feature a large area of black with some clearly defined patches of tan, often found on the legs, muzzle, and spots above the eyes. Similar patterns include liver and tan and blue and tan.

FLECKED OR TICKED A lightly speckled coat is also called belton in English Setters.

BICOLOR Bicolor coats, such as found on this Border Collie, feature one color coupled with white.

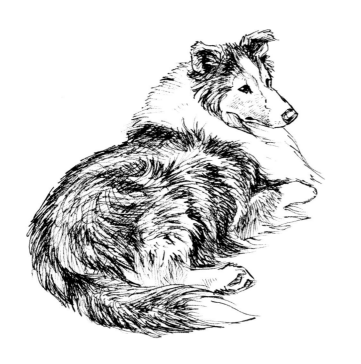

TRICOLOR Tricolor coats, like this Shetland Sheepdog, feature three distinct colors. Often they are black, liver or blue with tan and white.

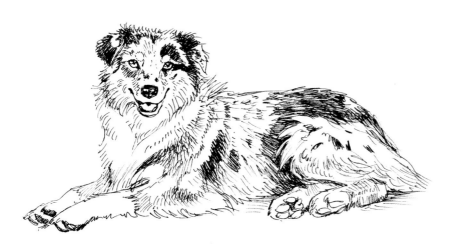

MERLE This Australian Shepherd is a blue merle. Merle is a marbled pattern that consists of one color with darker patches of that color. There may be white, black, tan, or other colors on the coat as well. Blue, red, and liver are common merle colors. Merle is called "dapple" in Dachshunds.

BRINDLE The brindle pattern consists of a lighter background color with dark stripes, as shown in this Border Collie mix.

DOGS IN MOTION

Drawing a dog in motion consists of bringing together several different elements into one harmonious whole. It involves understanding the basic gesture, or movement, occurring throughout your drawing. It also requires that you build the body up using basic shapes and knowledge of anatomy.

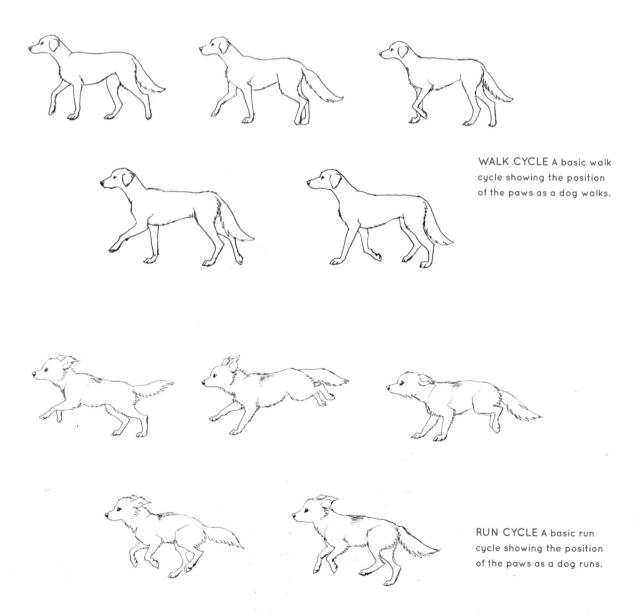

WALK CYCLE A basic walk cycle showing the position of the paws as a dog walks.

RUN CYCLE A basic run cycle showing the position of the paws as a dog runs.

This Border Collie crouches as it prepares to leap and catch a Frisbee. In the middle is the dog's form, built with basic shapes like a circle for the chest and head and tube shapes for the legs. On either side are sketches showing some of the patterns (left) and the flow of motion (right) in that form.

Like before, these Border Collie sketches display how one can build an action drawing by using gestures and lines (center) and blocking in the basic form. Also note how many of these lines flow into each other (same drawing with lines added on left). One line leading the eye into another adds to the force, cohesion, and thrust of your drawing and emphasizes motion.

This leaping Boston Terrier is drawn in several different sketches showing ways to approach capturing the action. Note how the basic lines tend to flow into or complement each other. Everything about this dog's form sweeps upward.

DOG EXPRESSIONS

Dogs have expressions much like humans do and there are enough similarities to provide a good clue to what a dog might be feeling. Some things are not as intuitive, however, and studying dog behaviors and postures helps ensure accuracy.

HAPPY/CONTENT

A content dog's face will be relaxed. Its mouth may be open and panting or it may be closed but will still be loose, not drawn into a pucker. Dogs also pant to cool down, so panting is not always the absolute indication of a happy dog. Other clues will tell the story. Look for eyes that may be bright and alert or half closed if the dog is relaxing. The ears will be relaxed or alert but not flattened on its head. Finally, while panting isn't an absolute indicator that a dog is pleased, a content panting dog just has a happy look to it. The lips often curl up into what truly looks like a smile.

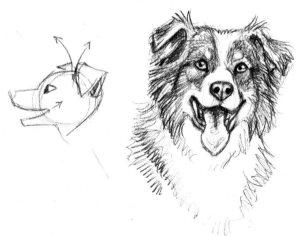

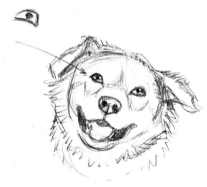

This mutt also seems to be smiling, just not as widely as the Australian Shepherd. His ears swing around, alert but not rigid. His "smile" pushes the lower lids of his eyes up, adding to his jovial look.

This Australian Shepherd seems to have a smile on her face. Her eyes are bright and ears are perked up.

This Great Pyrenees is relaxed. His ears hang from his head, his eyes are half closed, and his mouth is parted in a doggy smile.

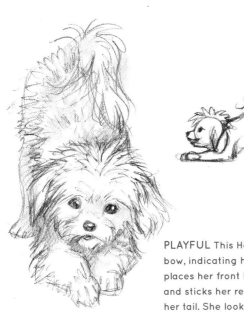

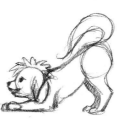

PLAYFUL This Havanese exhibits a play bow, indicating her playful mood. She places her front legs fully on the floor and sticks her rear in the air, wagging her tail. She looks directly at the viewer like an aggressive dog might but her face and body are relaxed, not rigid. She is alert but not aggressive.

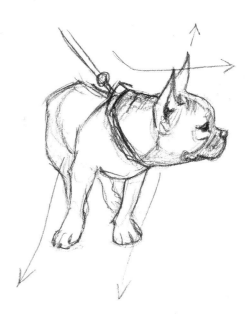

INQUISITIVE This French Bulldog pulls at his leash, leaning forward. Note the angle of his legs and how he thrusts his head in front of him, stretching it out (as shown by the arrows). His ears are pricked up in the direction of whatever has his attention. Curious dogs may cock their heads to one side, trying to pinpoint sound. Eyes will be wide. If whatever interests the dog is unknown, its mouth may be closed and neutral.

ANXIETY

A worried and anxious dog tends to try leaning away or getting away from the source of its anxiety. The dog may look stiff and tense or it may huddle down and try to look as small as possible.

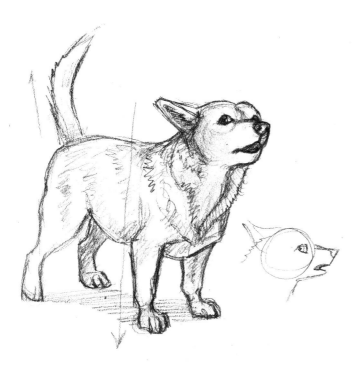

TENSE This barking mixed breed is tense and ready for possible trouble. Note the puckered mouth and stiff legs (as shown by the arrows). His tail is raised high in a more dominant manner. He wags it stiffly. A wagging tail does not always mean a dog is friendly. If the wagging tail is loose and relaxed then the dog is in a good mood. However, if the tail is wagging in a very stiff manner the dog is feeling excitement mixed with some tension or aggression. A dog wagging its tail in this manner is best given some space. Also note how the white of the dog's eye can be seen as he looks to the side. When the white of a dog's eye shows it can indicate some tension or even fear. (Though this isn't always the case.)

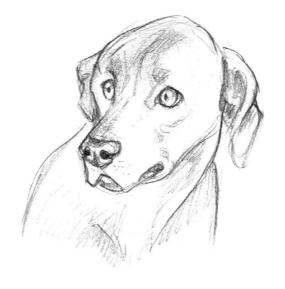

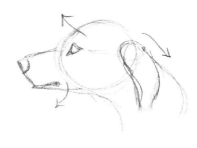

Note how the ears are pulled back and this dog's mouth is puckered and tight. Even the brows above his eyes are bunched up, adding to the worried expression, and the whites of his eyes show.

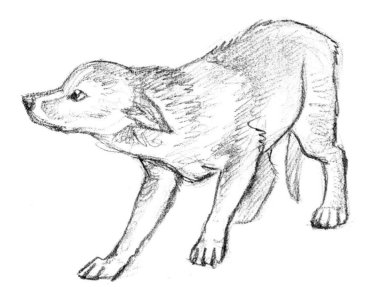

This dog exhibits signs that he is uneasy: bowing his head down, showing the whites of his eyes, and huddling his body. He may be submissive or defensive. He's likely trying to avoid a confrontation by trying to make himself look small. Fearful dogs (as well as aggressive dogs) may bristle the hair on their backs.

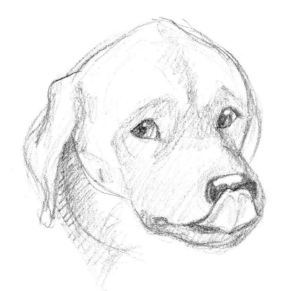

Another sign of nervousness can be displaced behavior like yawning when a dog isn't tired or licking its lips when there's no food around. This dog averts its eyes. Nervous dogs' warning signs should be respected.

AGGRESSIVE

When warning signs are ignored, the dog may launch into aggressive behavior that is quite unmistakable. The dog stares at the object of its aggression, drawing its lips back in a snarl. Ears may point forward, hackles may be raised, and the dog's body will be tense. It will look as large as possible and its legs will likely be stiff.

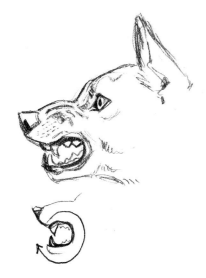

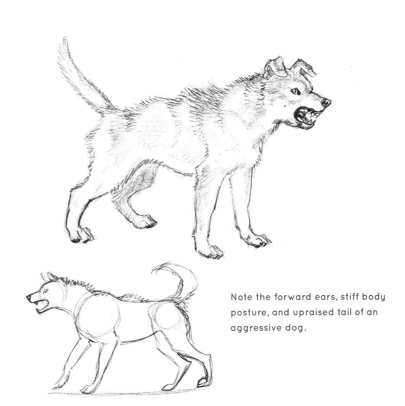

The lips of an aggressive dog may be curled up in a C-shaped snarl before trying to bite. The black lips and white teeth make the contrast especially noticeable. The muzzle will be wrinkled up during a snarl.

Note the forward ears, stiff body posture, and upraised tail of an aggressive dog.

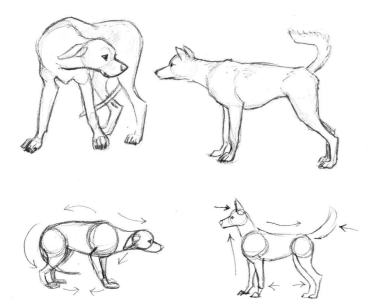

SUBMISSIVE AND DOMINANT These two dogs exhibit submissive (left) and dominant (right) behavior. The dog on the left may be a little larger but huddles her body down, lowers her head, pulls her ears back, and tucks her tail in. The dog on the right exhibits confident behavior, approaching with back straight, head and tail up, legs at a normal stance. She looks directly at the other dog. The submissive dog could also be fearful and the dominant dog could be aggressive, though not necessarily in this case.

Chapter Two

PUPPIES

This chapter will give some tips on drawing young dogs. There are some features and physical traits found across the spectrum of dog breeds and sizes. There is also a section on changes that a puppy undergoes from birth to about one year of age.

PUPPY FEATURES

Puppies have a number of distinct traits that help differentiate them from adult dogs. Key among those is a comparatively large head, short muzzle, knobby and gangly legs, and an innocent, awkward curiosity about the world around them.

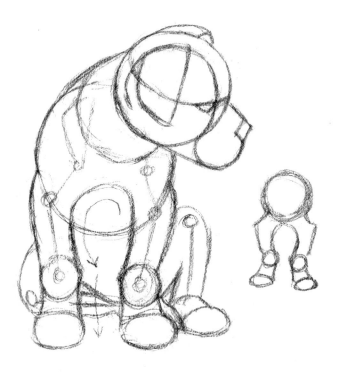

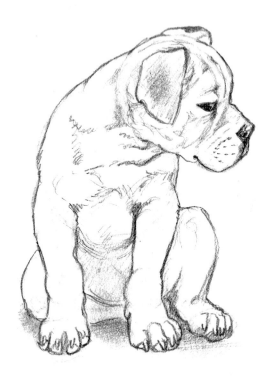

This sitting three-month-old American Bulldog has a head that from this angle looks about as large as its chest. I've drawn some of the basic shapes of its body, including arrows showing the horseshoe-like shape of its inner front legs. Getting that bow-legged stance, coupled with the knobby wrists, contributes to a puppy's awkward appearance. On the right, I've drawn an exaggerated front leg and chest area from the front view, highlighting the bowlegged stance and the knobby wrists.

In the finished drawing, note the curves of the puppy's body. Older dogs would show more angular and muscular features. A puppy is still soft and roly-poly in appearance. Keep the legs and belly rounded.

Young puppies like this Basset Hound have rounded heads and muzzles. Puppies appear gentle and soft.

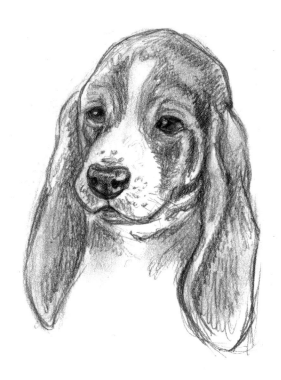

In the finished drawing of a young Basset Hound, note how the eyes look a little droopy and sleepy.

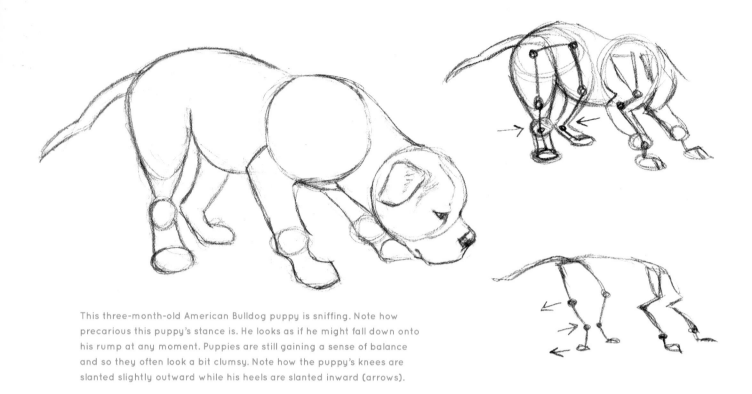

This three-month-old American Bulldog puppy is sniffing. Note how precarious this puppy's stance is. He looks as if he might fall down onto his rump at any moment. Puppies are still gaining a sense of balance and so they often look a bit clumsy. Note how the puppy's knees are slanted slightly outward while his heels are slanted inward (arrows).

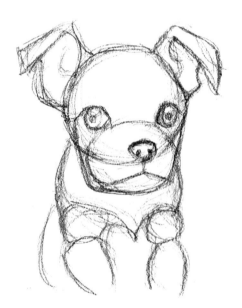

This young Boston Terrier puppy, who is about eight weeks old, has not yet grown into his eyes, ears, or other features. I blocked him in with a circle for his head and muzzle and added a roughly square-like area for his jaw.

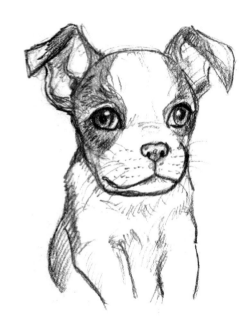

The finished drawing of the Boston Terrier puppy.

Puppies' feet look round and pudgy when they are young. These are a Basset Hound's feet. Front foot (left) and hind foot (right).

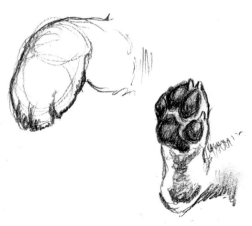

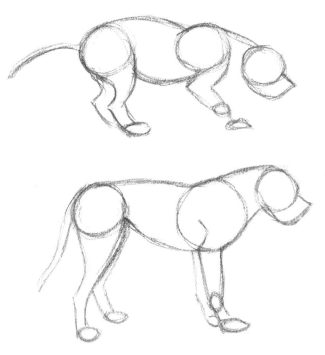

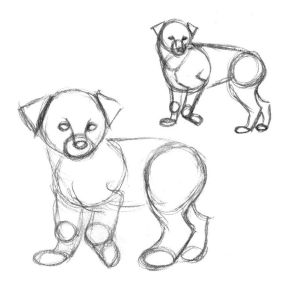

This is a three-month-old (top) and adult American Bulldog. Note how the puppy's chest and hips are about the same size and the belly is rounded. The adult dog's chest appears larger and the chest is far deeper than the belly, which is tucked in. The puppy leans back, unsteady on his feet, while the adult stands solidly on all fours, legs fairly straight. The adult's back is straighter in appearance than that of the puppy.

Note this ten-week-old Australian Shepherd puppy's comparatively larger head and feet and its much shorter and thicker legs. An adult Australian Shepherd is shown for comparison on top: note the much larger-looking chest and smaller-looking head and paws. It also has a longer muzzle.

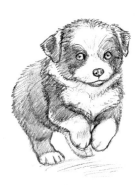

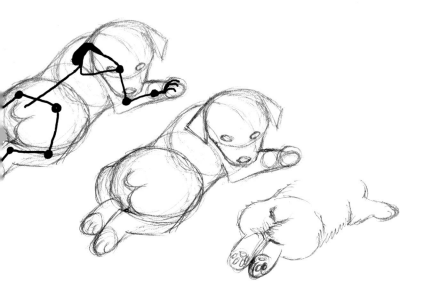

This running seven-week-old Australian Shepherd pup's body is all round shapes and big feet. Features like his toes aren't as well defined as they are on an adult. The legs of this young pup don't show much underlying anatomy. It's there but his limbs look thick and there are no sharply defined muscles, even on a dog with short fur.

The finished drawing. Keep drawings of young puppies soft and pudgy.

Puppies can adopt some distinctive and cute postures. Adult dogs can take this "flying frog" pose with their legs splayed behind them, but it is more commonly seen in puppies, such as this seven-week-old Australian Shepherd.

DEVELOPMENT OF NEWBORN PUPPY TO ONE YEAR (ADULT)

Puppies undergo changes as they age, starting off as pudgy, bean-like creatures and growing into muscular and distinctive adults of various shapes and sizes. Here we look at some of the basic changes through various stages of a puppy's growth.

NEWBORN TO FOUR WEEKS

For a few weeks after birth, puppies begin to go from looking like rounded jelly beans with legs to something a little more identifiable as puppies. When born, their eyes are shut and don't open until they are between a week and two weeks of age.

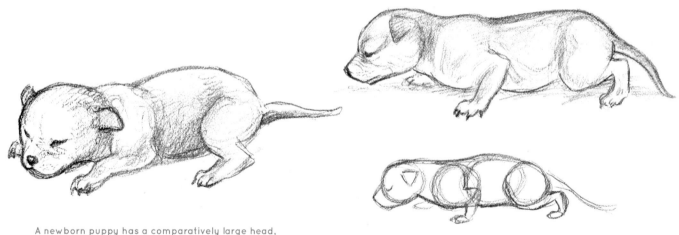

A newborn puppy has a comparatively large head, tiny ears, and small legs and toes. The eyes are closed. It can only crawl.

This Rhodesian Ridgeback puppy is starting to be a little more formed than the newborn. It's beginning to try to move around more by pushing its legs and feet, though it can't stand yet. Notice that the circles blocking in the chest, belly, and hips are all pretty even. The head is comparatively large and the body is still streamlined. The legs are weak and small.

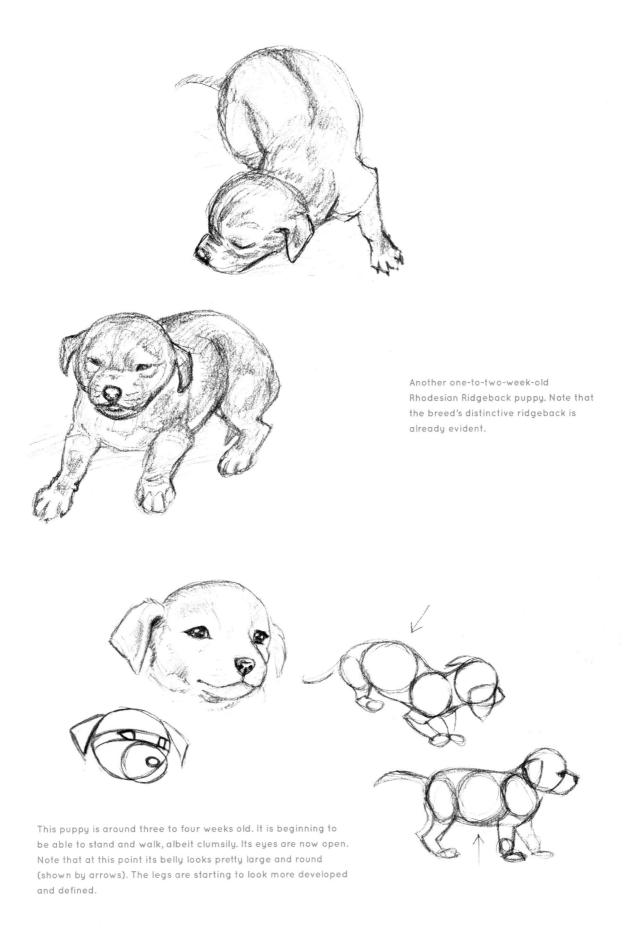

Another one-to-two-week-old
Rhodesian Ridgeback puppy. Note that
the breed's distinctive ridgeback is
already evident.

This puppy is around three to four weeks old. It is beginning to
be able to stand and walk, albeit clumsily. Its eyes are now open.
Note that at this point its belly looks pretty large and round
(shown by arrows). The legs are starting to look more developed
and defined.

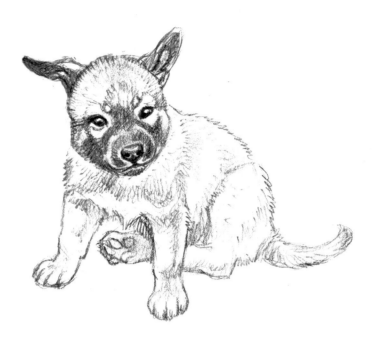

This five-week-old Belgian Malinois puppy is starting to show more of the adult dog he will become. He's not quite there yet and is still round in both face and body. His paws are starting to grow big. Larger breeds often have what seem to be oversized paws until they grow up and grow into those feet. Note also how his ears are slightly floppy. Many dogs with erect or semi-erect ears will start out somewhat floppy-eared. As they grow their ears firm up and eventually get to their final shape.

This seven-week-old Australian Shepherd puppy is starting to grow good, strong legs and can stand without looking like she'll topple over any moment. The legs are still short, though, and the face and body still have the rounded baby look.

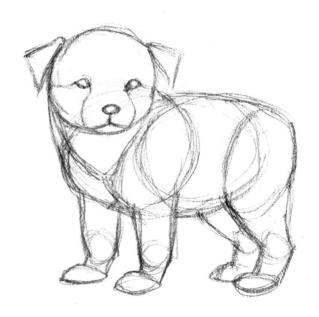

This longhair Dachshund puppy is still very young and pudgy in appearance at eight weeks old. The head looks large compared to the body. Note how rounded the head and muzzle are and how the muzzle isn't as distinct as it will be later in life.

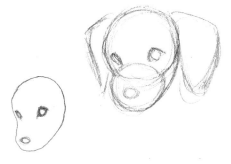

Right now the head and muzzle almost create a bean shape.

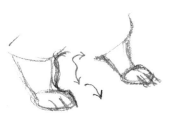

The eyes are slightly unfocused-looking, the pupils almost but not quite aligned.

The legs are very short, straight (except for the wrist joint), and not muscular. Instead they appear soft and somewhat awkward in their splayed stance.

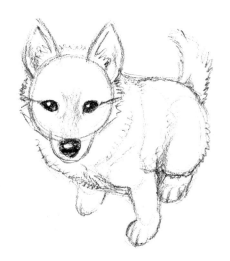

This nine-week-old Siberian Husky puppy looks up with an alert expression on his face. At this age puppies are quite energetic and eager to explore. Note that the face is getting thinner. As puppies grow older some begin to thin out slightly, looking quite gangly and long-legged in adolescence before finally hitting standard proportions as an adult.

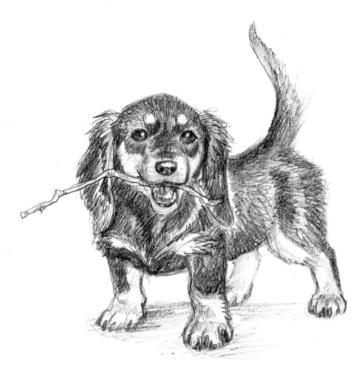

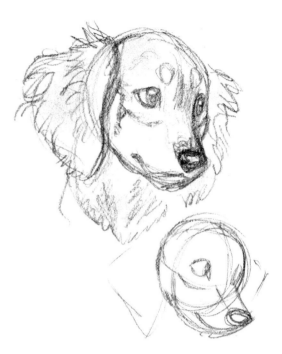

At twelve weeks old, this Dachshund puppy still shows most of the signs of puppyhood but is becoming stronger and surer than it was at eight weeks old. Note how the puppy can stand on its feet and its appearance and attitude is more confident. It carries its tail high. However, there is still a certain awkwardness to it. The legs show more definition but the knobby joints of the legs are very apparent. The head is still comparatively large to the body but not quite as exaggerated as before.

On this puppy's head, note that the muzzle is still large compared to the rest of the head but the features are beginning to be sharper and more defined. The eyes have a more focused look.

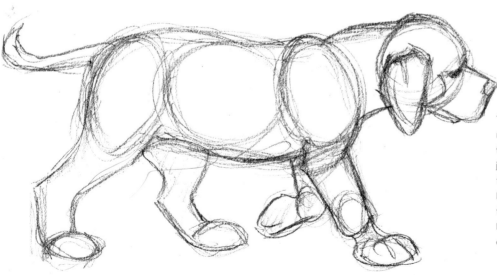

This American Mastiff is about three months old. Note how at this stage, this pup is getting very leggy. The joints in his legs are knobby and his feet and ears are comparatively large. He'll eventually grow into those feet but right now they look big. The body is starting to lengthen but the chest isn't as deep as it will get.

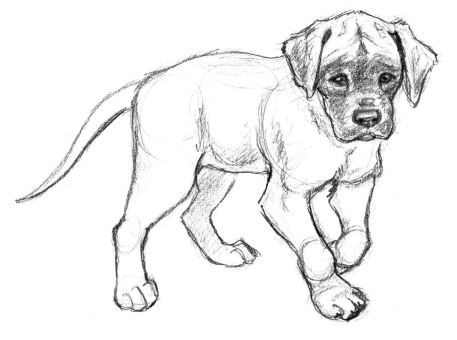

This is the same American Mastiff puppy, also at three months old. Again note how his body and legs are lengthening but the head, ears, and feet seem oversized.

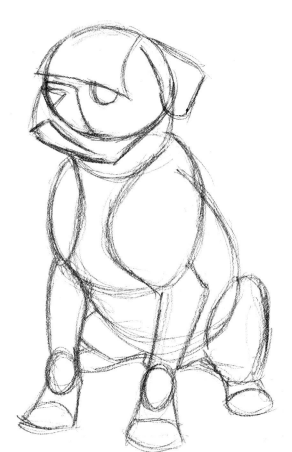

This four-month-old Pug is starting to get more adult proportions but still has the comparatively large head and gangly legs. Here I show some of the basic shapes of the puppy.

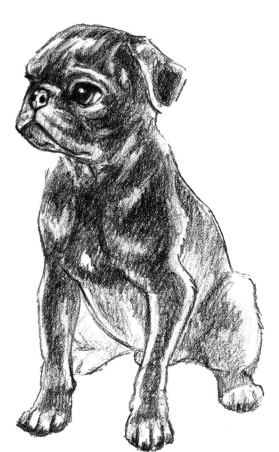

The finished drawing of the four-month-old Pug.

SIX MONTHS TO ADULT

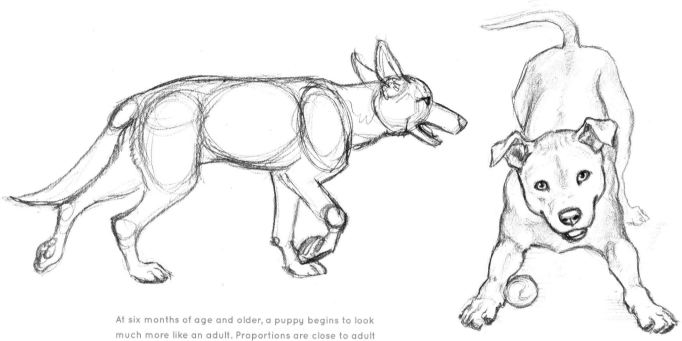

At six months of age and older, a puppy begins to look much more like an adult. Proportions are close to adult shapes and sizes. Note how the chest on this German Shepherd has started to deepen and the dog looks more muscular. However, legs are still long, joints pronounced, and feet and ears look big. A six-month-old often still has a leaner, lankier look to it. Even its fur may look thin. By the time it is a year old, its body will have thickened some, fur will begin to fill out completely, and muscles become fully developed. Dogs reach true mental and physical maturity at about two or three years of age, depending on breed.

This Staffordshire mix is about six months old and full of energy. Dogs at this age are like teenagers and need a lot of exercise.

At six months of age, note how this Dachshund's head is much smaller in proportion to its body than younger puppies. The proportions overall are beginning to look more adult. However, there is still a certain awkwardness to the pup. Its ears and paws are still a little large comparatively. The wrist joints are still knobby and prominent. This particular Dachshund has a silver dapple shorthair coat.

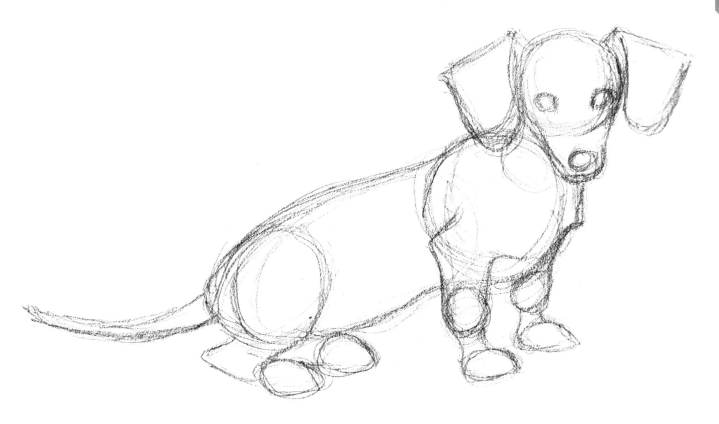

Here's my initial drawing of the six-month-old Dachshund. Note how some of the curves of the body (such as the bulge in the tummy) are soft and rounded, not sharp and angular.

Here is an adult wirehaired Dachshund. Note how the head and body have the normal proportions of adulthood, and the body is more angular and muscular than the younger dogs.

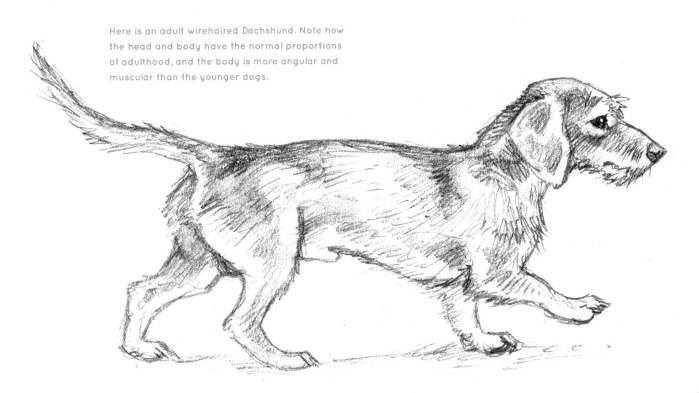

DRAWING AN AMERICAN BULLDOG PUPPY, THREE MONTHS OLD

1 Draw a circle for the head and draw a cross-shaped mark dividing it into four equal quadrants. Add a circle for the muzzle and the eyes along the head's center horizontal line, making sure that the outside edges of the muzzle line up with the outer corners of the eyes (see dotted lines). Add triangles for the ears. In this case one ear (on the left in the drawing) is perked up above the other ear, the lower tip of that ear lining up with the eyes. Add a slightly larger circle for the chest. Add some lines to measure the distance from the top of the head to the bottom of the muzzle, then block out an equal distance from the bottom of the muzzle to lower down on the body. The puppy's wrists will go here. Also measure the distance from the top of the head to the bottom of the chest, then mark one equal measurement below.

2 Connect the triangles of the ears to the head. Add small folds to the middle of the ears. Add the nose and mouth, connecting just below the main circle of the head. Draw a horseshoe shape that overlaps the chest. This will be the inside of the legs. Add pronounced circles for the wrists at the bottom. Then add slightly larger ovals a little below those. These will be the feet. Make sure each foot is a little less wide than the muzzle. Note how the inside edges of the wrist and paw's shapes line up vertically (see inside arrows). The outside, however, slants a little bit outward. The large wrists and awkward stance add to the gangly look of a puppy's legs.

3 At this point, add the outside of the legs and connect the paws with the wrists. Add toes. The paws are pointed slightly outward, so don't divide the foot with equal spaces between the toes. Draw the middle vertical line just a bit toward the outside of the foot. The space between the outside two toes should be a little smaller than the space between the inside two toes. Erase any extra lines you might have added around the legs and feet. Add the hind legs and tail. Draw the lower jaw slightly above the circle of the muzzle so that the upper lip, or flews, hangs a bit below the jaw. Add patches of color along the ear, shoulder, and leg.

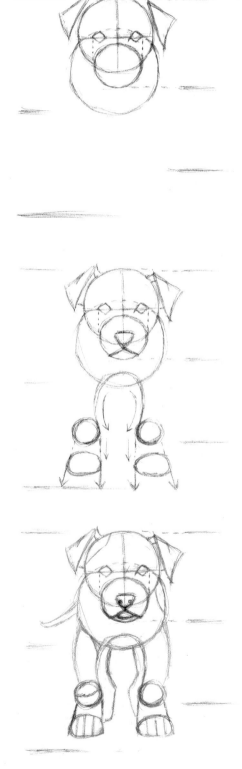

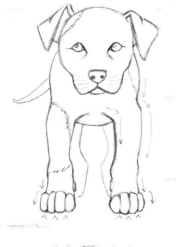

4 I went back and erased all the unneeded lines from the previous drawing, adding and further defining the finished outlines instead. When going over the legs, I kept the inside outline fairly straight but gave a slight curve to the outside outline, including having the elbows jut out a little. I made sure the wrists were knobby and added dewclaws just above the paws. While drawing the toes I indented a small V-shaped area between each toe on top and bottom. I drew the outside toe jutting out from the overall oval shape of the foot somewhat to indicate how the foot is splayed outward. Add nostrils and lines indicating the whiskers. Add highlights in the eyes as well as barely visible whites of the eyes on the inner corner, showing this pup's still slightly unfocused look.

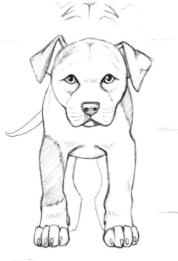

5 Lightly shade in the patches of color. Draw and shade in the pupils of the eyes and shade in the nose, leaving a light area on top. Add a dark patch of color between the nose and lips on one side and a patch on one side of the lower jaw. Add toenails. Using short, light strokes to suggest wrinkles on the top of the head (the basic pattern is simplified above the head in the drawing). Use those same short strokes to shade in areas under the bone ridges under the eyes, and the indentations between the forehead and top of the muzzle, and at the shoulders, wrists, and tendons on the legs.

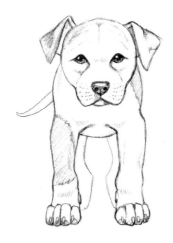

6 Almost there! Shade in the eyes, leaving the pupils just a tiny bit darker than the rest of the eyes. Leave the whites of the eyes lighter than the rest, just make sure they're small. I darkened the eyes below the top eyelid to the same shade of the pupil to indicate shadow. Further define shading and details on the ears and nose. Add dots for the whisker follicles, erasing the whisker row lines a little here and there. Add the paw pads and a little more shading showing the tendons and muscles in the legs. Now you have an American Bulldog puppy at three months.

DRAWING AN AUSTRALIAN SHEPHERD PUPPY

1 Here's a preliminary sketch of an eight-week-old Australian Shepherd puppy. I did this before anything else to block in the basic shapes and proportions before I started the step-by-step breakdown.

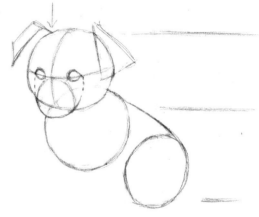

2 To begin, draw a circle for the head and add horizontal and vertical lines to create a plus-shaped mark on the head. Contour those lines to make them more three-dimensional in appearance. Add triangular ears on top and oval-shaped eyes along the horizontal line in the center. Draw a circle for the muzzle, using the outside corners of the eyes to help get the right width (as shown by the dotted lines). Once the head is blocked in, add an equal-sized circle for the chest. The front of that chest should line up about with the inside corner of the puppy's right ear (as shown with an arrow). Add an oval for the hindquarters and connect the chest and hindquarters with a line to indicate the back. Note that the distance from the top of the head circle to its bottom and the distance from the bottom of the head to the bottom of the hindquarters are almost the same (as shown with the horizontal lines on the right of the drawing). In other words, the puppy is about two head lengths tall.

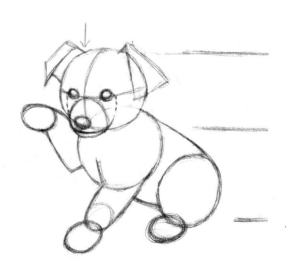

3 Now add the front legs, using ovals for the feet. Block in the wrist if that helps. Note that the arrow pointing where the top of the right ear connects to the head aligns with the raised arm's armpit. Draw the nose, mouth, and add smaller ovals in the eyes, which will be the pupils as the puppy looks up. Connect the base of the ears, showing where they attach to the head. Add a hind paw and the belly.

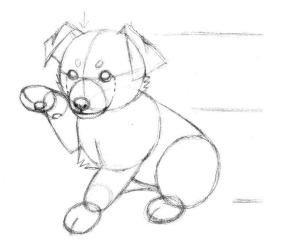

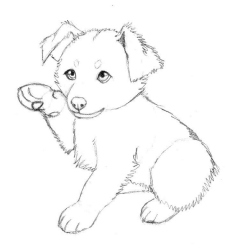

4 Add more details, including the small "eyespots" of color above the puppy's eyes, his nostrils, and the split in the upper lip, and crease in the nose. Add the creases in the ears and some indication of the fur ruff around the head and chest. Draw the middle toes and paw pads on each paw, where visible. Draw a circle where the right front leg's wrist is and add a small oval on the bottom for the pad that is there. Add the far hind leg.

5 At this point I started erasing the guidelines and cleaning up the drawing a bit. I added the final outlines. This can be done traditionally or, if you are working digitally, on top of the drawing with a new layer. I also added the rest of the toes and the dewclaw on the front paw that is lifted up. Add pupils and highlights in the eyes.

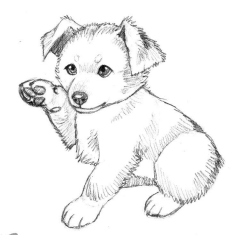

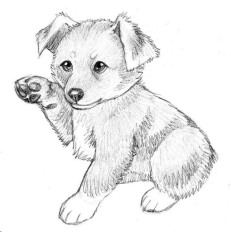

6 Begin shading in the puppy's body. Draw the rest of the paw pads and shade those in without getting too dark. Shade inside and on top of the ears, the irises of the eyes, the nose (leaving a highlight), and along the muzzle, head, legs, and body.

7 Finish the drawing by continuing to shade the body, very lightly this time, leaving the previously shaded areas as the main shadows. I used a finger to blend the fur to make it seem a bit softer, then went back over that to again define details I wanted to keep. I shaded the top of the eyeballs even more to give the impression of a cast shadow from the upper eyelid. I left a small, faint second highlight in the eye closest to the viewer. Continue to shade and add fur details as desired.

DRAWING A RECUMBENT
LABRADOR RETRIEVER PUPPY

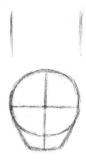

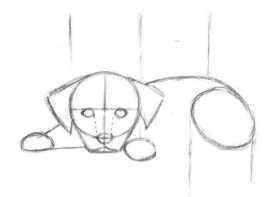

1 To draw a two-month-old Labrador Retriever puppy that is lying down, start by drawing a circle for the head and drawing a plus sign in the center to divide it into four equal parts. Add a blocky shape underneath for the muzzle, making sure the base is wider than the bottom. The muzzle should not extend very far from the bottom of the head circle. Leave room on the right for the body. Measure one more head width to the right to help blocking the body in next.

2 Now add nose and mouth, centering the nose on the bottom of the head circle. Use the top of the head to slope down onto the tops of the ears. Add the almond-shaped eyes just below the center horizontal line of the head. The dotted lines show how the eyes are set just slightly wider than the nose. Once this is done, add the paws and the further front leg. Add the back and hind leg, making sure the highest point on the back is right about where the second head-length measurement line is on the right. The oval shape for the hind leg is about the same width as the head.

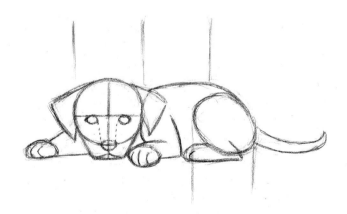

3 Add the rest of the body, including the hind foot. Note how the toes of the hind foot protrude slightly in front of the bent knee. I swept a line up from the heel to indicate the fold in the hind leg. Add the tail. In the chest area, add the front leg. Also add the toes on each visible paw. The left front paw is slanted slightly toward the viewer, so the curves of the toes aren't quite as round-looking as the toes on the paws that face more to the side.

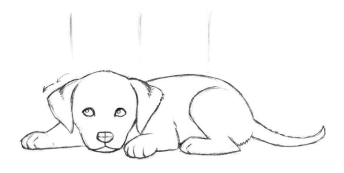

4 At this point lightly erase the guidelines and draw in the final outlines. You can keep the guidelines inside the nose for future reference. Add small circles for the highlights in the eyes. Note how the ears have a subtle crease to them.

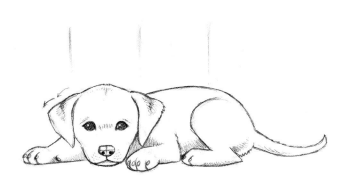

5 Begin shading in more details, like short, dense strokes to indicate slightly shadowed fur on the belly, legs, tail, and chest. Draw thin ovals for the toenails and add a dewclaw to the right front leg. Add nostrils on the nose and shade in the eyes and the creases of the ears. Draw some light, short lines to indicate the bridge of the nose between the eyes and some fur on top of the head. Add a few lines to indicate eyelids for a softer expression and add whisker rows.

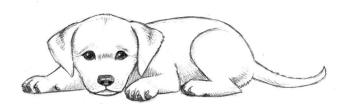

6 Finish the drawing by adding a bit more fur and shading. I added a little more definition from the outside corner of the eyes to the "cheeks." Add paw pads, which are basically thin ovals pointed down vertically under the toenails that widen slightly as they reach bottom. I also shaded the eyes in again, making them just a tiny bit darker where the pupils are. Shade in the nose, erasing the guidelines if needed and leaving a highlight just above the horizontal guideline that was inside.

Chapter Three

HERDING GROUP

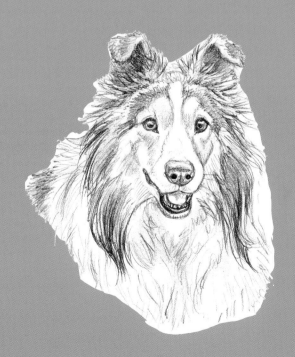

The Herding Group consists of dogs bred to herd live-stock. They tend to be highly intelligent and trainable and often naturally possess a herding instinct.

AUSTRALIAN CATTLE DOG

Also known as the Queensland Heeler or Blue Heeler, this breed hails from the Land Down Under, as its name implies. This sturdy and compact dog has limitless energy and its drive, tenacity, and stubbornness aid it as it nips the heels of cattle.

The Australian Cattle Dog has a roan coloration with mottled blue or red ticking and coloration, sometimes with tan accents. It often features a dark, solid mask over one or both eyes, a white tip to the tail, a light stripe between the eyes, and may have a few solid patches on its coat.

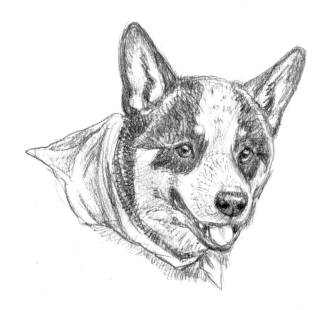

The Australian Cattle Dog has a broad skull with oval eyes and small pricked ears.

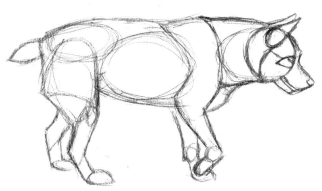

This breed has a low-set tail with a slight curve to it and round feet. The body is somewhat rectangular and stocky, but not sluggish. Here I've blocked in some of the basic shapes.

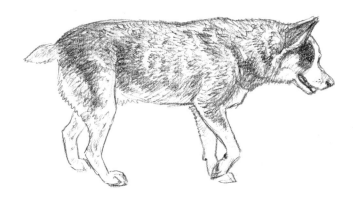

The finished drawing.

AUSTRALIAN SHEPHERD

Despite the name, this breed is actually all-American. It is believed that the dog's origins lie with the Basque shepherds who traveled from Australia to the United States, bringing their dogs with them. The rougher terrain of both countries demanded an energetic working breed that is both intelligent and hardy.

The Australian Shepherd has a medium-length, weather-resistant, double-layered coat. Typically, the Aussie may be: tricolor with black, white, and tan, or it may be black or red with tan points and white areas. Then there's the red or blue merle coloration (see page 39 for a merle Australian Shepherd), which features a lighter red or blue background, a white throat and possibly a white streak between the eyes and white areas on the legs, and patches of black (on a blue merle) or brown (on a red merle).

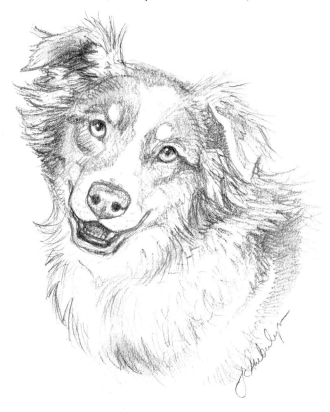

The Australian Shepherd can have amber, brown, or distinctive blue (or blue-flecked) eyes. It has triangular, high-set ears that perk up when alert.

The Aussie has a straight, level back and somewhat rectangular appearance. The tail is cropped or naturally bobbed.

BELGIAN MALINOIS

Originating in Belgium, this herding breed is often used for police and security work. This dog is intelligent and intense, with an aloof attitude toward strangers and a strong will. It's not a breed for beginners but is a loyal and hard-working companion.

The Belgian Malinois has a fawn or mahogany base color and short hair with black tips. Its muzzle and ears are black. There are solid black Malinois dogs but it is not considered a standard breed color by the AKC.

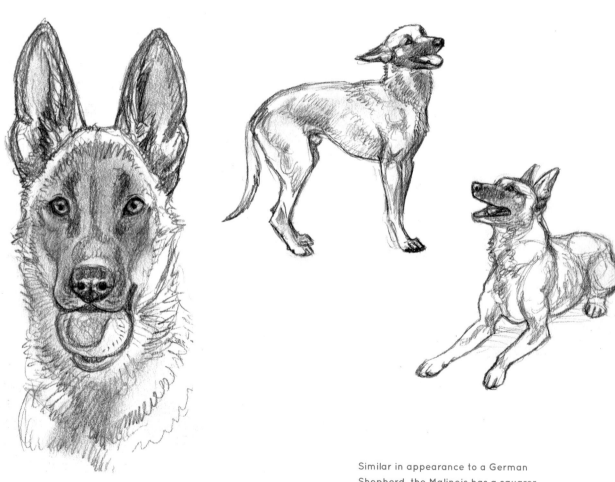

This breed has a flat skull and almond-shaped eyes. The ears are erect and point upward.

Similar in appearance to a German Shepherd, the Malinois has a squarer build. Its back is level, not sloping, and it is a somewhat lighter, smaller dog.

BORDER COLLIE

The distinctive black and white Border Collie originated in Great Britain in the borderlands area of England and Scotland. This highly intelligent and energetic dog is a skillful sheep herder as well as an extremely trainable and athletic companion for dog sports like flyball and agility. It needs plenty of exercise and prefers to stay close to its owner. This is a dog that needs a job to do.

The coat of the Border Collie is soft and usually medium in length, though there are short-haired Border Collies known for having smooth coats. It is best known for black coloration with a white stripe up between its eyes, and white on its muzzle, around its neck, on its belly and/or legs, and the tip of its tail. However, Border Collies may be a variety of other colors, such as tricolor, liver and white, solid colors, other more rare colors and patterns such as lilac or brindle, or come in a merle coloration. Merle dogs may have blue eyes.

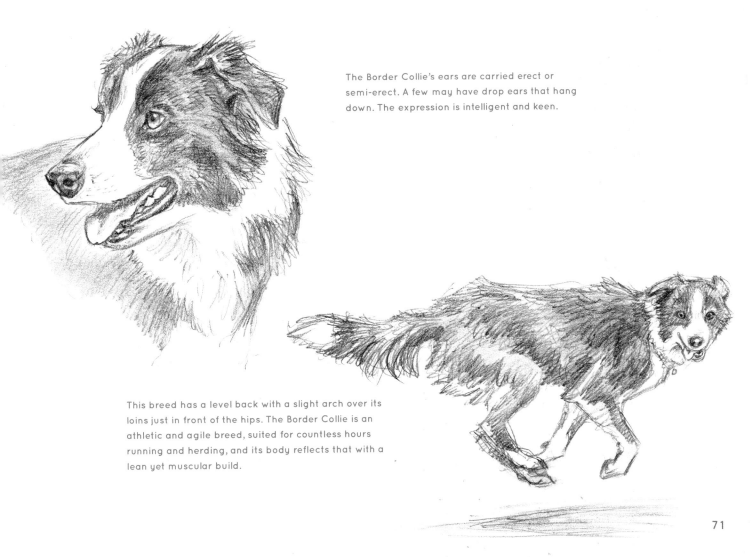

The Border Collie's ears are carried erect or semi-erect. A few may have drop ears that hang down. The expression is intelligent and keen.

This breed has a level back with a slight arch over its loins just in front of the hips. The Border Collie is an athletic and agile breed, suited for countless hours running and herding, and its body reflects that with a lean yet muscular build.

DRAWING A RUNNING BORDER COLLIE

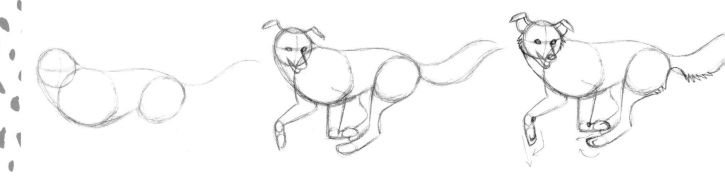

1 Draw circles for the head, chest, and hips. The head is jutting forward and overlaps the chest circle a little. Draw a line for the back connecting the head, chest, and hips and continue behind for the top of the tail. Add one arcing sweep of a line connecting the head, chest, and belly below the figure. Draw a plus shape that divides the head into four equal parts, curving the vertical line slightly and turning it to the right side slightly.

2 Add the legs, including small circles to indicate the wrists and front paws on the front legs and circles to indicate the paws on the hind legs. Complete the tail. Add the inner and top part of the ears, using an upside-down arc to connect the closer sides if you wish. Draw the ear tips, which are flopped slightly down. Draw the muzzle, eyes, and mouth.

3 Draw the rest of the ears, including the outside edges and an inside rim. Draw the nose and chin, connecting to the bottom of the head circle. Define the eyes more, including tear ducts. Add a ruff of fur on the cheeks and rear, and add some long strands to the tail, making the base a little thinner-looking. Draw the pads on the back of the wrists and the toes. I made the tops of the toes rather flat and curved the bottom, as shown by the arrows.

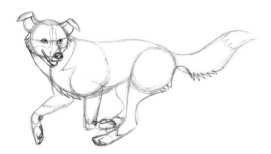

4 Add pupils and highlights in the eyes and nostrils in the nose. Define the mouth, including a hint of the canine tooth on the lower jaw. The tongue will pinch up in an upside-down V shape where the canine tooth pushes it up. Draw some more shaggy fur along the chest and add the white neck ruff and chest markings. Note how the shoulder markings sweep up along the shoulder from the closest front leg. Add the white tip to the tail and white markings on the feet. Draw the paw pads on each toe using an oval that narrows just a little toward the claws. Draw the white of the muzzle along the cheeks and the stripe that goes up between the eyes.

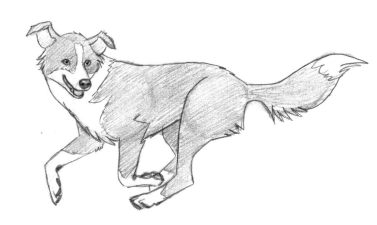

5 Finish the drawing by lightly erasing the guidelines, and draw the final outlines. Shade the black areas of the body as well as the pupils and nose, leaving highlights.

CANAAN DOG

The Canaan Dog is an ancient breed originating in what is now Israel and adapted to harsh conditions. The breed was largely feral for a long time until Dr. Rudolphina Menzel bred and trained several individuals as service dogs in the 1930s. These intelligent and adaptable dogs are highly trainable. They are aloof toward strangers and make excellent watchdogs.

The Canaan Dog has a double coat, the top layer harsh and straight and the undercoat dense. It comes in a range of colors, from white or black to solid colors like red and cream, sometimes with small white markings or white with color patches.

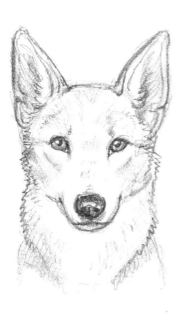

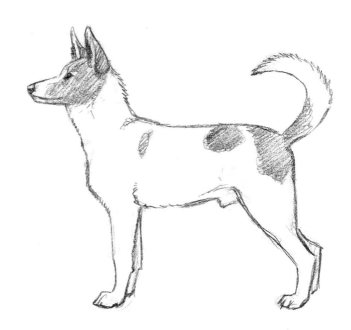

The Canaan Dog has almond-shaped eyes, erect and low-set ears, and a wedge-shaped head.

This ancient breed has strength, agility, and endurance, and its body is generally square-proportioned. It has a level back line with a slight arch to its loins (in front of the hips). The tail curls up, sometimes over its back.

COLLIE

The Collie comes in two coats: rough-coated (long) and smooth (short-haired). It originated in Scotland as a sheep herding dog. "Lassie" made this breed famous and endeared it to many who love its gentle and devoted nature.

Note that the Rough-Coated Collie and the Smooth Collie are the same breed with different coats. The Rough Collie has long, straight, and plush hair, whereas the Smooth Collie has a short, flat, and hard coat. Both have an undercoat. They may be sable and white, mostly white, merle, or tricolor.

Here are some of the basic shapes that comprise a Collie's head.

The finished drawing of a Smooth Collie. Collies have a distinctive flat skull and small ears that are held semi-erect with the tips pointing forward. The eyes are almond-shaped and have an alert, sweet, and intelligent look to them.

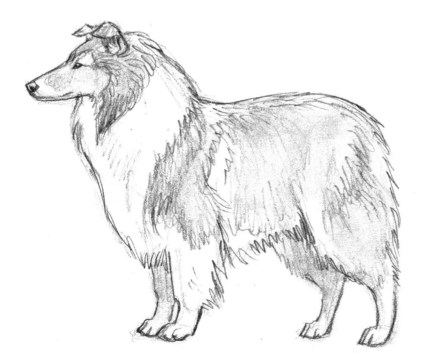

The Collie's body is slightly longer than tall, with small oval feet. The chest is deep and the back is level. Its tail hangs low.

CORGI

There are two kinds of corgi—the Cardigan Welsh Corgi and the Pembroke Welsh Corgi—and each is considered a separate breed. Both breeds originated in Wales where it is believed they were developed separately. The most obvious difference between the two is that the Cardigan has a tail and the Pembroke does not. More subtle differences include the fact that the Pembroke is usually more outgoing while the Cardigan more reserved with strangers. The Cardigan is slightly larger and heavier than the Pembroke and has somewhat more rounded ear tips.

CARDIGAN WELSH CORGI

This short-legged dog has long helped people in the home, on the hunt, and then as a driver of livestock. It can tirelessly nip at livestock's heels or be a fun-loving and loyal family companion.

Cardigans come in various colors, ranging from red, sable, and brindle to blue merle or black with tan and/or white markings.

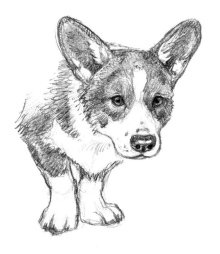

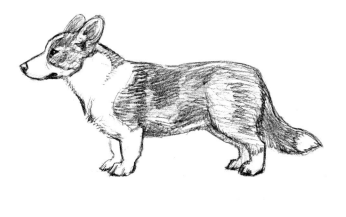

The Cardigan has medium to large eyes, a moderately flat skull, and large, erect ears that are rounded at the tip.

The back of the Cardigan is level, its chest is deep, and its tail is carried low. Feet are large and round and point slightly outward.

PEMBROKE WELSH CORGI

Like the Cardigan Welsh Corgi, the Pembroke was developed to assist the families of farmers, herding livestock and providing other assistance. Active and alert, the Pembroke enjoys attention.

The Pembroke Welsh Corgi comes in fawn, red, sable, or black and tan with or without white markings on the face, neck, underside, and feet.

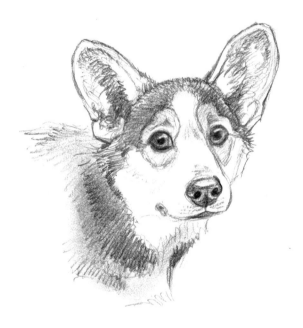

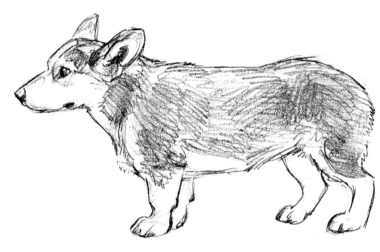

The Pembroke has a docked tail, which may be cropped or naturally occurring. The forearms turn slightly inward.

The Pembroke has a foxy face with medium-sized and oval eyes.

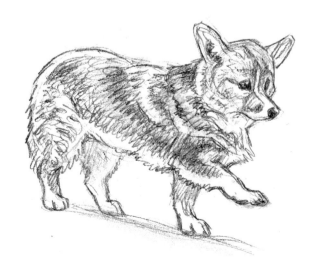

Here's a Pembroke Welsh Corgi stepping down an incline.

DRAWING A SITTING PEMBROKE CORGI

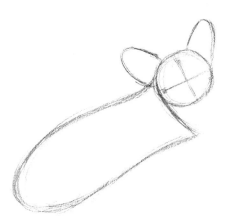

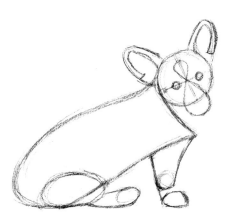

1 I used a more stylized approach on this corgi. Sometimes you see shapes in a figure that you can use to help you visualize it better. In this case the shoulder and chest created a swath of fur sweeping forward and I used it to help me draw the figure. Add a plus shape on the head circle to divide it into four equal quadrants.

2 Add eyes, using the horizontal dividing line on the head for placement. Add a bottom-heavy figure eight shape to create the muzzle below the eyes and the forehead stripe between the eyes. Add rims to the ears, stopping on the outside where the ear pockets are. Add the basic shapes of the legs. The pointy part of the chest should sweep down into the front leg.

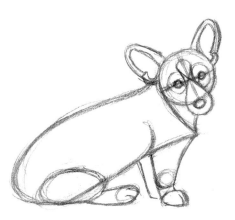

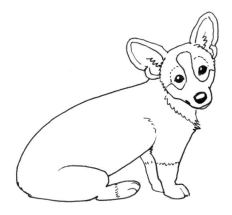

3 Add the nose and tear ducts. Widen the stripe between the eyes and add circular shapes around the eyes where the light tan is on the face. Finish the rims around the ears, letting the outside bottom rim arc out slightly. Complete the front leg and add toes to both front and hind paw. Add the far front leg. Add the neck, attaching it from chest to under the nose. Add the crease of the elbow against the ribs as an arcing line.

4 Finish the drawing by inking in the final lines and erasing the guidelines. I added a small squiggle inside the ears to indicate the crease leading to the ear canal. I also added lines to indicate white paws, neck, and cheeks. I shaded the nose, leaving a highlight on top, and added the mouth.

GERMAN SHEPHERD

Also known as the Alsatian, this dog is exceptionally intelligent and hard working. This breed originated in relatively recent times (the 1800s) for work as a herder, a police dog, and in search and rescue, and other tasks. It has found a place as one of the most popular dog breeds due to traits like its versatility, protective nature, and obedience. The German Shepherd is aloof toward strangers and is strong willed, requiring training and exercise to fulfill its potential.

The German Shepherd comes in various colors, the most common being tan or red with a black saddle and facial markings. A few German Shepherds are white, though that color is not officially recognized by the AKC. Its coat has a double layer and can come in medium length or a longer length, which is rarer.

This dog is longer than it is tall and has a somewhat bushy tail that hangs down with a slight curve. Looking at the back top line, the hips slope down from the shoulders. Some show dogs have especially pronounced sloping hips.

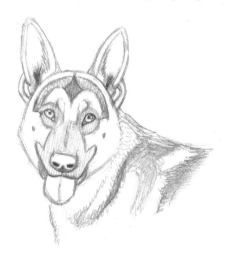

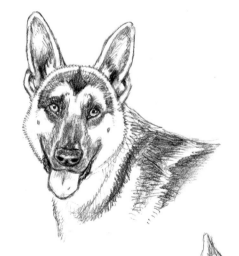

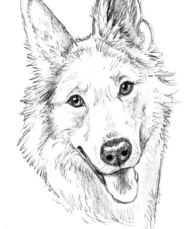

A stylized look at the head of a German Shepherd. Note the darker markings that form a circular shape above the eyebrows but don't quite make it up to the ears. There's an almost diamond-shaped dark mark on the center of the forehead. The dark markings extend around the eyes and the muzzle. There is also often a small dark spot on the dog's cheek where some whiskers grow. Note how the line of the dog's mouth points up to the cheek spot. Aligned with that, above the cheek spot, is the outside border of the dark forehead patch.

The finished drawing of a German Shepherd's head.

This German Shepherd is white in color, so it doesn't have the facial markings. The intelligent expression remains the same, as do those long, erect ears.

DRAWING A GERMAN SHEPHERD, SIDE VIEW

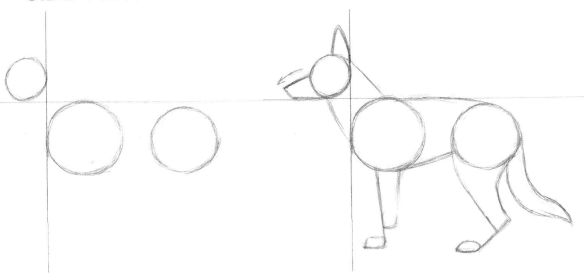

1 On the left side of the paper or computer screen, draw one horizontal and one vertical line that intersect. Draw a small circle for the head to the top left of the intersection, touching both lines, and a larger one for the chest at the bottom right of it. It should also touch both lines. A short distance to the right place a circle for the hips that is smaller than the chest but bigger than the head. The top of the circle should be a little lower than the horizontal line.

2 Add the rest of the dog's body. Connect the head, chest, and hips with a top line for the back and a bottom line for the belly. Keep the chest deep and tuck the belly in slightly. Continue the back line behind the body for the tail, which hangs down, then sweep the line back up for the bottom of the tail. Keep the tail somewhat bushy but not too much. Add the ear using the vertical line to position the back part of it. Use the horizontal line to help place the jaw and finish the rest of the muzzle. Note how the top of the muzzle is slightly Roman nosed, or has an arch to it. Finally, add the legs. For the front leg, angle the front of the leg slightly back as you draw the line down to where the foot will be. Then draw the foot in front of this line. Add the rest of the wrist and leg behind the front. For the hind leg, draw a curved line for the sweep of the leg, both front and back, meeting the heel. Then draw the back of the hind foot ending with the hind paw.

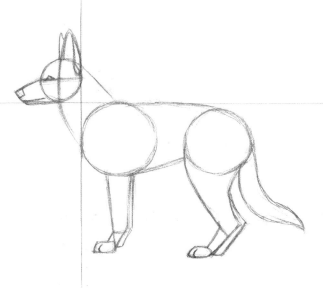

3 Add a vertical line extending from the front of the ear to the throat, dividing the head in half. Then add a horizontal line reaching from the top of the muzzle to the back of the head, dividing the head into four roughly equal parts. Use the horizontal line to place the eye and the base of the ear. Add the other ear, nose, and mouth. Flesh out the rest of the legs, filling in the wrists as well as adding the front of the hind foot. Add toes and the farther legs.

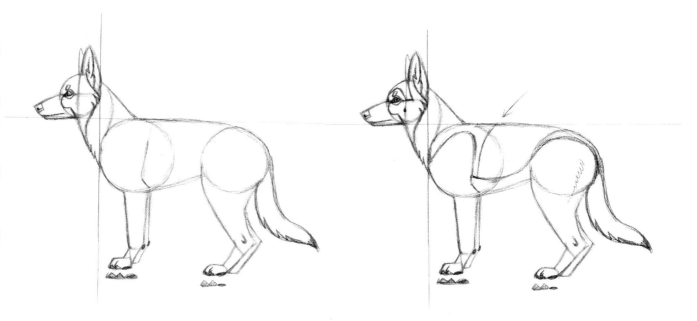

4 Begin adding more details, including a ruff of fur that sweeps down from inside the ears, down the cheek, then across the neck into the throat. Add the ear pocket on the side of the ear closest to the viewer. Add nostrils on the nose and begin blocking in markings on the face. Add the dark patch around the eyes and the eyebrow spots. Define the black of the muzzle by sweeping a line down from the tear duct in a C shape, dropping down at the corner of the mouth. Add some shaggy fur under the tail. Draw pads on the back of the wrist joints and the toes. Note that the paw pads form a series of shapes that look a bit like a letter M followed by a half oval. Draw the hollow area of the heel and the elbows and back of the shoulders coming up from the back of the front leg.

5 Continue drawing the basic markings. Add the patch of darker hair on the dog's forehead, using the horizontal dividing line for the bottom edge. Place a dark spot behind the cheek along the vertical dividing line. Block in the large black "saddle" on the dog's back, starting from the neck (leaving a small light area along the throat) and sweeping back over the shoulder. Connect with the line you drew earlier to indicate the back of the shoulders. Draw the saddle to cover most of the back, sweeping over the hips and to the tail. Then add another line angling from the bottom part of the saddle up toward the back, just behind the shoulder (as shown by the arrow). Add a small crease of fur in the rump where some major muscles are located and the color happens to change slightly. Add the pupils and highlights to the eyes.

6 Finish the drawing by lightly erasing the unnecessary guidelines and rendering the final lines. Use the line behind the shoulder to indicate a patch of longer, darker guard hairs. Shade in the black areas of the head, back, and tail.

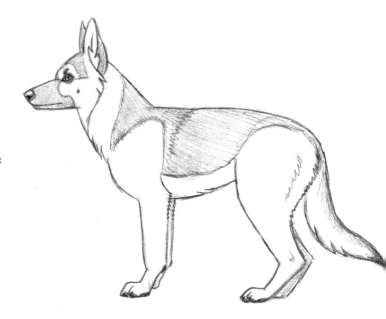

SHETLAND SHEEPDOG

The Shetland Sheepdog, or Sheltie, originates from the Shetland Islands in Scotland, where smaller herding dogs were needed for proportionately smaller sheep as well as ponies and chickens. A popular pet breed now, the Sheltie is sensitive, devoted, and quick to learn.

This breed has a double coat consisting of a short dense undercoat and a long, straight, and harsh outer coat. The fur is abundant and is mane-like around the neck. Shelties come in sable and white, merle, and black, marked with varying amounts of black and tan.

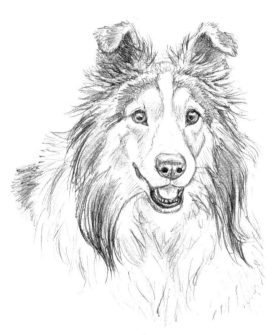

The Shetland Sheepdog has almond-shaped eyes and a distinctive long, narrow, somewhat flat head. Show dog's ears are carried erect with the top fourth tipping forward, though many pet dogs naturally have completely erect prick ears.

Here's a look at some of the basic shapes that comprise a Sheltie's head. Some Shelties have ears that perk all the way up, like this one.

The body of a Sheltie is sturdy but athletic and capable of working long hours. Its tail is carried low.

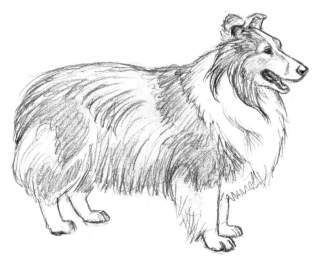

Chapter Four

HOUND GROUP

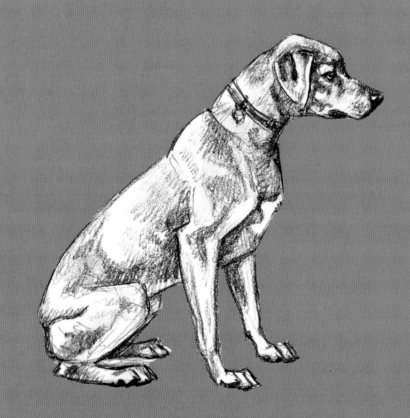

Hounds were bred to tirelessly pursue game over or under the ground. They tend to possess great stamina and a keen sense of smell.

AFGHAN HOUND

The Afghan Hound is an ancient breed that was developed in Afghanistan for the pursuit of hares and gazelles. It needs daily exercise and has a long, luxurious coat that requires regular brushing and grooming. It is aloof and reserved with strangers, but can display a playful side.

All colors are permissible in the breed standard except spotted.

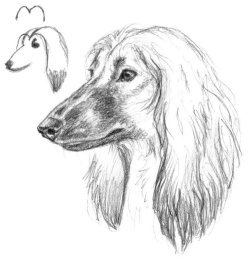

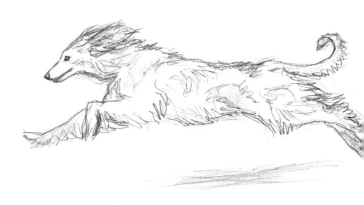

The Afghan Hound's head has a barely perceptible stop, the top line of the muzzle flowing fairly smoothly into the rest of the head. The top of the muzzle has a slight arch to it, giving it a bit of a "Roman nose" appearance.

Its eyes are dark and ears are long. Some dogs, such as this one, have dark ear tips, a dark muzzle, and dark brows above the eyes. Note how the hair parts here with an M shape.

When the Afghan Hound runs its hair flows and billows behind it. Like any coursing hound, it is fast and graceful.

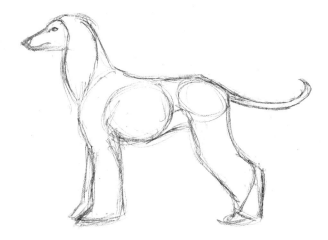

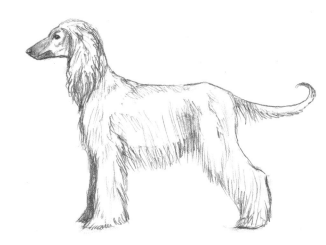

The hair on an Afghan Hound's legs obscures much of its anatomy. It can be helpful to think of it in blocks of shapes like the ones shown, or find shapes that help you visualize the dog.

In the finished drawing, note how the long, silky hair flows almost straight down on its body and the more sparsely haired tail is held with an upward curve ending in a tight curl.

BASENJI

The Basenji is an ancient dog breed developed in Africa for hunting small game. It is feisty and rather catlike in some of its mannerisms. The Basenji is perhaps most famous for being the dog that doesn't bark (much), though it does make sounds and can produce short barks and howls. It is especially known for its "yodel."

The Basenji comes in various colors ranging from red, black, and brindle, to black and tan. It has white feet, chest, and tail tip. It may have a white collar and blaze up its forehead.

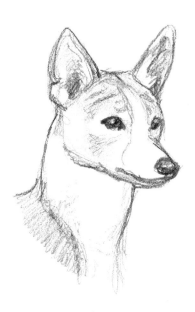

The forehead of a Basenji is wrinkled. Ears are erect and eyes are almond-shaped.

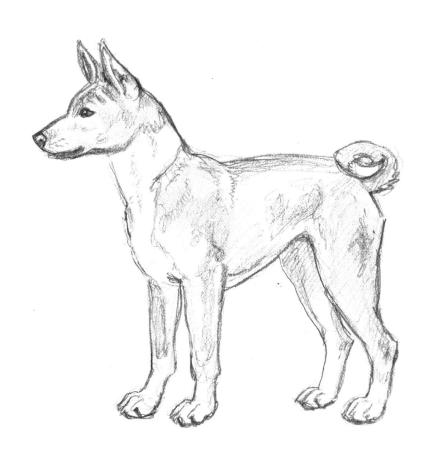

The tail is tightly curled over its back. The Basenji's feet are small and oval and its back is short.

BASSET HOUND

The Basset Hound is a heavy-boned, stocky dog with short legs and long ears that has its origins in France and Great Britain. The skin along its face and neck tends to hang loosely and sometimes gives it a sad appearance. It has a thick neck and fairly short, straight hair with a tricolor black, brown, and white appearance. It is a fairly large breed that may seem smaller because of its short legs.

When drawing a Basset Hound, keep in mind the short legs, long ears and body, and somewhat sad, droopy expression. It moves deliberately but not clumsily. Sociable and good-natured, it is also stubborn.

DRAWING A BASSET HOUND HEAD

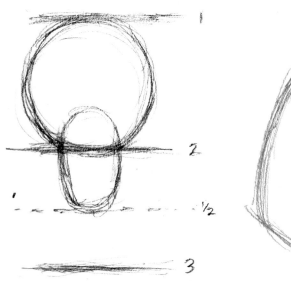
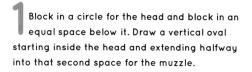
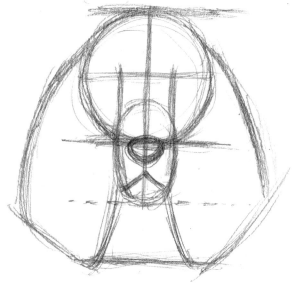

1 Block in a circle for the head and block in an equal space below it. Draw a vertical oval starting inside the head and extending halfway into that second space for the muzzle.

2 Add a plus sign on the head to help you block in proportions, then draw two lines sweeping up on either side of the muzzle (as shown) to help you place the eyes later. Add a nose, mouth, and the ears, which will slope down from the head and end at the bottom line you blocked in earlier, so basically one head length down from the head itself.

 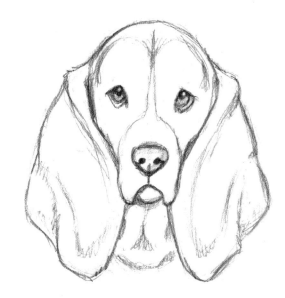

3 Add the eyes, slanting the top and bottom up slightly to give the eyes a sad, droopy look. Add pupils and some baggy skin under the eyeballs. Add nostrils to the nose and define the mouth further, giving the top of the muzzle a more jowly appearance. Add a stripe up from the muzzle along the center of the head. Flesh out the bottom part of the head where the muzzle slopes to join it. Now define the ears, adding some folds where the rims overlap the rest of the skin.

4 At this point I lightly erased most of the pencil lines so that my work area wouldn't be cluttered by unnecessary lines. That done, work on adding the final outlines to the dog's head. Add highlights in the eyes and connect the nostrils to the outside of the nose. Shade the dark eyes in a little and shade the nose if desired. Add some more layering and indications of the short hair on the ears and some of the bony, sleek slope of the dog's forehead. Define the stripe running up from the muzzle to the top of the head. Draw the layered skin of the neck.

The drawing can be finished at this point if you wish.

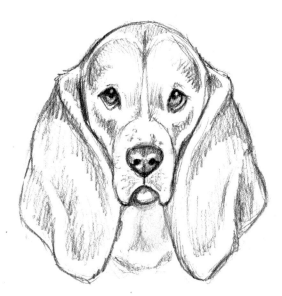 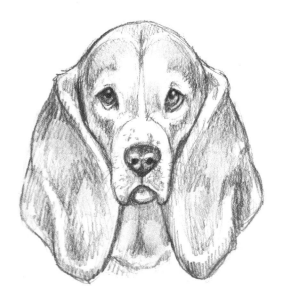

5 To add more depth to the Basset Hound's head, continue using short pencil strokes and shading to further define the glossy, short hair on the dog's head. The ridges above the eyes and under the eye sockets should be defined and the nose can be shaded and highlights added. Fill in the ears with strokes that add shadow to layers and folds.

6 To finish the drawing I kept adding more to the appearance of depth by shading in areas like the cheeks and most of the ears. I smudged the pencil shading in some places to add a softer look, like on the forehead and the ears and then went over that with more pencil lines to suggest fur.

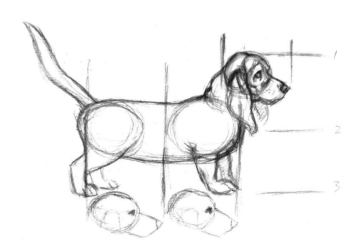

The Basset Hound has baggy skin on its head that gives it a droopy, sad expression. The ears are set low on its head, lining up just under the eye line. The flews, or upper lips, of the Basset hang over the rest of its mouth.

Note that the occipital crest of this dog is quite pronounced, giving the top of its head a bumpy appearance (indicated with the arrows).

The Basset Hound has a comparatively large head. Its body is a little over two head lengths long. The height of the head and neck when lifted up is about the same as the length from the mid-chest to the bottoms of the front paws.

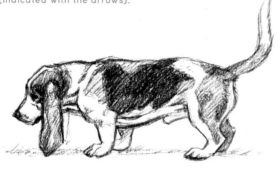

Basset Hounds have the patchy coloration of a hound. This usually includes large areas of a darker color on the back (often black and/or brown) and mostly white legs and neck. There are sometimes smaller freckle-like spots in white areas such as the legs. The hair is short and smooth and the skin is loose.

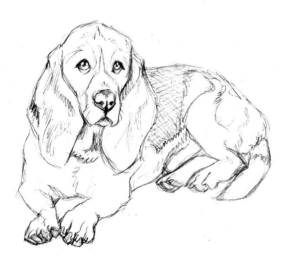

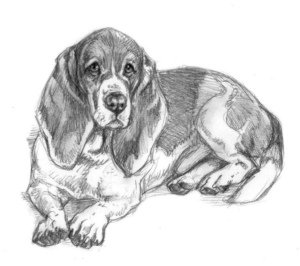

This is an outline drawing of a Basset Hound lying down. The short legs only stick out a little bit in front of the dog.

And here is the finished drawing of a Basset Hound lying down.

BEAGLE

The Beagle is considered the merry hound, known for its cheerful disposition and gentle and friendly nature. Quite vocal, it is an independent breed bred in England to pursue rabbits. It needs daily exercise and enjoys time both inside and outside.

The Beagle's coat is medium in length, hard, and smooth, perfect for running around outdoors through brush and field. Colors are any hound colors (tricolor, tan and white, red and white, ticking like a Bluetick Coonhound, and similar patterns).

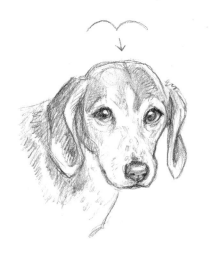

The Beagle has a soft and gentle expression. There can be a prominent groove up the center of the skull between the eyes extending up the forehead (it creates an M shape sometimes when viewed from the front—as shown by the arrow here). This groove is right along the line where the white stripe that goes up the forehead on some dogs usually is. Ears are rounded and medium in length and the muzzle is square. Eyes are usually dark but not always.

DRAWING A BEAGLE, SIDE VIEW

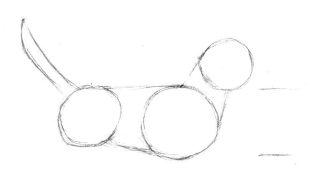

1 First, measure out three parallel, horizontal lines that are equal distance from one another on the side of the drawing. These lines indicate the space from the top of the back to the bottom of the chest, and the space from the bottom of the chest to about where the feet will go. Then block in circles indicating the chest, hips, and head, and connect them by adding the neck and abdomen. Add the tail, which sticks up fairly high.

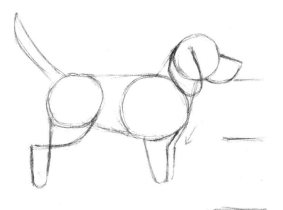

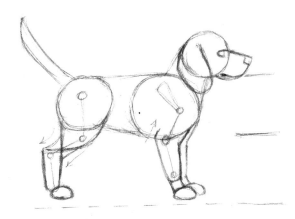

2 Now add the ear and muzzle to the head. Add the front legs, rounding the bottom of the legs where the wrist joints are. The arrow shows how the front leg angles in from the shoulder. Make sure to leave enough space so that the paws (which you will add later) won't extend past the bottom line. Block in the basic shape of the hind legs. In this example, those shapes consist of a sweeping arc from the front of the hips to the back of the heels, and a mostly straight line from the rear to the front of the bottom of the hind leg. Connect them at the bottom. Note that the bottom of the hind leg joint as it stands now is slightly below the bottom of the front leg's wrist joint. Next, you'll be adding the paws.

3 Add the front and back paws. On the front legs, make sure to extend the leg down a little from the wrist joint with a rectangular shape before attaching the paw itself. The back paw is attached more directly here. Flesh out the heel or hock joint as shown with the arrows. I have added some basic "bone and joint" shapes to show the overall positioning of the inner skeletal anatomy. The arrow near the front leg shows how the elbow can be added in an angled line.

Draw the eye, using the top of the muzzle as a guide and continuing with a hook shape. Then add the nose and mouth.

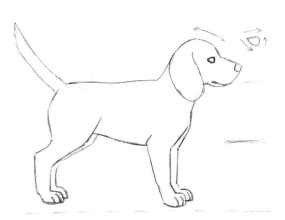

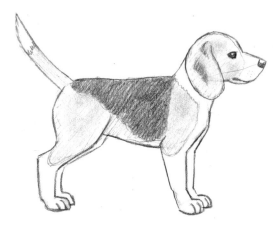

4 At this point, erase most of the guidelines. Leave just the outlines you intend to keep in the finished drawing. I flattened the head slightly (as evidenced by the arrow). I erased the guideline leading from the top of the muzzle to the eye and finished the outline of the eye. Note the drawing to the side, showing how the finished eye is basically a teardrop shape. Lastly, add toes and the farther of the two hind legs.

5 Now shade in the color patterns on the beagle's coat. Leave the muzzle and stripe on top of the head white, as well as the neck, feet, legs, chest, and tail tip. Shade a lighter (tan) color on the back and then the darker black patch on the top of the back and ribs. Shade in the eyes, nose, and some detail on the ears.

BLUETICK COONHOUND

The Bluetick Coonhound originated in the United States and is a scenthound, bred to tirelessly pursue quarry (like raccoons) through the woods and fields. It is an energetic dog that needs a job to do. This hound is muscular but sleek and more deep-chested than wide. It is named for the blue ticking, or mottling, of its coarse, glossy coat. The back is slightly arched, the legs straight and well-muscled, and the tail is held aloft.

The Bluetick Coonhound comes in two colors: blue ticked and blue ticked and tan.

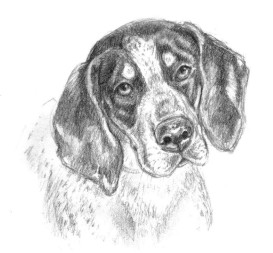

The head is slightly domed and broad, with large, pleading eyes. The ears hang low and wide on the head and taper to a point at the tips.

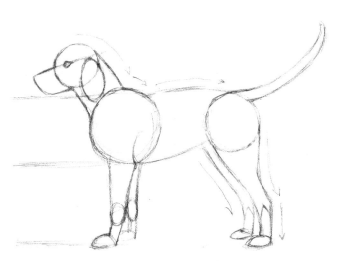

Note the slightly arched back and straight legs of the Bluetick. The legs are about as tall as the space between the chest and back.

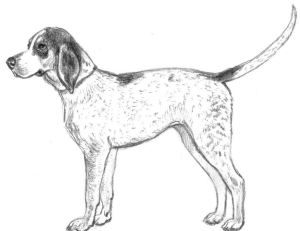

Here's a finished drawing of the previous basic one. Note the freckled or ticked coloration. This dog had tan legs and "cheeks."

BORZOI

The Borzoi, or Russian Wolfhound, is a strikingly elegant sighthound developed in Russia for hunting wolves. It is quiet, independent, gentle, and sensitive.

The coat is usually fuller on males than females and requires brushing and upkeep. Its hair is long, silky, sometimes rather wavy in appearance, and lies fairly flat on the body. The Borzoi comes in a variety of colors and coat patterns. Black and white Borzois are often spotted.

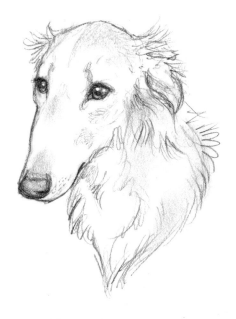

The entire head is very long, with little change between the muzzle and the rest of the skull.

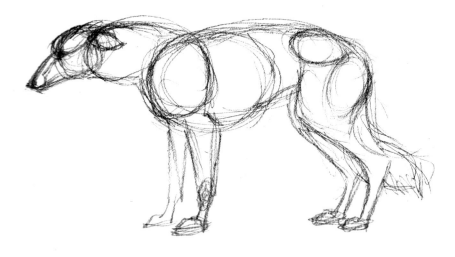

This drawing of a Borzoi shows some of the main shapes of the body. Note the multiple curves and ovals.

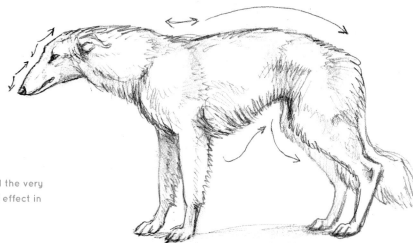

The finished drawing. The back is arched and the very "Roman nose"-like muzzle can be seen in full effect in this profile, as shown by the arrows.

DACHSHUND

The Dachshund is a distinctive breed known for its long body and short legs. Originally bred to pursue quarry into its own burrows, the Dachshund is a popular pet dog today. Active and curious, the Dachshund makes a good watchdog. The legs are extremely short compared to most dog breeds. Dachshunds have a prominent breastbone. The tail is set high and continues the top line of the back.

Dachshunds come in three coat types: smooth coat, longhaired, and wirehaired. There are several acceptable colors, from solid cream, sable or red, black and tan, chocolate and tan, blue and tan, to a grizzled coloration in wirehaired Dachshunds known as wild boar. Dachshunds can also have merle (dapple), sable, piebald, and brindle coloration. The red-and-black and tan colors are most common in the breed.

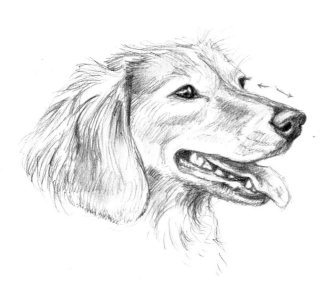

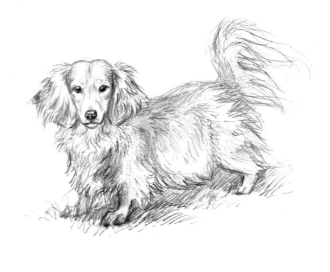

The snout of a Dachshund has a slight arch to it (indicated by arrows). The stop from muzzle to forehead is not pronounced. The Dachshund has high-set, rounded ears and almond-shaped eyes that are usually dark. Eyes can come in colors like green or blue but darker colors are usually preferred in breed standards. Dogs with dapple coats can sometimes have eyes of two different colors.

Longhaired Dachshunds (pictured here) have a silky coat with feathering along the legs and ears.

Wirehaired Dachshunds have a short, coarse coat with a fine undercoat and may have a "bearded" appearance.

Smooth-coat Dachshunds have short, glossy coats. The next step-by-step sequence will show how to draw a smooth-coat Dachshund.

DRAWING A DACHSHUND

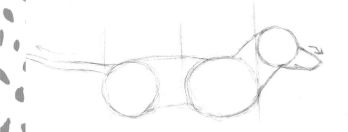 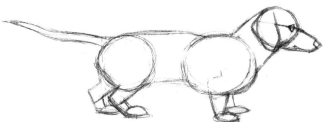

1 Block in the body using a circle for the head and hips and an oval for the chest. Note that the length of the chest from front to back is equal to the distance from the chest to the base of the tail (as shown with vertical lines). Also note how the front of the chest aligns with the back of the head in this drawing. Arrows also indicate the slight crook in the tail and the arched top line of the muzzle. I also drew the mouth.

2 Add eyes (that line up with the top line of the muzzle as shown) and nose. The ears are set high on the head and don't extend very far beyond the bottom of the dog's jaw. Add the legs and feet, indicating the shoulder and elbow joint of the front leg.

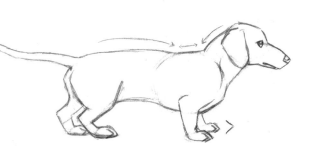

3 At this stage I cleaned up the drawing some, erasing the guidelines and making the final outline. I also added horizontally laid V-shaped marks to indicate the toes. Also note the slight arch of the back and neck leading to the flat shoulders, as indicated by arrows. Add highlights to the eyes and nose.

4 To finish the drawing, shade in the eyes and nose. Add toenails, whiskers, and some indications of muscles, bone ridges, and fur.

GREYHOUND

The Greyhound is an ancient breed that was established, as it is known today, in Great Britain. It is the classic sighthound, speedy and lithe and capable of outrunning rabbits and other quarry. The Greyhound has a deep chest, arched loins, thin legs, long neck, and a long tail that tapers down. Everything about this dog is streamlined.

The coat of the Greyhound is short and it can come in a variety of colors, from solid white, tan, gray, red, or black to brindled or spotted.

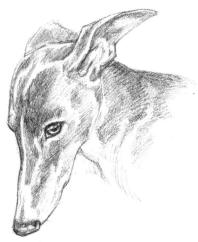

The Greyhound has a very long, narrow head and muzzle without a pronounced stop.

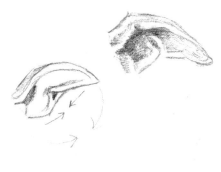

Greyhounds have ears that are somewhat pointed but fold back in a sort of half-moon shape.

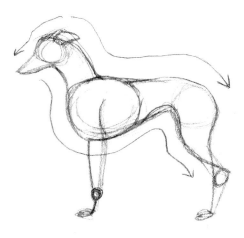

This is a simplified version of a Greyhound's body. Note how arched the neck and back are and how deep and curvy the chest is.

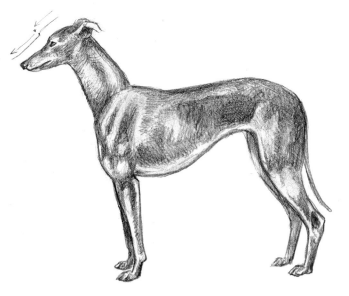

A finished drawing of the same Greyhound's body.

IRISH WOLFHOUND

The Irish Wolfhound is the world's tallest dog breed. An ancient breed, it was developed into the dog we know today in Ireland. These large dogs hunted the (now extinct) wolves and Irish elk there. The Irish Wolfhound is a gentle giant. Calm and friendly with strangers, it is also courageous and powerful.

The Irish Wolfhound comes in various colors, including brindle, gray, black, white, red, wheaten, and fawn. The coat is rough and shaggy in appearance. The hair length varies in individuals from a shorter to a more medium length.

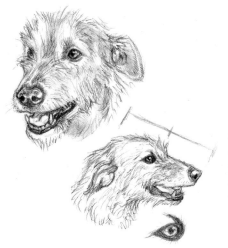

The Irish Wolfhound has a somewhat bearded look due to shaggy hair on its muzzle. Tufts of hair give it the semblance of eyebrows above the eyes. Its eyes are fairly dark and its ears are small and folded back. Note how the length from the muzzle to the eyes is about the same as the length from the eyes to the back of the head. Its lips and nose are black.

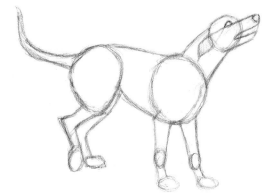

The head and neck are carried high. Note how deep the chest is in this basic blocked-in shape of an Irish Wolfhound's body.

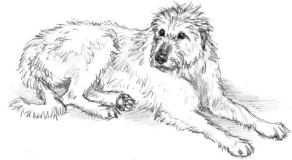

This Irish Wolfhound has a longer coat than the previous one. It gives the dog's legs, tail, and other features a shaggier appearance.

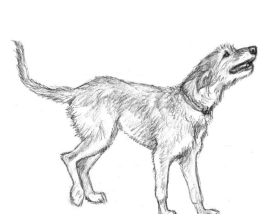

The finished drawing. The tail is long and slightly curved upward. The Wolfhound's feet are large and rounded.

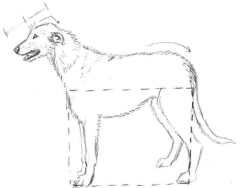

Note how a rectangle shape fits fairly well along the Irish Wolfhound's legs. The front of the chest and the tips of the front toes align, as does the slope of the rear, pointing down to the tips of the rear toes. The loins are arched (shown by the arrow near the hips). There is a pronounced angle to the back of the head.

RHODESIAN RIDGEBACK

The Rhodesian Ridgeback has a distinctive ridge of hair running along its back from behind the shoulders to the front of the hips. Originating in southern Africa, it was developed to hunt large game, including lions. It is a muscular dog with compact feet. This dog can be protective, strong-willed, and aloof toward strangers.

Colors can range from light wheaten to red wheaten. The hair is short and sleek. The nose can be black, brown, or liver.

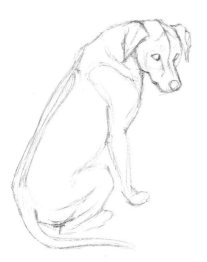

The head of a Rhodesian Ridgeback may have a few wrinkles, especially above and below the eyes. The ears are high-set, eyes are round, and skull is broad.

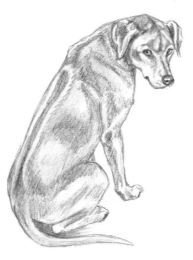

Here's a basic outline of a sitting Rhodesian Ridgeback, showing the distinctive ridge on the back.

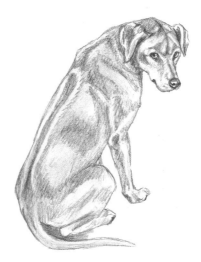

In this finished sketch of the Ridgeback, note how the hair along either side of the ridge is highlighted in the drawing.

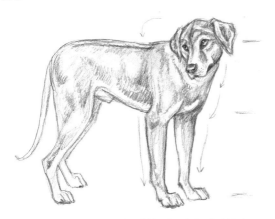

The body of the Rhodesian Ridgeback is slightly longer than tall. The tail tapers down and is usually carried with a slight curve. This dog is shown standing at a slightly three-quarter angle. Note how straight the chest and legs appear at this angle. The height from the back to the bottom of the chest is about the same height as the legs. Note also how square the feet appear.

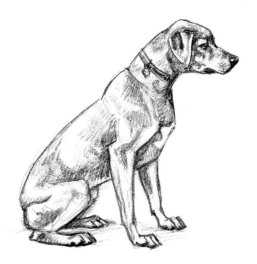

When a Rhodesian Ridgeback is sitting down, the profile is muscular and the head is blocky.

SALUKI

The Saluki is one of the most ancient of dog breeds, originating in the Middle East and used to hunt gazelles, hares, and other game. It is built much like a Greyhound and is fast and graceful. Its head is long and narrow with dark, gentle eyes. Aloof and reserved with strangers, it is devoted to its family.

Salukis come in two coats: feathered and smooth. Feathered coats feature long hair on the ears, tail, between the toes, and may include long hair on the legs. The smooth variety does not. There are several colors: white, red, cream, fawn, golden, tricolor, grizzled, black and tan, or any of these colors with white.

The head is long without a pronounced stop.

DRAWING A SALUKI HEAD

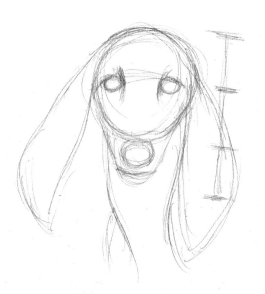

1 First I blocked in the basic shapes: a circle for the head, the cone-like shape under it for the muzzle, and pendulous ears hanging nearly flat from the head. Note that the space from the top of the head to the eyes is about the same distance as the space from the eyes to the top of the nose and from the top of the nose to the chin. I also roughed in the neck, mouth, and the farthest shoulder. There are arced lines in the inner edges of the eyes to indicate where the muzzle connects and the tear ducts lie.

2 I went in and further defined the basic details of the eyes, nose, and mouth, as well as started to pencil in the outline of the long fur on the ears. I defined the way the muzzle slopes up to attach to the inside corners of the eyes, as well as the ridge of bone above each eye; this included a V-shaped depression higher on the forehead. I flattened the top of the head slightly (note the straight line penciled in up there). Lastly, I added the basic shape of the collar.

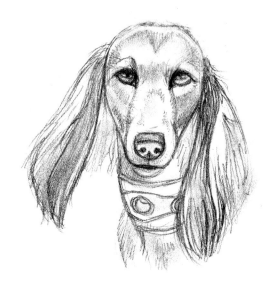

3 At this point I erased some lines and added more detail on the features of the head and in the fur. I started shading in the eyes, adding shadows and highlights on the top half. I darkened parts of the nose and added shading to depressions in the head and jaws. Areas like bone ridges that jut out more were left unshaded for now. I used several long, fine strokes to indicate the longer hair on the ears and a dark streak of coloration there. Short strokes were also added along the neck and other spots I wanted to shade, and the collar was defined more.

4 At this stage I used my finger to smudge the lines, blending the pencil strokes and adding some soft shading. There are also smudging sticks that one can use to blend a drawing in this manner.

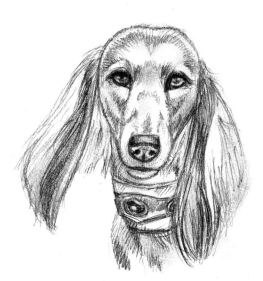

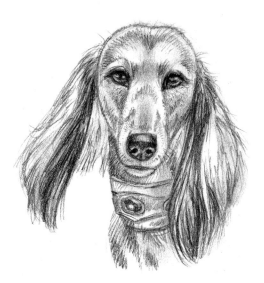

5 Once I smudged broad areas of the drawing, I went back and added definition once again with pencil strokes that indicated the outline and individual details. (The soft, smudgy background enhances the pencil strokes.) I added eyelashes and details to the eyes, texture on the nose, and more clumps of hair on the ears. I worked on the collar, shading areas and defining the decorations.

6 Finally, I added small details and any shading I felt still needed to be done, like on the nose. I used multiple tiny strokes to indicate dense, short hair. I used a kneaded eraser to make sure the highlights in the eyes were as bright as I wanted them to be. Some areas like the collar and nose were smudged just a little bit again, then pencil strokes added. I also added some whiskers.

SALUKI BODY

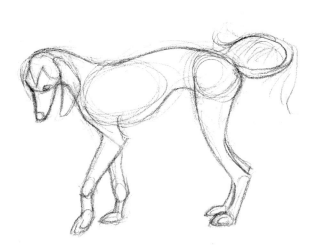

Note the Saluki's deep chest, arched back, and very long legs.

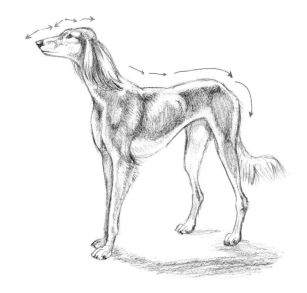

The plumed tail can be held up or hanging low and to the back. Note how long the face appears and the slight arch on the top of the muzzle (as indicated by the arrows). Arrows also show the arch and angles of the back. Salukis are lean and muscular.

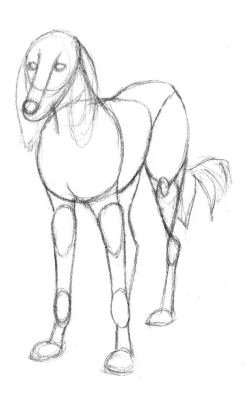

Here are some of the underlying basic shapes I used to block in this Saluki standing at a three-quarter angle.

The finished drawing of a black-and-tan saluki.

WHIPPET

Developed in England, the Whippet looks like a small Greyhound and was used in racing and rabbit coursing. It is a very devoted and demonstrative dog and quite sensitive.

It comes in numerous colors and has very short hair. The Whippet is sensitive to cold and does best as an indoor dog.

This older Whippet pants on a hot day. Note the folded Greyhound-like ears. The stop between the muzzle and forehead is very subtle.

Whippets have very deep chests, arched backs, long legs, and tails carried low.

Chapter Five

SPORTING GROUP

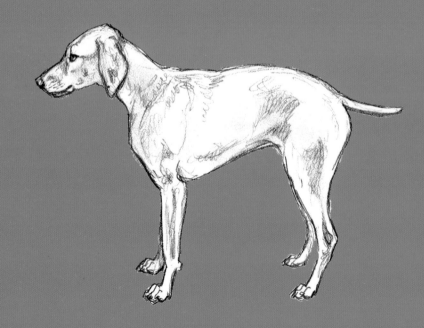

The Sporting Group consists of dogs bred to hunt and retrieve on land or in water. They tend to be active, friendly dogs popular with many.

CHESAPEAKE BAY RETRIEVER

The Chesapeake Bay Retriever, developed in the United States, is the descendant of two shipwrecked English dogs given to their rescuers. The Chessie is a great waterfowl retriever, at ease swimming even in cold water. This calm, independent, brave, and hardy dog is one of the earliest AKC recognized breeds.

The Chessie's coat is wavy and oily, giving the dog a natural water resistance. It will be some shade of brown.

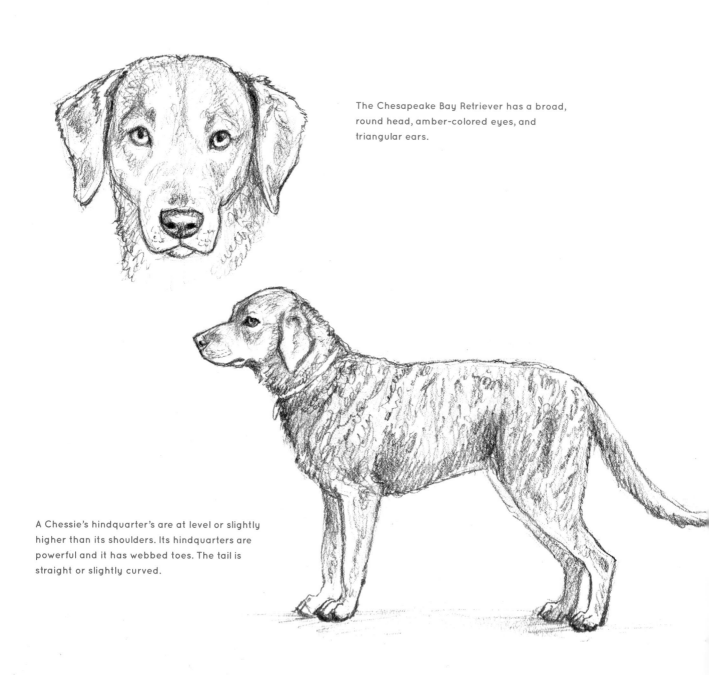

The Chesapeake Bay Retriever has a broad, round head, amber-colored eyes, and triangular ears.

A Chessie's hindquarter's are at level or slightly higher than its shoulders. Its hindquarters are powerful and it has webbed toes. The tail is straight or slightly curved.

COCKER SPANIEL

The American Cocker Spaniel and English Cocker Spaniel are two different breeds but share some similarities.

The English Cocker Spaniel is similar to the American Cocker Spaniel, but the English breed is taller with a narrower head and chest. The American is smaller with a domed head, shorter muzzle, and shorter back.

AMERICAN COCKER SPANIEL

The American Cocker Spaniel originates from the United States. This dog is known as a "merry" breed, and can be playful, sweet, sensitive, and eager to please. It serves as a good watchdog.

This breed has fairly long silky or wavy fur. It comes in three basic recognized colors: black or black with tan accents, parti-color, which is white with patches of another color, and "Any Solid Color Other than Black," or ASCOB. ASCOB coloration ranges from light tan to deep red.

The American Cocker Spaniel has a distinctly domed, rounded head with a short muzzle and soft expression. Its nose is upturned. It has rounder eyes and more pronounced eyebrows than the English Cocker Spaniel. Its ears are long and low-set, with soft silky hair. The nose can be black or brown depending on the color.

Note the small detail sketches here. On top is a stylized American Cocker Spaniel head and on the bottom is the English Cocker Spaniel. Note how the American's head is more of a figure eight shape and the English is an oval with a rectangular shape pointing down for the muzzle. Note also how domed and high the top of the American's head is.

The top of an American Cocker Spaniel's back is short and shows a subtle slant down from the shoulders to the hips. The tail is usually cropped and is carried pointing horizontally from the back or slightly above. Its feet are round.

The fur of an American Cocker Spaniel may be so long that the legs are not immediately obvious, such as in this show cut. The hidden anatomy is shown here and influences the look of the fur running down the midsection past the belly, causing it to tuck inward just a little.

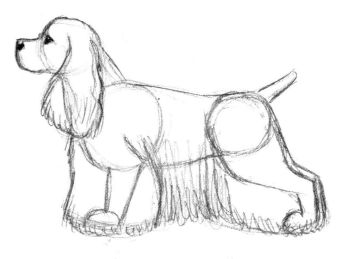

ENGLISH COCKER SPANIEL

The English Cocker Spaniel, which indeed originates from England, retains more hunting instinct than the American breed. As a result it needs a little more exercise. Social, determined, and sensitive, it is cheerful and trainable.

The English Cocker Spaniel has a medium-length coat and comes in a variety of colors. It may be a solid color, parti-colored, or roan, a mix of white and color. Colors range from black, black and tan, golden, liver (brown), and red, to black and white, and more.

The English breed's eyes are more oval than the American Cocker Spaniel's. The head is slightly flattened, not quite as round as the American breed. Like the American Cocker Spaniel, it has long, low-set ears.

DRAWING AN ENGLISH COCKER SPANIEL HEAD

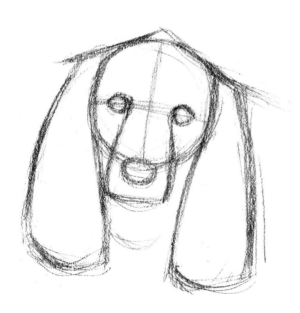

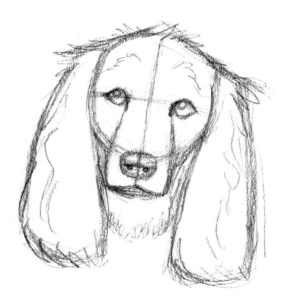

1 Block in the basic shapes of the head, ears, eyes, and nose. You can use a flattened, upside-down V shape to get the slope of the top of the head and the ears.

2 Refine the details, adding nostrils (you can use lines in a cross shape, dividing the head into quadrants, to guide their placement along the horizontal center line inside the nose). Add the mouth and chin and begin to draw in the fur. Add the "eyebrows."

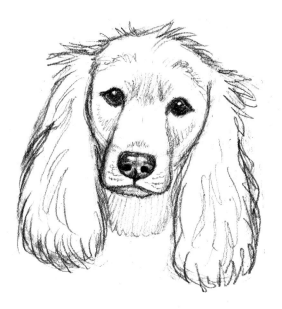

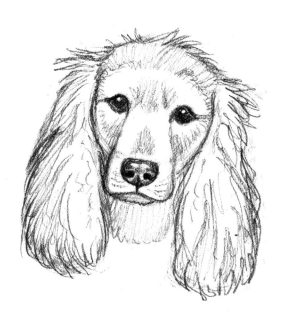

3 Erase the unneeded lines and darken and define the ones you want to keep. Shade in the eyes and nose, leaving highlights. Add whisker follicles and some indications of the bony ridge of the cheeks. Draw in some of the long lines of the ear fur.

4 At this point continue drawing in short lines for the fur, letting the strokes radiate out in the direction that the hair would lie. Add some squiggly lines along the ears and shorter, denser lines to shade in the stop between the eyes and the short hair above the nose.

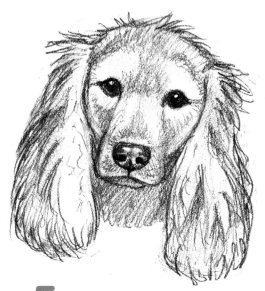

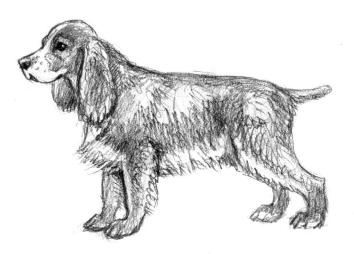

5 Finish the drawing by smudging the pencil to shade the entire dog in lightly. Then go back over the drawing, retouching and again defining the lines that may have been somewhat smudged. Add some soft pencil strokes where a little detail might help, such as on the muzzle and ears.

The English Cocker Spaniel has a slightly sloping back and usually has a docked tail. It has catlike feet.

ENGLISH SETTER

Originating from England, the English Setter is an elegant, active dog. It is good-natured and tends to do well with children, strangers, and other dogs. There are two recognized bloodlines of English Setter: the *Laverack Setter*, which provides the foundation of the heavier show dogs, and *Llewellin Setters*, which provide the foundation of dogs out in the field. The English Setters shown in this book are from the Llewellin bloodlines, which are generally smaller and have less feathering, or wisps of long hair flowing from certain parts of its body.

The English Setter has a long, flat coat with feathering on the ears, tail, underside, and legs. It is usually white with ticking of colors such as liver, blue, lemon, black, or orange. This ticking or spotting in an English Setter is called "belton."

The English Setter has a well-defined stop between the top of its muzzle and its forehead. It has large, round eyes, a square muzzle, and low-set ears.

The English Setter is athletic and handsome, with a long flowing coat and refined appearance. The tail is usually held straight out or up when on point on game. The back slopes slightly downward from head to tail.

ENGLISH SPRINGER SPANIEL

The English Springer Spaniel is an enthusiastic, affectionate breed used for flushing and retrieving of game. It is an ideal family companion that needs plenty of exercise. The genetic lines of show dogs and field dogs show some differences. Field dogs have shorter coats and ears than show dogs, which are thicker and heavier than field dogs.

The breed's coat is of medium length, flat or wavy, with a dense undercoat. Colors include black or liver with white and tricolor with black or liver and white with tan markings. The white on its coat may show ticking.

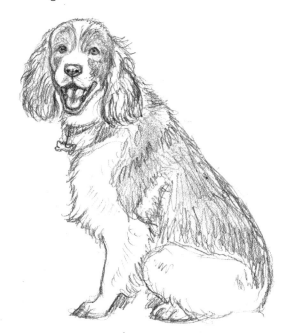

The English Springer Spaniel has a somewhat rounded head, oval eyes, and long ears. Its upper lips, or flews, hang down from the mouth.

The body of an English Springer Spaniel is well-proportioned, slightly longer than tall, and its back slopes slightly down from the shoulders to the hips.

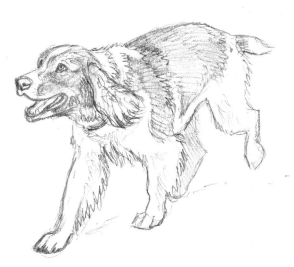

OTHER SPANIELS

There are many spaniels, but providing detailed descriptions of each one is beyond the scope of this book. Here are a few of the other breeds.

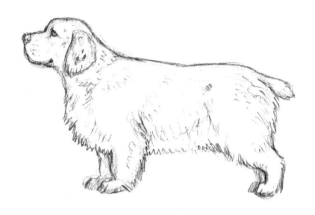

CLUMBER SPANIEL The Clumber Spaniel originates in England, featuring a white coat with a few lemon or orange markings. It is easygoing, with a massive head, short legs, and large feet.

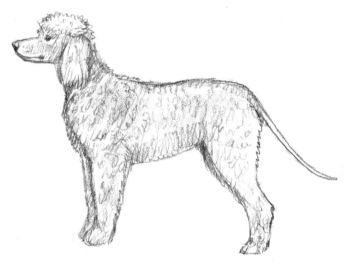

IRISH WATER SPANIEL This Irish breed is one of the oldest and most distinct spaniels. It can be confused with a poodle, however, for both share a tightly curled coat. It has a long, tapering "rat" tail. Liver in color, this is an excellent water retriever and an enthusiastic, energetic, and sometimes stubborn dog.

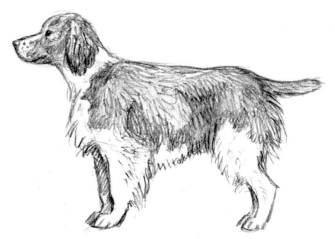

WELSH SPRINGER SPANIEL This breed originates from Wales. Steady, devoted, and independent, it needs daily exercise. Red and white in color, its legs are comparatively shorter than the English Springer Spaniel and its ears are shorter. It also tends to be calmer and more reserved toward strangers than the English Springer Spaniel.

GERMAN SHORTHAIR POINTER

The German Shorthair Pointer is an active, versatile hunting breed that wants to spend time with its owner, whether that time is spent inside or outdoors. Devoted and sensitive, this dog does well with families and is highly trainable. As its name implies, it originates from Germany.

The German Shorthair Pointer has a short, flat coat. It has a liver or liver and white coat and often features a largely solid liver-colored head with a ticked pattern of liver and white on its body.

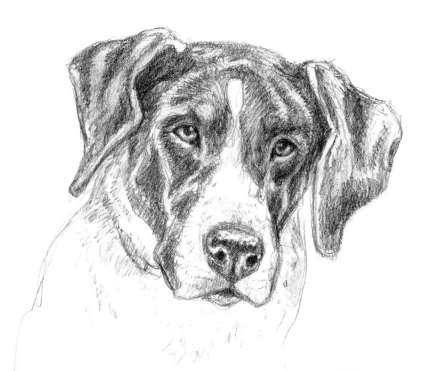

The German Shorthair Pointer has a brown nose and almond-shaped eye. Its ears are broad, rounded, and set high on its head.

The body is relatively square or slightly longer than tall. It is athletic in appearance, with a back that is strong and short. Most German Shorthair Pointers have cropped tails. Their dewclaws are often removed as well, to prevent tearing in the field.

GOLDEN RETRIEVER

The Golden Retriever is a very popular dog breed and it's not hard to see why. Friendly, good with kids, even-tempered, and beautiful, this dog is found in households everywhere. A great family dog, it is equally adept out in the field, retrieving birds as it was originally bred to do in the United Kingdom.

The iconic coat of the Golden Retriever comes in various shades of gold. The fur is long but not so long that it would be a disadvantage for the dog while working outside in the field. The topcoat is water resistant and slightly wavy while the undercoat is soft and keeps the dog warm.

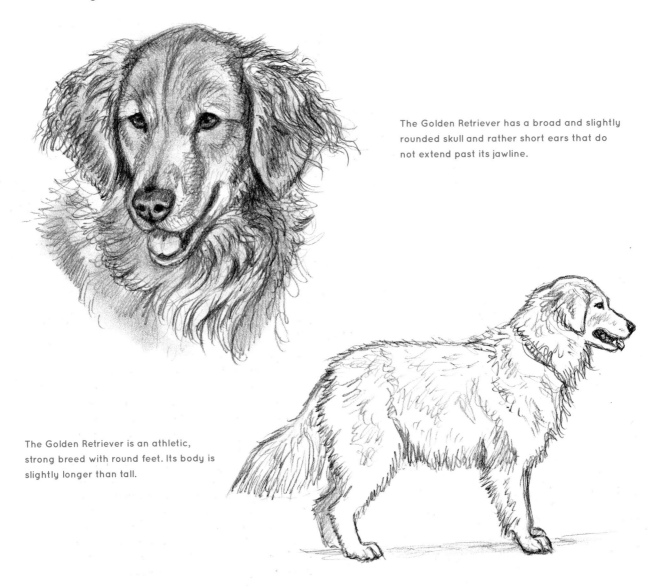

The Golden Retriever has a broad and slightly rounded skull and rather short ears that do not extend past its jawline.

The Golden Retriever is an athletic, strong breed with round feet. Its body is slightly longer than tall.

DRAWING A GOLDEN RETRIEVER STANDING AT AN ANGLE

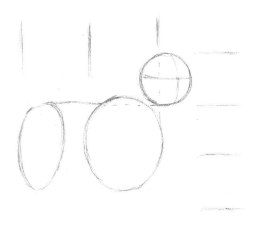

1 This will be a Golden Retriever standing in a three-quarter angle from the viewer. Start out by blocking circles for the head and chest and an oval for the hindquarters. I've marked off some measurements on the right and top of this drawing to help you block the proportions in correctly. Note that, on the right, the drawing is measured into four head lengths. On the top, the width of the chest is about the same as the width from the back of the ribs to the hindquarters. Also note that the bottom of the head's circle lines up with the back and the shoulders protrude just a bit above the line of the back. Finally, add a slightly curved, horizontal line in the center of the head's circle and a curved dividing line vertically that will be the center line between the eyes later.

2 Add lines for the belly and neck, connecting the head, chest, and hips together. Note how the vertical dividing line on the head merges into the line indicating the throat that then moves onto the chest. Draw a cone shape for the muzzle using that vertical dividing line to place it on the head. The top of the muzzle should be where the vertical and horizontal dividing lines in the head meet in a cross shape. Continue the line of the back to show where the tail will be. Then add lines indicating the legs. Draw a rod for the closer hind leg and draw the back line of the farthest hind leg, including an angle where the heel juts out. Block in the front lines of the front legs using an upside down U shape. Add circles for the paws.

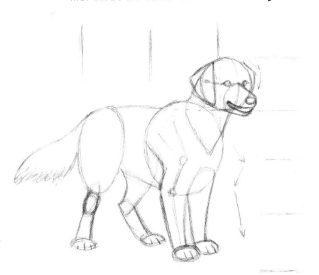

3 Now add more details to the head, including the eyes, nose, and mouth (which is open and panting). The ears are triangular shapes that slope down from the top of the head and jut out a little on either side. (The ears don't extend past the bottom of the head, however.) Add the tail, lines that indicate the toes, and an oval shape to indicate the heel of the closest hind leg. Fill in the front legs. I indicated the basic skeletal structure of the nearest front leg. The arrows on the right of the dog show the angles used in drawing the back of the closest front leg as well as the overall angles of the front legs. Also flesh out the neck and where it attaches to the body, using a V shape.

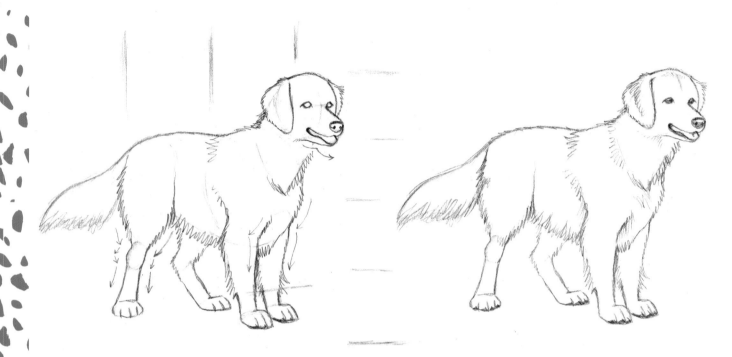

4 At this stage, begin lightly erasing the guidelines so that you can pencil in the final outlines. For that, I added shaggy fur, which is especially prominent on the belly, neck, and legs. I also defined the eyes and nostrils. Note the guideline arrow I placed under the jaw to show where the line of the lower lip sweeps upward, then down again. In drawing the outline of the dog's body, I put several subtle suggestions of muscle and form that are underneath all the fur. Because they might be missed, I added arrows to help show just where they were. On the closest hind leg note that I kept the bulge of the heel but the outside edge of that bulge juts out more than the inside edge that is closer to the belly. On the front legs, I suggested the bulge where the shoulder is, then indented the line where the shoulder meets the leg. (I indicated where this occurred on the front of both front legs.) Also note that I didn't add as much shaggy hair below the spot where the front leg meets the wrist (indicated by the horizontal line).

5 Finish the drawing, erasing any remaining unwanted guidelines. Shade the eyes and nose in, leaving a highlight in each of them. Add some shading in the middle of the ear and along the forehead where there is a slight crease. Add the dark lower lip under the tongue as well as a line indicating the crease in the middle of the tongue. I filled in some more fur, making sure to keep it looking long and soft. Finally, I shaded some hint of the pads on the bottom of the toes. Fur conceals the pads to some degree, but an indication of pads and nails adds to the realism of the drawing.

LABRADOR RETRIEVER

The Labrador Retriever is well-known and loved as a great family dog as well as an excellent retriever and service dog. Highly trainable, it does well with children and other animals. Friendly, steady, and active, this breed enjoys both the water and the field, as well as time spent indoors with its family. The Lab originated in Canada as a waterfowl retriever and working dog at ease in the water. There are some differences in show and field dogs; the show dog genetic lines tend to be slightly stockier and squarer of face than the field dogs.

Labradors come in three colors: solid black, chocolate, and yellow. A small white patch on the chest is permissible. Its coat is short, dense, and water-resistant.

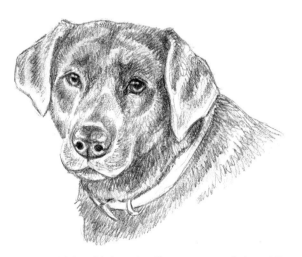

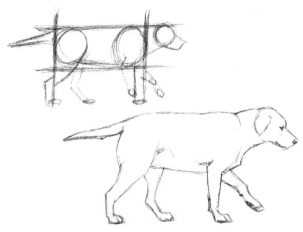

The Lab's head is broad, with a pronounced stop at the base of the muzzle near the eyes. The eyes are kind and intelligent and will be hazel or brown. The dog's triangular ears are set slightly above the eyes and hang close to the head. The muzzle is strong, somewhat square, and of medium length.

A muscular, strong dog, the Labrador Retriever's body is heavyset and solid. It is somewhat rectangular in overall shape or slightly longer than tall. The chest does not look especially deep compared to the stomach. Labs have otter-like tails that are thick at their base and slightly flat as they taper to a more slender tip. Note how this Labrador's body fits inside a rectangle shape.

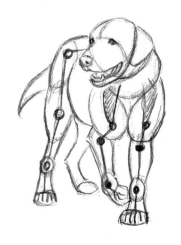

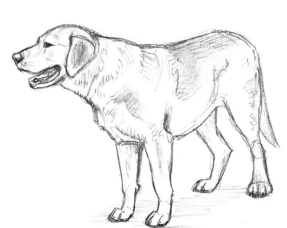

More Labs. Keep the body solid and fairly compact.

DRAWING A SITTING
LABRADOR RETRIEVER

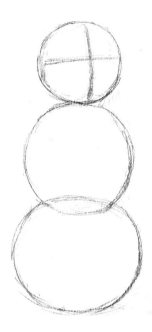

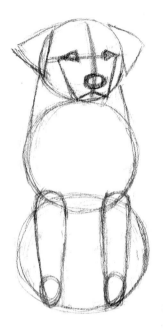

1 First draw three circles in a snowman-like shape. The top circle is smallest and the bottom circle is the largest. The bottom two circles overlap each other slightly. Add a cross shape on the top circle but keep it slightly off center toward the right of the drawing. The dog will be facing just a little off-center from the viewer. Allow the cross-shaped lines to curve slightly, following the "ball shape" of the circle.

2 Add the eyes as triangular shapes, pointing outward. Add the nose and muzzle, using the outside corners of the eyes to guide your line down to the bottom of the head circle. The muzzle should be slightly narrower near the nose and mouth. Add the upper lips of the mouth. The muzzle and mouth together create an upside down M shape. Add triangular ears. Add the neck between the top and middle circles. Draw tube-shaped front legs just overlapping the middle chest circle and ending with a rounded edge at the bottom circle. Add a circular shape at the bottom of the legs for the wrists.

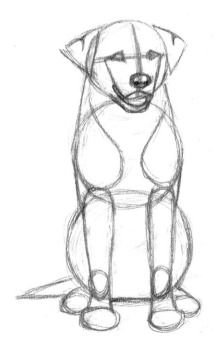

3 Add more details, like the creases in the ears and the nostrils. Add the lower jaw and a slightly open mouth. Fill in the shoulders more, adding a little to the sides between the middle and bottom circle. Add the paws and tail. Use a flat line for the bottom of the tail that aligns with a flattened line where the rear sits.

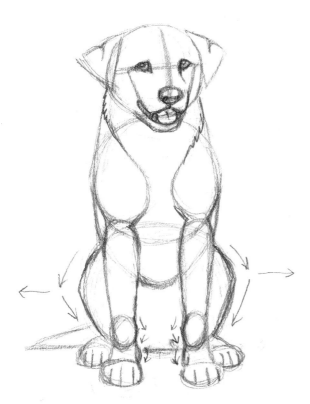

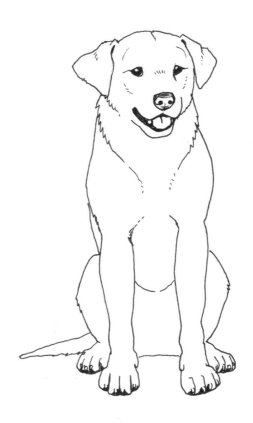

4 Refine the drawing, adding a tongue and putting details in the eyes, including tear ducts and highlights. Remember that the eye on the right in the drawing (the dog's left eye) is slightly farther away and that the way the muzzle juts out blocks just a little bit more of that eye from view. Thus the line of the top of the muzzle is more pronounced. Draw some of the fur of the neck and add the belly. Add toes, the dewclaws, and define the joints of the wrists. The arrows inside the legs show the angular lines I used. Complete the hind legs, letting the area where the knees point out (indicated by the outward pointing arrows) jut out just a bit. This gives a slightly angular effect, as shown by the arrows that point downward outside the hind legs.

5 At this point, finish the drawing by inking in the final lines, then erase the pencil marks.

OTHER RETRIEVERS

There are many retrievers but providing detailed descriptions of each is beyond the scope of this book. However, here are examples of a few of the other retriever breeds.

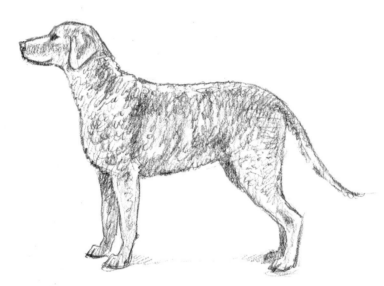

CURLY-COATED RETRIEVER This black or liver dog looks a bit like a Labrador Retriever with curly hair. It has some Irish Water Spaniel and Poodle in it, giving it the curly coat. Originating from England, it is calm, gentle, and reserved with strangers.

NOVA SCOTIA DUCK TOLLING RETRIEVER This dog's name is also its place of origin. Sporting a distinctive red and white coat, this energetic retriever was used to lure ducks in by playing along the water, arousing the bird's curiosity and tolling (luring) them in where the hunters were waiting.

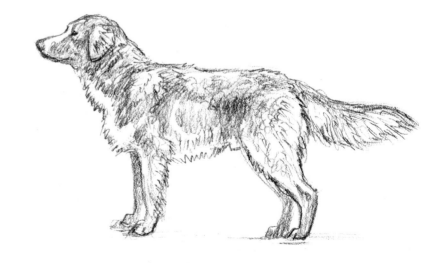

LAGATTO ROMAGNOLO

A recent addition to the Sporting Group, this dog originates from Italy. Skillful as a water retriever, it is also used to hunt for truffles, a valuable type of fungus. The Lagotto is very observant, affectionate, and intelligent.

This breed has a dense, curly, and wooly coat that doesn't shed a lot. It may have a solid-color coat of white, off-white, or brown or may have white with brown or orange patches or may be roan. White markings may grow out by the time it reaches adulthood.

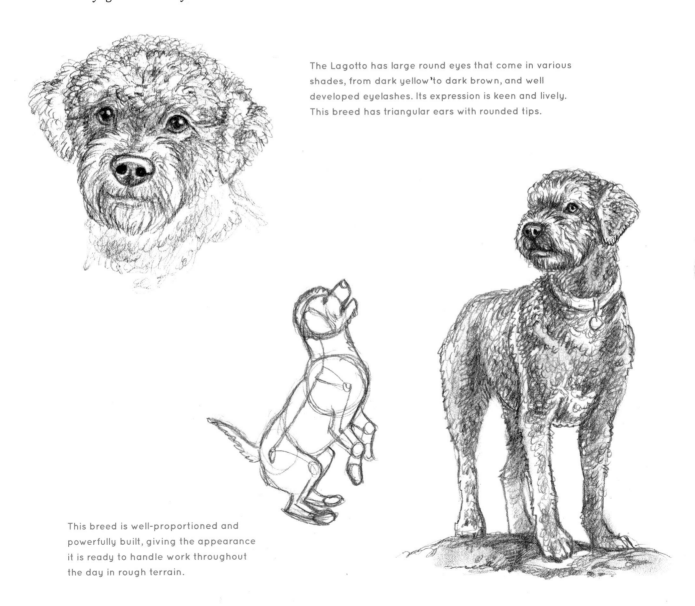

The Lagotto has large round eyes that come in various shades, from dark yellow to dark brown, and well developed eyelashes. Its expression is keen and lively. This breed has triangular ears with rounded tips.

This breed is well-proportioned and powerfully built, giving the appearance it is ready to handle work throughout the day in rough terrain.

VIZSLA

The Vizsla comes from Hungary and is a svelte, athletic, active dog. It is sensitive, gentle, and affectionate, equally comfortable as a hunting dog or a family dog.

The coat is short, smooth, and dense. Vizslas have distinctive golden rust-colored fur. They do not have an undercoat.

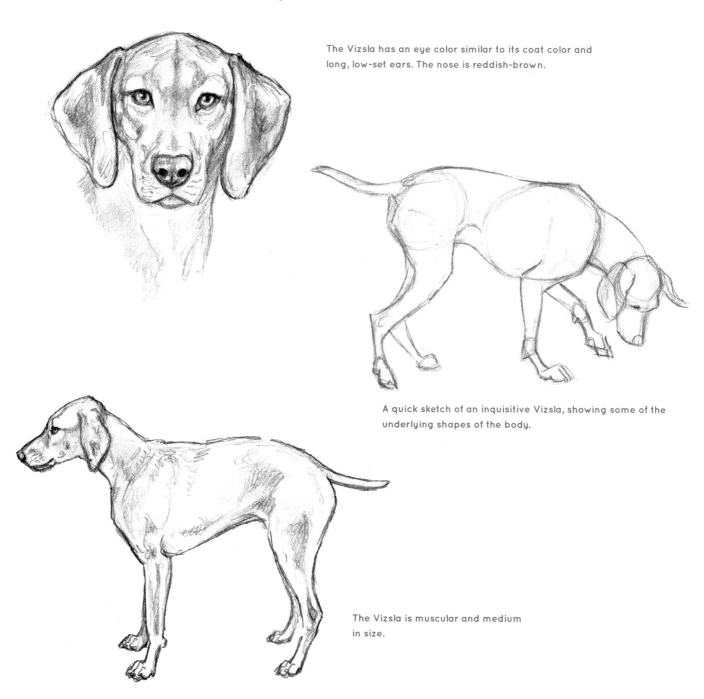

The Vizsla has an eye color similar to its coat color and long, low-set ears. The nose is reddish-brown.

A quick sketch of an inquisitive Vizsla, showing some of the underlying shapes of the body.

The Vizsla is muscular and medium in size.

WEIMARANER

The distinctly silver-gray–colored Weimaraner hails from Germany and is a versatile hunting breed able to pursue game of all sizes, even bears and deer. It is energetic, bold, and can be stubborn. The Weimaraner craves attention and needs plenty of exercise.

This dog's silver-gray to mouse-gray coat is short and sleek.

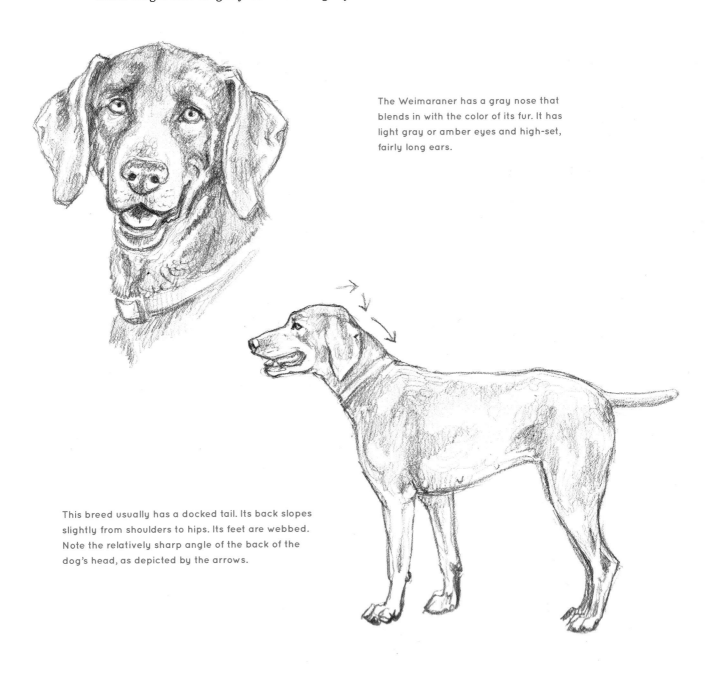

The Weimaraner has a gray nose that blends in with the color of its fur. It has light gray or amber eyes and high-set, fairly long ears.

This breed usually has a docked tail. Its back slopes slightly from shoulders to hips. Its feet are webbed. Note the relatively sharp angle of the back of the dog's head, as depicted by the arrows.

Chapter Six

NON-SPORTING GROUP

The Non-Sporting Group features a wide variety of dogs that were bred in different places for a wide variety of purposes, from worker to watchdog to hunting dog to circus dog to companion.

AMERICAN ESKIMO DOG

The American Eskimo Dog, or Eskie, originated in America as a general farm worker and watchdog. This dog is a type of spitz, a dog characterized by long fur, pointed face and ears, and often white fur. In fact, the American Eskimo Dog has sometimes been referred to simply as the American Spitz. Eskies are energetic, playful, and are so receptive to training they have a history as circus dogs. They are known for their "smiles."

The American Eskimo Dog has a long, thick, white coat, sometimes with cream markings.

The Eskie has black lips, nose, and eye rims and a wedge-shaped head. It has erect, triangular ears and a thick ruff of fur around its neck.

DRAWING AN AMERICAN ESKIMO DOG

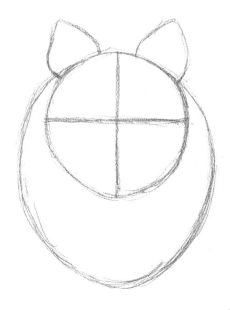
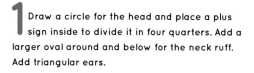
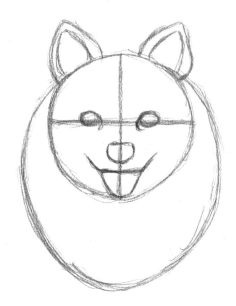

1 Draw a circle for the head and place a plus sign inside to divide it in four quarters. Add a larger oval around and below for the neck ruff. Add triangular ears.

2 Draw the eyes, adding a curved line in the inner corners for a tear duct. Add the nose. Note how the top of the nose is somewhat flat while the bottom pinches down at the very bottom slightly. Add an inside rim in the ears and draw a mouth. It consists of an upper lip, which is almost a wide U shape but with a flat bottom. The lower jaw is another U shape.

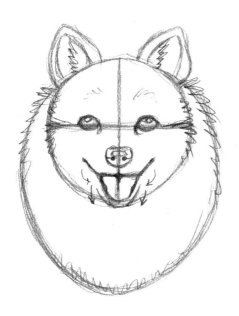

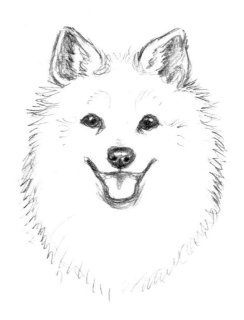

3 Start putting in the final details, including some of the fur along the outline of the head and neck. Add some fur along the cheeks using the horizontal dividing line on the head to guide you. Add some hair inside the ears and highlights on the eyes and nose. Add nostrils. Add a little definition to the tongue to indicate the way it pinches inward in a very subtle manner. This is where the canine teeth are and the lips are tightly attached to the jaw. I've indicated the slight pinch with arrows.

4 Erase guidelines and finish the drawing, shading in the nose and eyes as well as lightly shading inside the ears.

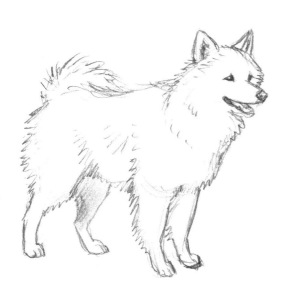

The Eskie has a compact body, oval feet, and a plumed tail that is curled over its back.

A sitting Eskie was drawn in pen and ink.

BICHON FRISE

The Bichon Frise originated in the Mediterranean region during ancient times. Sometimes mistaken for a poodle, it is a bit shorter-legged, longer-bodied, and has a more rounded skull with a shorter, wider muzzle. This playful, active dog is good with children and quite affectionate. It has long been a family dog and sometimes a performer as well.

The Bichon Frise has a white, fluffy double coat (sometimes with cream shading). The undercoat is soft and dense and the outercoat is more coarse and curly.

The Bichon Frise has dark, round eyes and drop ears.

DRAWING A BICHON FRISE HEAD

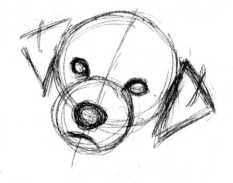

1 The first few steps consist of lightly blocking in the head of this Bichon Frise with a pencil. Put in two circles, a slightly larger one for the head and one for the muzzle. I added a stripe indicating the center of the face.

2 I blocked in the eyes, nose, mouth, and triangular shapes for the ears. I added a line in the middle of the ears showing where they indent a little. This is useful information for shading the ear later.

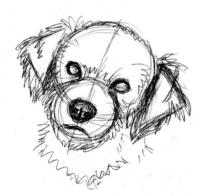

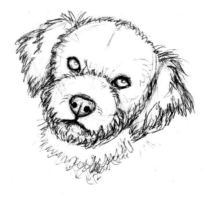

3 I added some suggestion of fur and the neck. Nostrils and the "center line" were added to the nose.

4 At this point I erased some lines and began work on the final stage of the drawing. I added definition to the fur all around the face, ears, and neck. I cleaned up lines around the nose and eyes and added highlights.

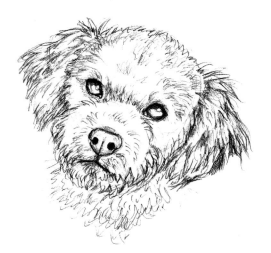

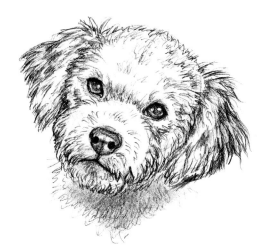

5 I continued working on the wavy fur, adding definition and detail using short, squiggly strokes on the head and longer lines on the ears. I used many V-shaped lines on the ears. Several squiggly lines next to one another add weight to the outside jawline and muzzle. I added some shading to the eyes.

6 I added pupils to the eyes and applied shading to the nose. I continued working on the fur and added some shading under the eyes to suggest both fur and the bone structure (lower eye socket/cheek) underneath it. I also smudged some areas to soften them, including the neck area. This made the neck softer so that it is not as "busy" and doesn't compete with the detailed area of the muzzle above it. I smudged some areas of the mouth, and between the eyes and the ears as well. I added some squiggly lines below the lower lip to provide a three-dimensional effect there.

7 I added lines over the smudged areas as needed. The nose and eyes were finished, with attention given to highlights and shadows. I smudged a few more areas very lightly to add a (subtle) soft effect. Finally, I went over the jawline and overall outline again with my pencil, making sure the head shape was distinct from the ears and neck.

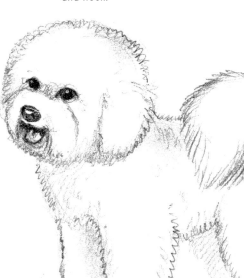

Bichons carry their plumed tails over their back. They have round feet.

BOSTON TERRIER

The Boston Terrier was developed in the United States. This relatively recent breed is a popular, lively dog that makes a great watchdog and companion. It can be somewhat stubborn but learns quickly.

The coat is short and fine and is black, seal, or brindle with white markings between (but not touching) the eyes, on the muzzle, on the chest, and it may have a white collar or legs.

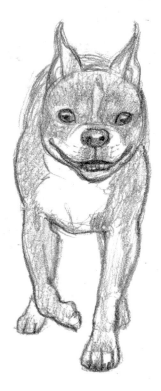

Here is a Boston Terrier's head viewed from the side, showing some basic shapes.

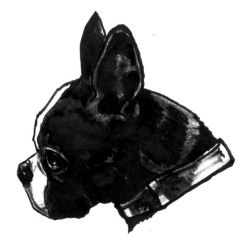

The finished, inked-in drawing.

The Boston Terrier has a square face with a very short, smooth muzzle and erect ears. It has large, round eyes.

A Boston Terrier's head from a three-quarter view, showing some of the basic shapes.

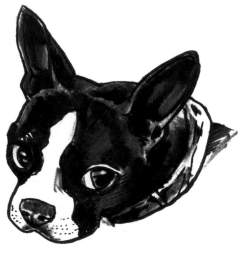

The finished, inked-in drawing of a Boston Terrier's head.

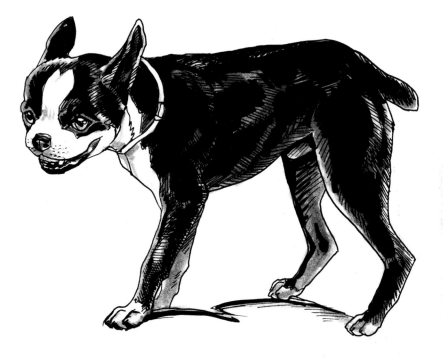

Some studies showing how the short, square muzzle, eyes, and mouth are set very close together on a round head.

The body of this breed is compact, its chest is broad, and its tail is short. The tail may be straight or corkscrewed. Bostons are often born with stub tails.

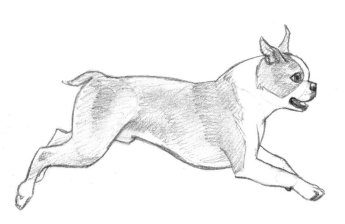

Some of the stylized, rough shapes found in a running Boston Terrier's body.

The finished drawing of a running Boston Terrier.

BULLDOG

The English Bulldog originated in England, as its name implies. It was originally developed as a bullbaiting dog, a cruel sport where dogs would latch onto a bull's nose or otherwise harass it. When that was finally outlawed, the breed was in danger of extinction but fanciers rescued it from obscurity by breeding for nonaggressive dogs. The bulldog of today is a gentle, amiable personality in a tough-looking exterior. They get along well with children.

The Bulldog has a short, glossy coat that comes in solid white, fawn, red, or brindle on a white background.

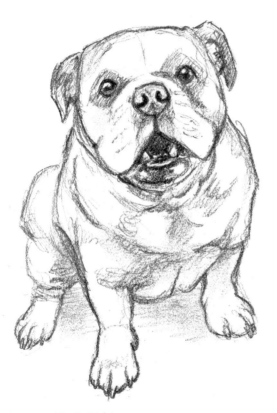

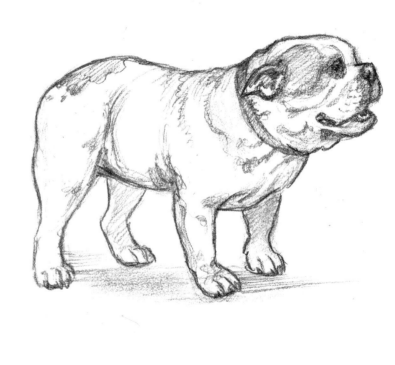

The Bulldog's broad head and face are covered in wrinkles and it has a square muzzle and overshot jaw. The nose is tipped upward and the flews, or upper lips, hang over massive jaws. The dog's head's circumference equals at least the height of the dog at the shoulders.

The Bulldog has a broad, round back, rounded ribs, wide shoulders, and a short straight or screwed tail. The hind legs are longer than the forelegs.

CHINESE SHAR-PEI

This breed was developed in China for many functions, including herding, hunting, dog fighting, and as a guardian. It nearly went extinct but fanciers helped save the breed and today many are acquainted with this independent, self-possessed, devoted, and undemonstrative dog.

Shar-Pei means sandy coat, and indeed the Shar-Pei often tends to have a sandy coat. It can range from any solid color from black to apricot, with or without a black mask on the face. There are three types of coat a Shar-Pei may have: horse coat (rough and prickly), brush coat (longer and softer in feel), and bear coat which is longer, rare, and not officially recognized by the AKC.

 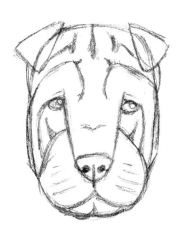 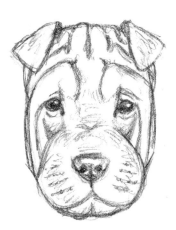

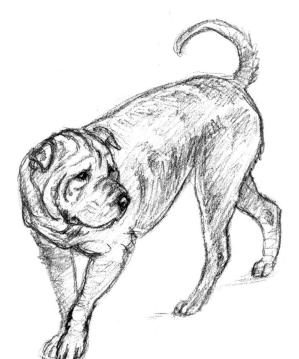

The Shar-Pei has an ample dewlap, or flap of skin, on its neck. It has an extremely full and wide muzzle and a blue-black tongue and mouth (a featured shared with the Chow Chow). It has short, triangular ears and a hippo-like muzzle. The eyes are small, sunken, and almond-shaped. Here is a three-step drawing of a Shar-Pei's head.

The Shar-Pei's body is compact and square. Its head is comparatively large. The dog's tail is set high, tapering, and curled over the side of the back. It has ample wrinkles through the body and head.

CHOW CHOW

Like the Shar-Pei, the Chow Chow originated in China in ancient times and has a distinctive blue-black tongue. It was developed as a cart puller, guardian, and a food source as well as possibly a hunter of game. The Chow is dignified and undemonstrative even with its family, though it is devoted and protective. It is somewhat suspicious of strangers.

This breed has a thick and coarse coat with a wooly undercoat. Some have a rough coat that is straight and off-standing or a smooth coat that is hard and smooth. Accepted colors are solid black, red, blue, cinnamon, and cream.

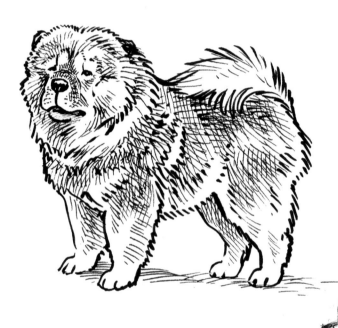

The Chow's head is massive-looking with a padded button of skin on the inside top corner of the eye, where the "eyebrow" would be. It has almond-shaped eyes, a black nose (except blue dogs may have a gray nose), and small, triangular ears that are carried erect.

This dog is powerfully and squarely built, with heavy bones and strong muscles. Its hind legs are relatively straight. The tail is carried close to the back.

DALMATIAN

The distinctive Dalmatian originated in Yugoslavia and has held many roles including shepherd, war dog, sentinel, retriever, ratter, and circus dog. It was in Victorian England that it became known as a coach dog, protecting the horses from marauding dogs as well as adding some style. As automobiles came into being, Dalmatians found a new niche as a fire engine dog and eventually became a popular pet dog as well. It is a high-energy companion that is playful, enthusiastic, and requires plenty of exercise.

The Dalmatian's coat is short and sleek and is white with black or liver-colored spots. Spots should be round, distinct, and well-defined.

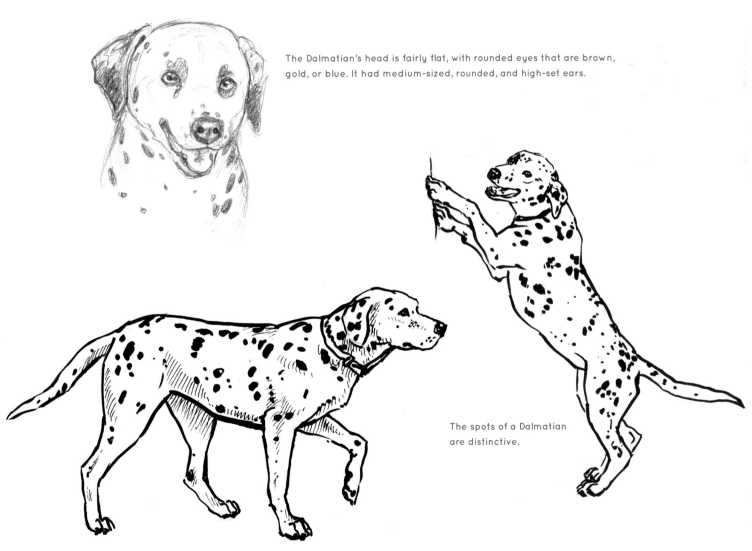

The Dalmatian's head is fairly flat, with rounded eyes that are brown, gold, or blue. It had medium-sized, rounded, and high-set ears.

The spots of a Dalmatian are distinctive.

The Dalmatian is an athletic, sturdy dog with a deep chest, round feet, and a tail carried high with a slight upward curve.

FRENCH BULLDOG

The French Bulldog, or Frenchie, does indeed originate in France. Often popular with high society, this dog is a now a popular and companionable pet. It is playful, amiable, and eager to please.

It has a single, short coat and comes in various colors such as brindle, fawn with a black mask, white, and brindle and white.

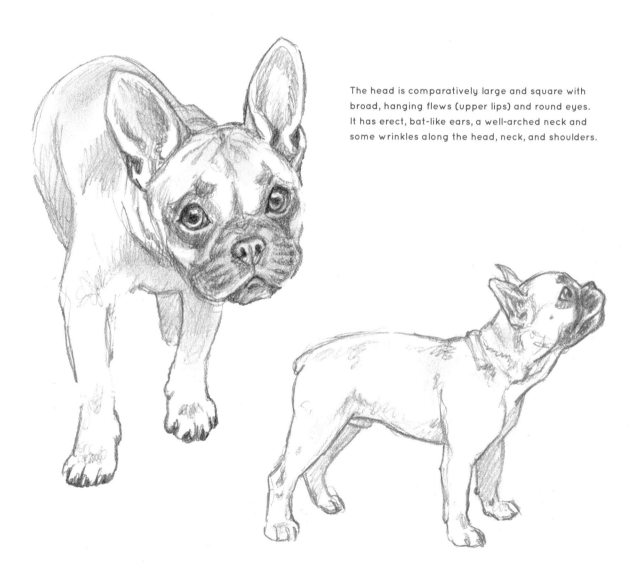

The head is comparatively large and square with broad, hanging flews (upper lips) and round eyes. It has erect, bat-like ears, a well-arched neck and some wrinkles along the head, neck, and shoulders.

The Frenchie has a short straight or screwed tail, which is low-set. The forelegs are straight and muscular and wide-set. The back is strong and short, wide at the shoulders and narrowing at the loins and hips. The hind legs are muscular, strong, and longer than the forelegs.

KEESHOND

The Keeshond, or Wolf Spitz, developed in the Netherlands and has origins as a watchdog, companion, and barge dog, keeping watch on boats. The Keeshond is a well-balanced household companion: lively but not highly demanding, loving, adventurous, intelligent, and affectionate.

The Keeshond has a thick double coat with a downy undercoat and long, straight hair standing off of its body. The color tends to be a mixture of black, gray, and cream. It has black ears, tail tip, muzzle, and eye rings, or "spectacles." It has a lighter, thick ruff of fur on its neck. There is lighter fur on the hind legs called "trousers," as well as lighter fur behind the shoulders, on the feet, and the tail.

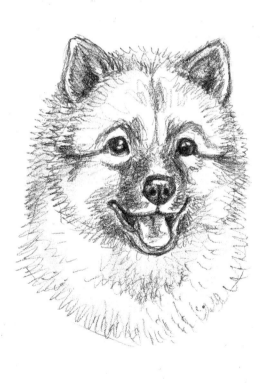

The Keeshond has almond-shaped eyes, a wedge-shaped skull when viewed from above, and small, erect, triangular ears.

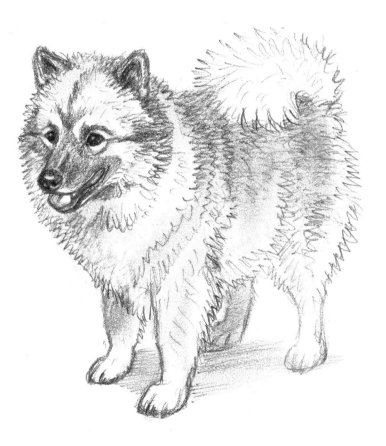

The body is square-proportioned and sturdy. The dog has round feet and a tail tightly curled over and lying flat against its back. Males of this breed may have more fully developed ruffs of fur along the neck.

LHASA APSO

The Lhasa Apso originated long ago in Tibet as a revered companion and watchdog. It is bold, independent, and energetic but not demanding. The long coat requires brushing and grooming.

The Lhasa Apso has a long, straight, heavy coat and comes in various colors.

This dog's head is fairly narrow with long "whiskers" and "beard." It has a level or somewhat undershot jaw and medium eyes. The drop ears are long and heavily feathered.

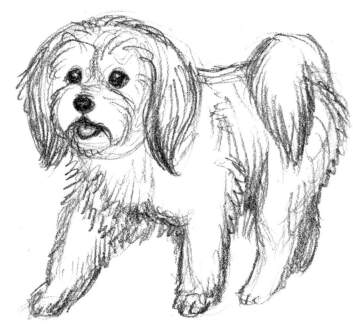

The Lhasa Apso has round feet, a tail that is carried over the back, and a well-developed back and thighs.

POODLE, STANDARD AND MINIATURE

The Poodle is a popular breed that is extremely intelligent, obedient, and playful. The famous Poodle haircut comes from its roots as a water retriever. The balls of fur kept its joints warm in water as well as providing later decoration during entertainment acts. The Poodle has been retriever, circus dog, high society companion, military dog, guard dog, and more. The Poodle is sensitive and devoted to its family. While often associated with high society France, the Poodle originated in Germany. It was later standardized in France.

There are three sizes of Poodle: the Standard (largest), Miniature (medium), and Toy (smallest). The Standard and Miniature are classified by the AKC as Non-Sporting breeds. The Toy is placed in the Toy Group. Standards are better with children given their size though Miniatures can be, with proper socialization for both children and dog.

Poodles have curly, dense, and harsh coats that may be trimmed in a number of ways and can be any solid color. Trims are called cuts or clips.

Poodles have long, fine muzzles, oval eyes, and ears that are set at or slightly below eye level, while dropping down.

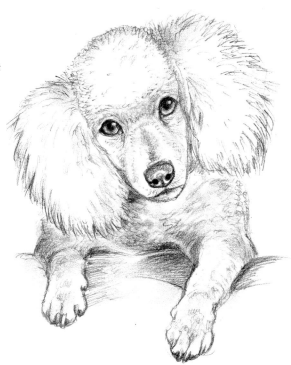

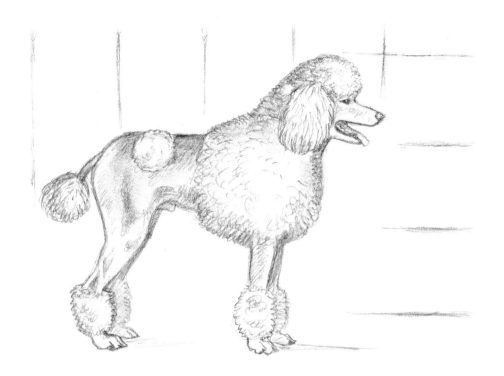

STANDARD POODLE This Standard Poodle sports a show cut called the Continental Clip. Both the Standard and Miniature have level backs, small oval feet with a slightly pinched look, and a docked tail that is straight and often carried up. It is square-proportioned. The length from the breastbone to the rump is about the same distance from the top of the shoulders to the feet. Note how the Standard is about four head lengths long. If you measure from the top of the head to the bottom, it is over three head lengths tall.

MINIATURE POODLE Here's a Miniature Poodle in a Lamb Clip, which is an easy-care, even trim for pet Poodles. Note how the Miniature has a proportionally larger head than the Standard. The body is a little over three head lengths long and about three head lengths tall.

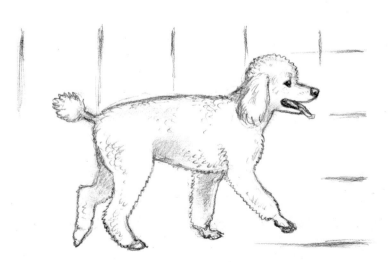

SHIBA INU

The Shiba Inu originated in Japan as a hunting and companion dog, the smallest and likely most ancient of six Japanese breeds. Shiba may refer to either "small" or to a type of brushwood that has leaves which turn red in the fall. Inu is the Japanese word for dog. The Shiba Inu is headstrong, fearless, hardy, and lively but can settle down while indoors with enough exercise. It makes a great watchdog. Shiba Inus are known for the screams and "yodels" they produce when protesting or expressing excitement.

The Shiba Inu has a double coat with a strong straight outer coat and soft undercoat. Colors can include red, red with black overlay (red sesame), black and tan in addition to some cream or white trim.

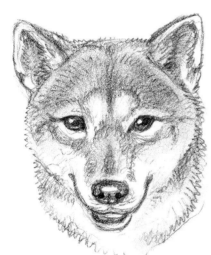

The Shiba Inu has a foxy face with small triangular ears that tilt forward. It has slightly triangular eyes.

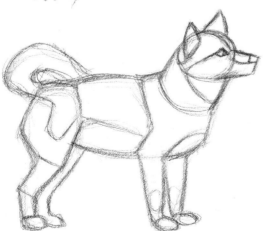

The tail is curled up over the back. The body is compact and muscular. Here, some of the basic shapes are blocked in.

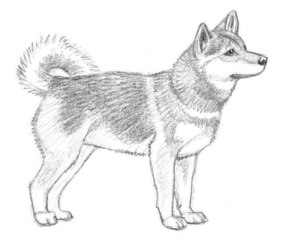

Here's the finished drawing of a Shiba Inu.

Chapter Seven

TERRIER GROUP

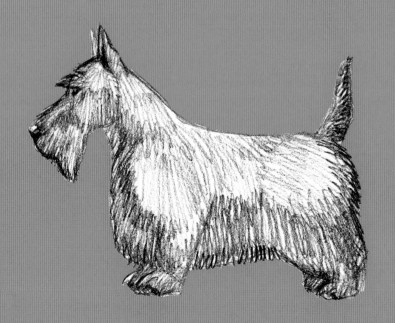

Terriers are known for their feisty, active, and strong-willed temperaments. Most were bred to hunt animals considered to be vermin.

AIREDALE TERRIER

The Airedale has origins in England and was once used in badger and otter hunting as well as bird retrieval. Now it is sometimes put to work as a police dog or guardian. The "King of Terriers" is the largest terrier and highly versatile. This breed is strong, intelligent, and adventurous as well as sometimes stubborn.

The coat of the Airedale is wiry, dense, and hard with some wave and crinkling to the hair. The color is a distinctive tan with a black or grizzled saddle mark on the back.

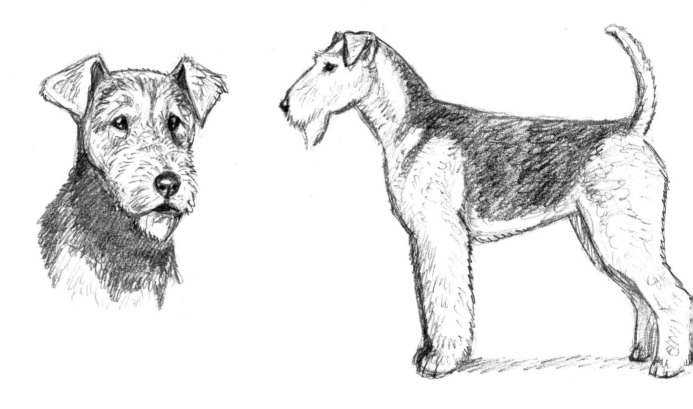

The head of an Airedale Terrier is long and flat, with small eyes and almost no visible stop (where the forehead meets the top of the muzzle in front of the eyes). It has triangular ears that fold above the level of the skull.

The Airedale has a short and level back with a tail that is set high and medium in length. It has long legs and a robust but agile body.

AMERICAN STAFFORDSHIRE TERRIER

The American Staffordshire Terrier is one of the breeds sometimes referred to as a "pitbull." Also known as an Amstaff, this powerful dog is friendly, protective, and usually very good with children. It is very people-oriented and needs exercise and attention. It can be stubborn. It originated in the United States as a bullbaiting dog. Even then, however, the dogs had to be docile and obedient to their owners whether highly excited or not. Bullbaiting was finally banned and the breed shifted into the companion dog it is today.

The Amstaff can come in any solid or partial color, but black and tan, liver, or more than 80 percent white are not preferred. It has a short, glossy coat.

The American Staffordshire Terrier's head is broad, with high-set cropped or uncropped ears. Its jaws are powerful. It has prominent cheek muscles and a distinct stop between the top of the muzzle and forehead.

The basic shapes of an American Staffordshire Terrier's head. Note that the overall head is almost apple-shaped.

The finished drawing.

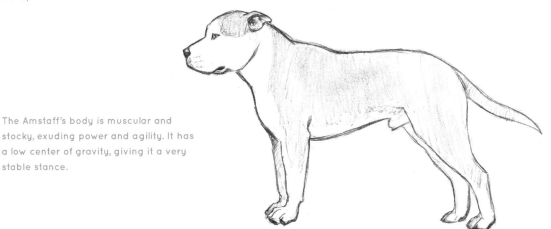

The Amstaff's body is muscular and stocky, exuding power and agility. It has a low center of gravity, giving it a very stable stance.

143

BEDLINGTON TERRIER

The Bedlington Terrier originated in England as a hunter of small game and pests. It is an unusual terrier with a lamb-like appearance. It is sensitive, companionable, quiet, and calmer than some other terriers but can be stubborn and may chase small animals outdoors.

The coat of the Bedlington Terrier is a mixture of fluffy hard and soft hair that contributes to its lamb-like appearance and has sometimes been described as "linty." Some appear almost white but the color standards are actually blue, sandy, or liver, each with or without tan points. Puppies may start out with darker fur that lightens as they age.

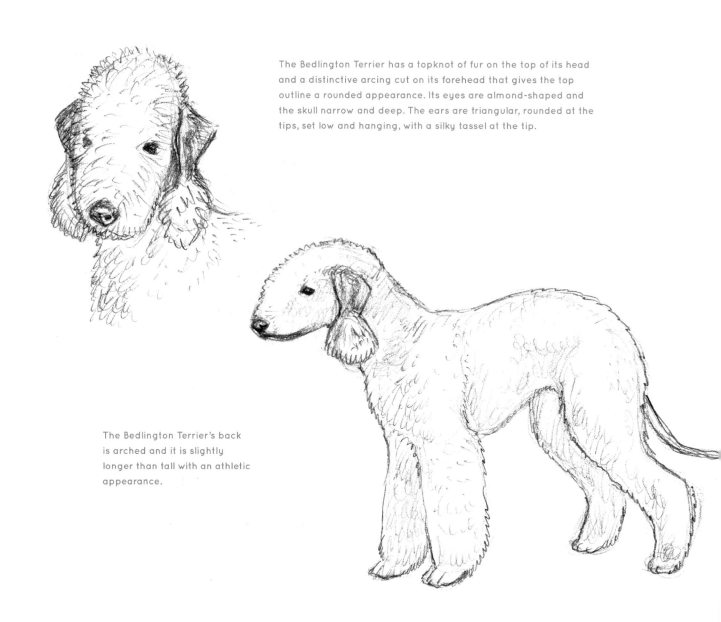

The Bedlington Terrier has a topknot of fur on the top of its head and a distinctive arcing cut on its forehead that gives the top outline a rounded appearance. Its eyes are almond-shaped and the skull narrow and deep. The ears are triangular, rounded at the tips, set low and hanging, with a silky tassel at the tip.

The Bedlington Terrier's back is arched and it is slightly longer than tall with an athletic appearance.

BULL TERRIER

The Bull Terrier has a distinctive, almost football-shaped head. Made famous in the 1980s by the advertising mascot Spuds McKenzie, the Bull Terrier originated in England as a fighting dog and vermin eradicator before becoming the friendly and comical dog we know today. It is still a terrier, though, and can be independent and stubborn.

The coat is short and flat. Dogs may be white with some markings on the head or various other colors with some white. Brindle coloration is often preferred in the breed.

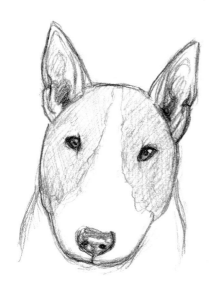

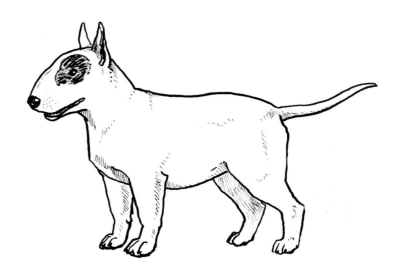

The head is egg-shaped. In profile, the top outline curves from the nose to the forehead. Eyes are small, deep-set, and triangular and ears are small and erect.

The Bull Terrier has a stocky, muscular appearance with a short back, wide chest, and short tail that is carried horizontally.

CAIRN TERRIER

If you've ever watched *The Wizard of Oz*, you have already seen a Cairn Terrier. This was the dog that played Toto. Small, scrappy, and spirited, the Cairn Terrier hails from Scotland with roots as a ratter. One of the oldest terrier breeds, it is energetic and inquisitive.

The Cairn Terrier's coat is weather-resistant, with a soft undercoat and harsh and wiry outer coat. It comes in any color but white. The breed standard favors dark ears, tail tip, and muzzle. Brindle dogs may change color as they age, turning progressively more black or silver.

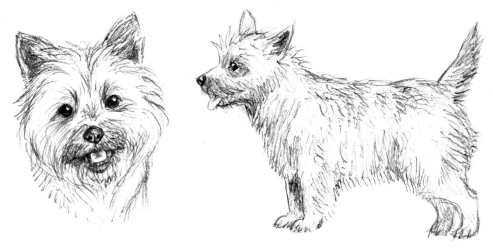

The Cairn Terrier has small eyes and a very broad skull. Its ears are small, pointed, erect, and wide-set.

The Cairn Terrier has short legs and comparatively large feet. Its front feet are bigger than its hind feet.

KERRY BLUE TERRIER

The Kerry Blue Terrier is an Irish breed that originated as a farm dog. It was useful for a variety of purposes, from pest control to herding to retrieving game. Puppies are born black and do not develop their signature blue color until they are about nine months to two years old. It is versatile, well-mannered, adventurous, and said to have a sense of humor.

The coat of the Kerry Blue is dense, soft, and wavy and has a distinctive blue-gray color.

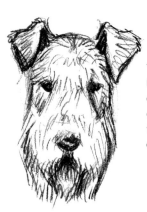

The Kerry Blue has a long head with small eyes and a keen expression. The ears are triangular, erect, facing forward, and folded above the top of the head.

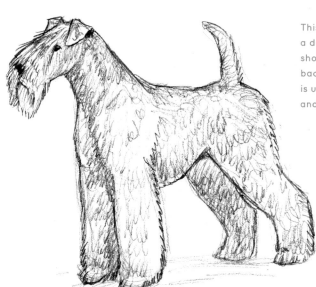

This breed has a deep chest, short and straight back, and its tail is usually docked and carried high.

MINIATURE SCHNAUZER

The Miniature Schnauzer is the smallest and most popular of the Schnauzers and originates from Germany. (There is also a Standard Schnauzer and the even bigger Giant Schnauzer.) The word "schnauzer" means snout or muzzle in German, referring to the dog's distinctive "beard." It is inquisitive, alert, aloof, and playful. It can be stubborn. It is a tough, sturdy breed with origins as a ratter.

This breed has a double coat of wiry outer hair and dense undercoat. Colors can include black and silver, salt and pepper, or black. All-white Schnauzers exist but are not recognized by some breed associations.

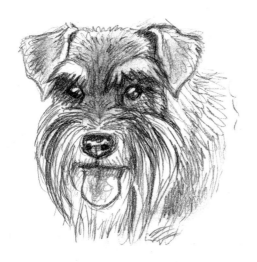

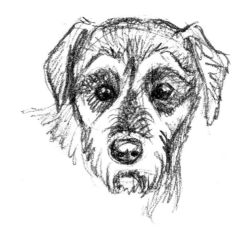

The Miniature Schnauzer can have ears that are cropped to stand upright or they can be natural (as shown here). The ears are set high on the head and natural ones are small and V-shaped, folding close on the head. The head is rectangular with a pronounced "beard" left on the dog. The eyes are deep-set and oval.

This is an older Miniature Schnauzer without as much long hair on its head, showing a little more of the facial shape.

DRAWING A MINIATURE SCHNAUZER BODY

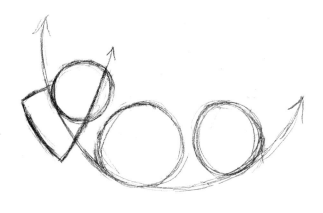

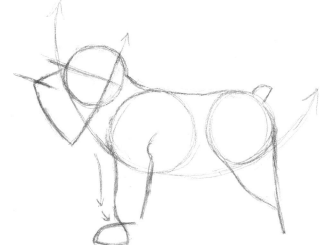

1 The Miniature Schnauzer has a mostly level topline along its back that slopes slightly down toward the hips. The tail is usually docked and held high.

Draw three circles: a small one for the head, a larger one for the chest, and a medium-sized one for the hips. Make sure the bottom of these circles form an arc, as shown by the curved arrow. Draw a triangular shape for what will be the beard and muzzle on the head in profile. The flat bottom of the triangle is the front of the muzzle. The triangular shape should extend into the circle of the head, cutting up the bottom quarter (shown with an arrow). This will form the base of the ear later.

2 Now connect the circles on top with lines to indicate the neck and back. Indicate the tail. Draw two lines on the head circle that indicate where the eyes and nose will go. The eye line should create a slightly tilted plus shape with the line you created inside the head earlier for the base of the ear. The nose line should be parallel to the eye line and cut through the top corner of the muzzle. Draw the front leg as a somewhat tubular shape, letting the line curve down and back (as shown with arrows) to the back of the front paw. Then sweep that line up to indicate the entire front paw and cross the earlier line to connect to the back of the front leg. Next, start drawing the hind leg, showing the front of the leg and giving it a slight curve where the "knee" would be. Sweep down from the rump and angle slightly back until you almost reach the area where the ground would be.

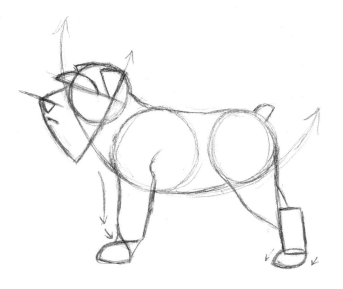

3 Continue working on the hind leg, adding a rectangle for the heel of the foot. The previously drawn hind leg lines should come to a point in front of this rectangle about halfway down it. Draw an oval that slants slightly forward (see arrows) for the hind paw. Add a line connecting the back of the hind leg to the top of the heel rectangle. Add a half circle over the eye line to help indicate where the dog's distinctive "eyebrows" will be. Draw the rest of the ear, making an upside-down triangle using the ear base line to guide you, and the other ear. Draw the triangular nose and a relatively flat line for the mouth that is parallel to the eye and nose lines drawn previously. Draw a stomach. Connect the front paw to the front leg with lines giving the "wrist" some width.

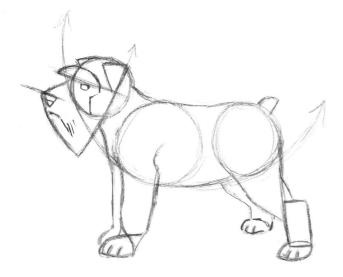

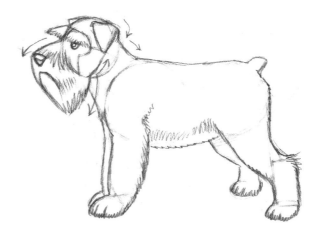

4 Draw the eye below the "eyebrow" and sweep the top curve of the "eyebrow" down to circle under the eye and then drop straight down to the bottom of the head circle. Add some jagged lines on the corner of the mouth to indicate how the fur sweeps down from the visible front part of the dog's "lips." Add the front and hind leg on the farthest side of the dog. Draw toes and the throat, which angles in to meet the bottom of the "beard" in an upside-down V shape and sweeps down to the front of the farthest front leg.

5 Erase some of the guidelines and clean up the drawing so that it is ready for the final lines. Add more definition to the mouth, indicating the shaggy fur hanging down like a moustache. The arrow along the top of the muzzle shows how it arcs slightly and that the tip isn't too sharp. Draw the long hair sweeping down and forward from the muzzle, letting it meet the curved line under the eye you drew earlier. Draw the longer fur along the legs. Define the jawline, letting the moustache spring at an angle from it to the bottom of the muzzle (as shown with arrows). Also bring the back of the head in (shown by the arrows at the back of the neck). Draw some of the shaggy fur along the side and belly. Add a highlight to the eye and nose.

6 Shade the eyes and nose, leaving the highlights. Draw in the fur, using pencil strokes that follow the direction of the hair down and back on the dog's body. Leave some white patches on the cheeks, bottom of the moustache, "eyebrows," the legs, and front of the shoulders. Shade and darken areas around the eyes and in the crease of the ear.

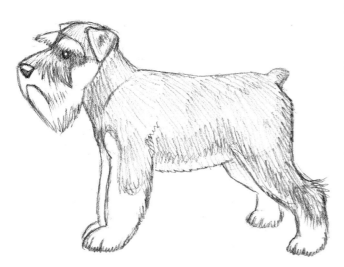

PARSON RUSSELL TERRIER

There are two breeds that started as one until they were split and are often still confused with each other: the Jack Russell Terrier and Parson Russell Terrier. Originating in England, the Jack Russell Terrier is a familiar dog to many, but what is lesser known is that it is not officially recognized as a breed by the American Kennel Club. Parson Russell Terriers are officially recognized by the AKC. Parson Russell Terriers are slightly taller than Jack Russell Terriers, with longer legs and a squarer body. The Jack Russell has a longer body than it is tall. Some still follow their original purpose, which was pursuing foxes into their burrows. Both breeds require a lot of exercise and are small, scrappy, and intelligent dogs.

The Parson Russell Terrier has either a smooth coat (short hair) or a broken coat. A broken coat is short-haired except for longer hair on the head, face, legs, or body. Jack Russell Terriers may also have rough coats, which are longer hair all over the body. Both breeds are predominantly white with tan, brown, or black markings.

DRAWING A BROKEN-COAT PARSON RUSSELL TERRIER HEAD

1 The head of a Parson Russell Terrier features a fairly flat skull, almond-shaped eyes, and small V-shaped ears carried high on the head, with tips pointing toward the ear.

Draw a circle for the head, then a horizontal and vertical line that meet slightly off-center to the right of the center and curve a little toward the right (vertical line) and down (horizontal line). The dog will be facing slightly to the viewer's right. Add a smaller circle for the muzzle that juts out a tiny bit beyond the right side of the main head circle (as shown with dotted lines).

2 Add the eyes along the horizontal head line (one on each side of the vertical line) and ears. Let the farthest ear, on the viewer's right, jut out past the muzzle (where the dotted line is). Add a nose that is mostly below the head circle and to the right of the vertical head line.

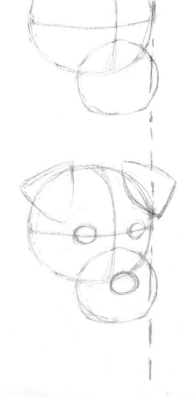

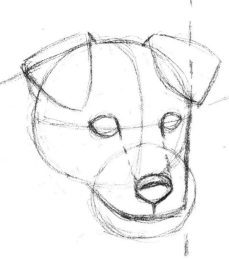 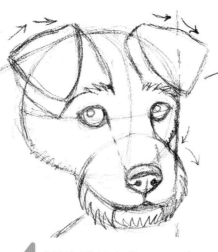 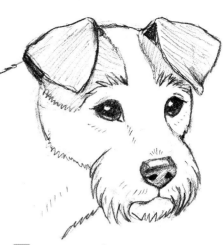

3 Now add more details to the eyes, drawing in tear ducts that line up with the sides of the nose (dotted lines). Connect the triangles of the ears with the top of the head using small lines. Add a line parallel to the top of the nose and a slight pointed tip to the bottom of it. Draw the mouth and connect it with a line extending outward to the bottom of the head circle. Also connect it to the other side of the head, using the dotted line to guide you. Since that side of the muzzle is farther away from the viewer, less is seen and it appears less wide. Draw the back of the neck sloping from the back of the head.

4 Add highlights to the eyes and a slight bump on the tops of the ears (as shown by arrows). Draw in the nostrils and the line dividing the bottom front of the nose. Indicate the tan patches on either side of the head. While putting in the bottom of the patch leave some space between the patches and the eyes, drawing some of the shaggy fur of the dog's "eyebrows." Also add shaggy fur to the dog's muzzle. Define the lower part of the head, letting it tuck in where the farthest eye and muzzle join (the arrows on right).

5 Finish the drawing, erasing guidelines and putting in final lines. Shade the nose and eyes. I left a blank rectangular shape on the top of the nose to indicate a moist highlight. Note also that I darkened the crease in the dog's farthest ear tip and added a few lines to indicate fur on the head.

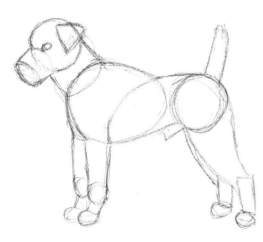

Some of the basic shapes of the Parson Russell Terrier's body. Note how the muzzle forms a tube shape and the back line of the front legs sweeps up to meet the rump. Also note how rectangles fit into the heels of the dog—this is a technique one can use for drawing dog's hind legs.

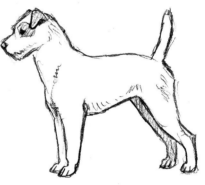

The finished drawing.

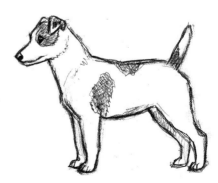

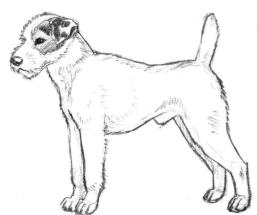

Note how the Parson Russell Terrier (top) has longer legs and a squarer appearance overall than the Jack Russell (bottom). The Jack Russell has a longer, more rectangular body.

SCOTTISH TERRIER

The Scottish Terrier is a well-known breed that is indeed from Scotland. It is fearless, independent, alert, and rugged in build. This breed was developed as a hunter of pests and retains an inquisitive, feisty, determined demeanor. It may be reserved with strangers.

The coat of the Scottish Terrier consists of a dense undercoat and a wiry, hard outer coat. The black Scottish Terrier is perhaps most famous but it also comes in white, wheaten, gray, or brindle as well.

The head is long with a medium width to it. The ears and eyes are small. The ears are erect and pointed.

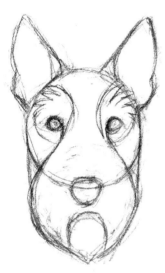
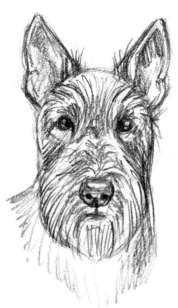

Some of the basic underlying shapes of a Scottish Terrier's head.

The finished drawing of a Scottish Terrier's head.

DRAWING A SCOTTISH TERRIER BODY

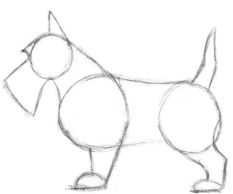

1 The Scottish Terrier has a short-legged, heavy-boned body that is still rather fast and agile. I drew some of the basic underlying shapes of a Scottish Terrier's body, simplified.

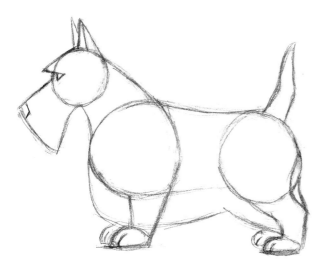

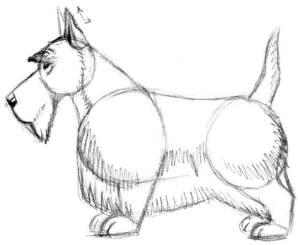

2 I added some of the long, shaggy hair hanging from the body, the rest of the legs and ears, and facial details.

3 I added details to the fur, using long, scribbled strokes to indicate the shaggy hair. I made an indent on the tip of the muzzle where the upper lip curves down to the mouth, then protrudes again as fur sprouts from the chin. The ear tip was pinched to make it look narrower (see arrows). The "eyebrows" were defined and nose and eyes gained details.

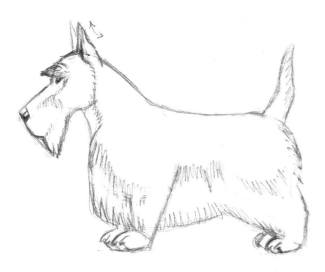

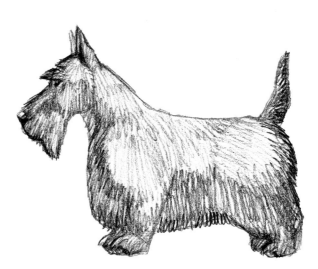

4 Here I erased the foundation lines of the dog's body. I also added some facial and toe details like claws.

5 I finished the drawing, shading with strokes that follow the direction of the fur.

153

STAFFORDSHIRE BULL TERRIER

The Staffordshire Bull Terrier, or Staffie, is an English breed that along with the American Staffordshire Terrier, American Pit Bull Terrier, and sometimes the American Bulldog, is sometimes called a "pit bull." Their tough appearance belies the fact that they are playful, amiable dogs sometimes referred to as "Nanny Dogs" because they are traditionally very good with children, even serving as their protector.

The Staffie has a short, glossy coat and comes in a variety of solid colors, including white, black, red, blue, or fawn, with or without white. It also comes in brindle or brindle and white.

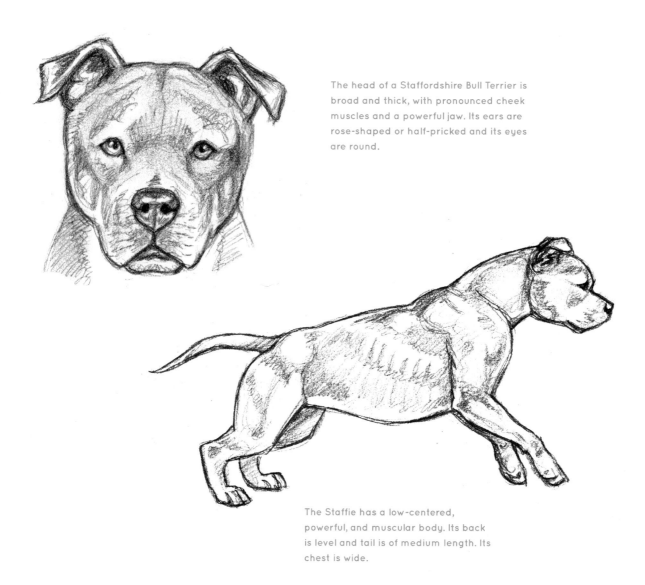

The head of a Staffordshire Bull Terrier is broad and thick, with pronounced cheek muscles and a powerful jaw. Its ears are rose-shaped or half-pricked and its eyes are round.

The Staffie has a low-centered, powerful, and muscular body. Its back is level and tail is of medium length. Its chest is wide.

WEST HIGHLAND WHITE TERRIER

The Westie is a friendly, curious, stubborn terrier with a distinctive white coat. This popular breed is enjoyed as a pet today but originally was bred in Scotland as a hunter of foxes, badgers, and other animals.

The coat is wiry, harsh, and always white in color.

The Westie has a blunt muzzle and a somewhat rounded head, especially when groomed. Its eyes are small and almond-shaped and it has erect, small, pointed ears.

DRAWING A WEST HIGHLAND WHITE TERRIER HEAD

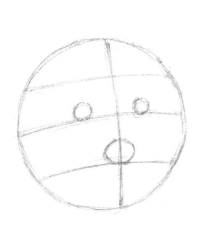 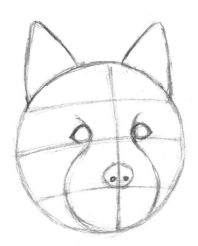 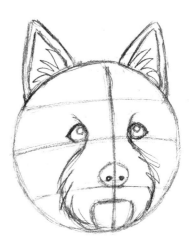

1 First draw a circle. Divide it into quarters with a plus shape, arcing the vertical line slightly to the right and the horizontal line slightly up. Draw the horizontal line just barely above center so that the bottom left quarter is the biggest, as shown. The dog will be looking a little bit to the right of the viewer and up. Draw two additional horizontal lines dividing the bottom half and the top half equally. Add small circles for the eyes above the middle horizontal line and a larger one for the nose in the center of the vertical one right above the bottom horizontal line.

2 Add nostrils to the nose. Draw a muzzle, creating a circular shape on the bottom half of the head circle. Use the inside corners of the eyes to connect the top part and draw down from there. The outside of the muzzle should be about as wide as the outside corners of the eyes. Draw triangular ears, using the top horizontal line on the head as a base for the outside corner of each ear. Add corners to the eyes to make an almond shape for each.

3 Add small circles as highlights to the eyes. Draw the inside rim of the ears and add the long shaggy fur sprouting in front of them. Draw the mouth, which is an almost flat horizontal line just under the nose, then sweep down from either corner in a circular shape to the bottom of the muzzle. Add shaggy fur on either side of the muzzle, pointing downward.

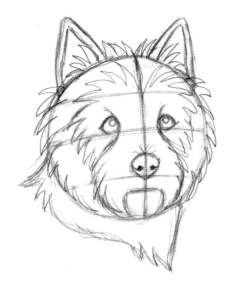

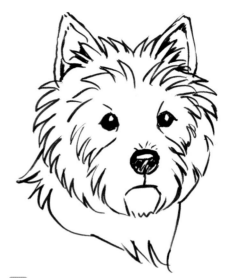

4 At this stage, add shaggy fur all around the head. I included some around the eyes leading to the muzzle and drew shaggy clumps of fur all around the head itself. I also added a neck. Add details to the nostrils on the nose, connecting the nasal holes to the grooves that lead to the outside rim.

5 Ink in the drawing, then erase the pencil lines. In this case I used a brush pen to get a varied line width to my strokes. I added a highlight to the nose and some squiggly lines on the chin to indicate the fur there.

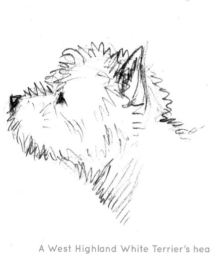

A West Highland White Terrier's head, from a side view.

The Westie has round feet and a carrot-shaped tail. Its body is compact and it has short legs. This is a strong, determined dog that could travel down a fox's burrow.

WIRE FOX TERRIER

There are two kinds of Fox Terrier and both are considered separate breeds. There is the Wire Fox Terrier and the Smooth Fox Terrier (which looks similar but has a short, smooth coat). The Wire Fox Terrier is an energetic, intelligent breed that was bred in England for fox hunting.

The coat is wiry, dense, and may be slightly crinkled, with a short, fine undercoat. The dominant color is white with brown markings and often a black saddle mark.

The Wire Fox Terrier has a long, flat, narrow head with small, round eyes and folded, V-shaped ears set high on the head.

This is a sturdy dog with a square build. Its tail is of medium length and held high.

Chapter Eight

WORKING GROUP

The Working Group consists of dogs bred for various physical tasks, such as pulling sleds, hunting game, or guarding livestock or property.

AKITA

The Akita is the largest breed originating from Japan. Bred to hunt large game, the Akita is renowned and venerated as regal, bold, protective, and devoted to its family. It is demonstrative and affectionate with those it knows and aloof toward strangers. Hachikō was a famous Akita who lived in Japan, waiting for his owner to come home on the train each evening. His owner died at work one day in 1925 but the loyal dog came back at the same time each evening to wait for him until he died in 1935. Many people were moved by his loyalty and it helped produce awareness of his breed, which at that time consisted of only 30 known dogs.

There is some debate as to whether there are one or two separate Akita breeds, the Japanese Akita and the American Akita. In many countries they are considered two breeds but in the United States and Canada all are classified as one.

In Japan, accepted Akita colors include all white or red, sesame, brindle, or fawn with white markings on the muzzle, neck, chest, body, tail, and inside of legs. In the United States and Canada, other colors are allowed in the show ring, including black or white masks and pinto splotching. The fur is short and thick, though some long-haired dogs do exist.

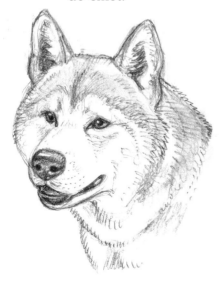

The Akita is a Spitz-type breed and has small, triangular eyes, a large, bear-like head, and erect, pointed ears that are set at a similar angle to the neck from a side view. The stop between the top of the muzzle and the forehead is pronounced.

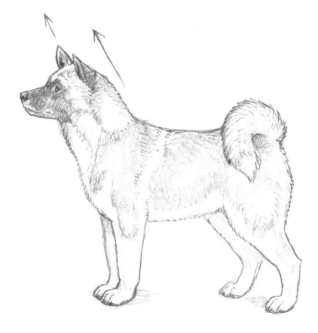

The Akita's body conveys power and grace. Heavy-boned, it is slightly longer than tall. Its tail is large, plumed, and curves up over its back gently or in a double curl.

ALASKAN MALAMUTE

This breed originated in the state of Alaska in the United States as a large game-hunting and heavy-sled-pulling dog for the Inuit people known as the Mahlemut (now known as Kobuk) who lived along Alaska's northwest coast. People and dogs lived, worked, and hunted together in a close relationship. A New England dog-racing enthusiast began breeding the dogs in the 1920s when the Malamute was in danger of being lost to an influx of dogs coming into Alaska. Today, this beautiful, strong, playful, and independent dog has many admirers around the world. Sometimes confused with Siberian Huskies, the Malamute is a larger, more heavy-boned dog.

The Alaskan Malamute has a thick double coat that provides it with excellent insulation, with a coarse outer coat and wooly, oily, and dense undercoat. Accepted colors include all white or red, sable, or light gray to black with white shading and a white mask.

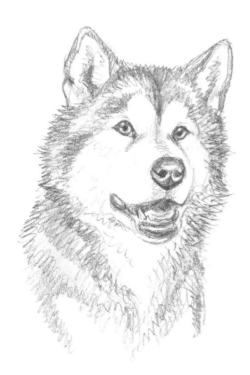

The Malamute has a large muzzle and broad head. Its ears are triangular and slightly rounded at the tips. Eyes are almond-shaped.

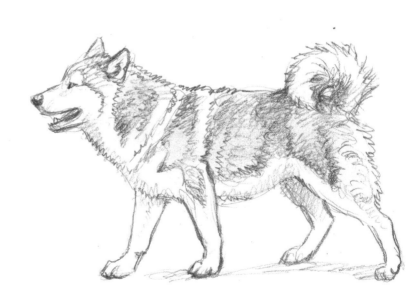

Slightly longer than tall, the Malamute has a powerful build and tireless gait. Its paws are large and its fully plumed tail is carried over its back.

BERNESE MOUNTAIN DOG

Originally from Switzerland, the Bernese Mountain Dog has been useful as an alpine herder, flock guard, and general farm dog since ancient times. It is loyal, easygoing, and gentle with children. It enjoys being outdoors and is suited for cold weather but likes to stay close to its human family.

The coat of this breed is thick, moderately long, and either straight or slightly wavy. It is tricolored, with a black body, rust markings and white flashings (patches) on its muzzle, and a stripe between the eyes, throat, belly, and inside of the legs. The rust color shows as dots above its eyes, patches on either side of its mouth, a small rust rim around the white chest, and rust markings on the legs.

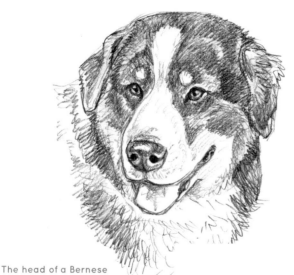

The head of a Bernese Mountain Dog has a well-defined stop between the top of the muzzle and the forehead from profile. The ears are triangular with rounded tips and hang close to the head.

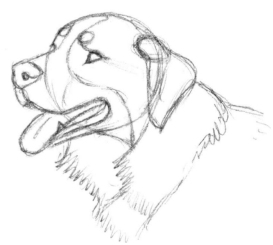

A Bernese Mountain Dog's head, showing some of the basic geometric shapes it consists of.

This is a large, muscular dog that is slightly longer than tall. It has round feet that have arched toes and a bushy tail that is held low. Its dewclaws are often removed.

BOXER

The Boxer is a popular breed that originated in Germany for bullbaiting, hunting, and guarding purposes. Today it is enjoyed as a playful, inquisitive, and devoted companion to the entire family. It is active and requires plenty of exercise. Sometimes stubborn and headstrong, it responds to positive training techniques. It makes an instinctive guardian.

The Boxer's coat is short and glossy. It may be fawn or brindle with or without white patches and a black mask. In the UK and Europe, fawn-colored Boxers may come in a rich, deep color and be called "red." There are also Boxers that are largely white though they are not accepted in the show ring.

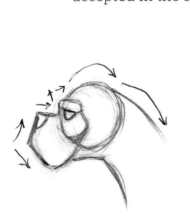 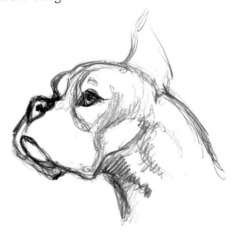

The Boxer has a blunt, broad muzzle and an undershot bite with a lower jaw that juts prominently forward. There are shallow wrinkles on the forehead and a distinct stop between the top of the muzzle and the forehead. Ears may be cropped or uncropped, though in the AKC, it is preferred that show dogs have cropped ears. In the drawing on the left, note the distinct angles of the head in profile, as shown by arrows. On the right is a Boxer head at a three-quarter angle, showcasing some of the major forms and shapes.

DRAWING A BOXER HEAD

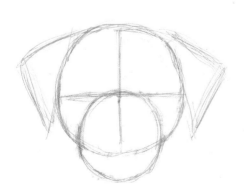

1 Begin by drawing a circle for the head and lightly draw a "plus" shape centered inside it to guide placement of facial features. Add a smaller circle for the muzzle in the bottom half of the larger circle. Finally, block in upside-down triangle shapes for the ears. Align the top of the triangles with the top of the head circle.

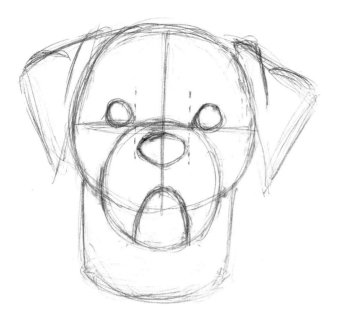

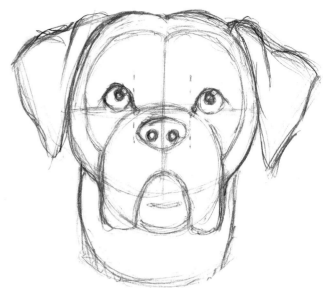

2 Block in oval shapes for the eyes above the center horizontal dividing line of the head. Keep them an equal distance from the center vertical dividing line and the outside of the circle. Draw an oval for the nose, using faint dotted lines if you'd like to be sure it aligns with the inside corners of the eyes. Add an inside fold in the ears on each side and a C shape for the mouth. Add a cylinder shape for the neck.

3 Go back and fine-tune the head, taking more care while drawing the outlines of the eyes, nose and nostrils, ears, and other features. Add pupils to the eyes and small circles for the highlights. You can block in the area of the cheekbones and the bony forehead around the boxer's eyes as well. Lastly, add the loose skin hanging from the dog's lips, making the bottom of the lips align with the bottom of the jaw.

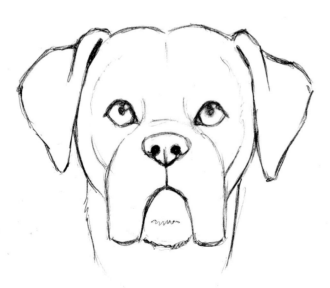

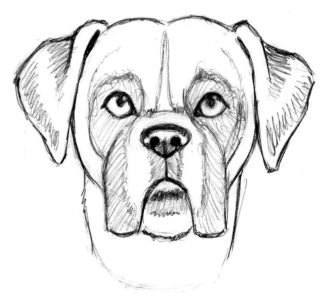

4 At this stage, you can go back and erase most of the guiding lines and darken outlines you wish to keep. The pupils and nostrils are shaded in.

5 Now begin shading parts of the fur and markings. Add the dark markings around the muzzle, jowls, and eyes. Indicate a white streak between the eyes linking to the white on the middle of the muzzle. Add tone under the top rim of the eyes and begin shading the top and bottom of the nose. Shade in a wide, horizontal line to indicate the lip and then darken the area underneath it. Also begin shading the indented areas of the ears.

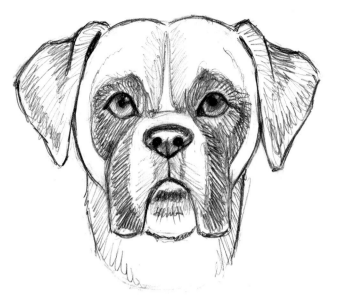

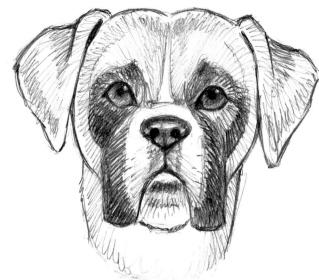

6 Refine the drawing further, shading in more of the eyes and nose. Go back into the dark patches on either side of the muzzle and continue adding pencil strokes to tone it in. Lightly add some shading in the lighter areas of the muzzle (toward the top lip) to add more of a blended effect. Shade the ears and neck more. Begin lightly shading in the fur on each side of the white streak on the forehead.

7 Finish the drawing, shading in more of the fur on the head and neck. Go back over the black markings on the sides of the muzzle and around the eyes and darken them more. Define highlights on the nose and make sure the highlights of the eyes are distinct, erasing if needed to achieve white space. Darken the eyes a little more. Add subtle hints of whiskers and whisker follicles.

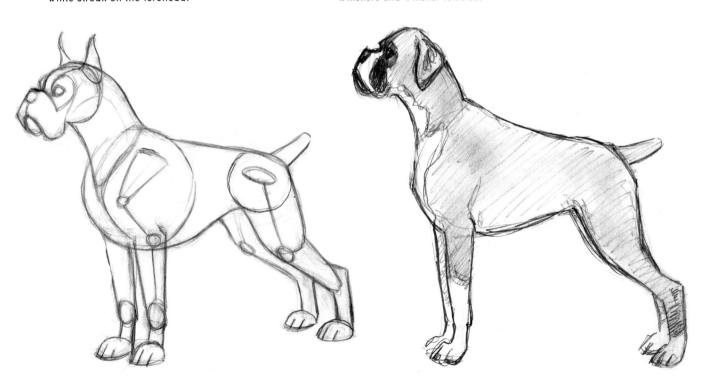

The Boxer is an athletic, muscular dog with a deep chest and a square build. The back slopes down a little from the shoulders and the tail is set high and docked under AKC standards. This drawing shows some of the basic shapes that make up the Boxer's body and the skeleton structure underneath. Note the deep chest that consists of a circular shape, the arched neck, straight front legs, and hind legs that slope back. The Boxer has a solid appearance.

A Boxer showing typical markings.

DOBERMAN PINSCHER

The Doberman originated in Germany as a guard dog for a man named Herr Doberman. In the late 1800s he developed a dog that could accompany him on his rounds as a tax collector and it didn't take long for the breed to gain popularity. Today, the Doberman Pinscher is valued as an intelligent, active, and highly trainable guardian, family pet, show, and/or work dog.

The Doberman's fur is short and glossy. Colors are black, red, fawn, or blue with tan.

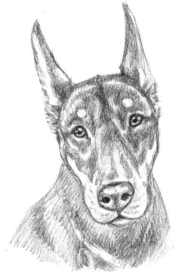

The Doberman's head is long, eyes almond-shaped, and expression keen. Its ears may be cropped and carried erect or uncropped and hang naturally to the side.

DRAWING A DOBERMAN PINSCHER HEAD

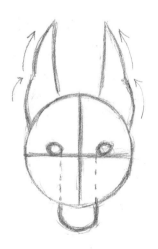

1 Draw a circle and add a plus shape to divide the circle into equal quarters. Draw thin, sharply tipped ears that pinch in slightly on the outside. Add the eyes just above the center horizontal line. Draw the nose using the inside corners of the eyes as a guideline. The inside corner of the eyes and outside edge of the nose should line up. Draw the nose just under the head circle.

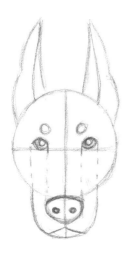
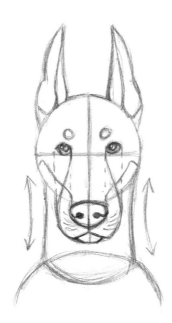
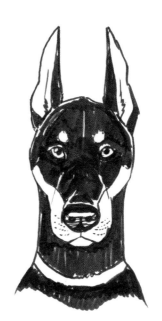

2 Add eye spots above the eyes and show the front part of the outer ear with lines dividing it from the inside of the ears. Note the inside line is about in line with the outside of the eyes. Draw the muzzle as a somewhat rounded rectangular shape, using the outside of the eyes to help guide you on width. Draw the top of the nose and continue the middle vertical dividing line below the head circle to the jaw. Add the nostrils of the nose on either side of that dividing line and add the mouth. Define the eyes more and add pupils.

3 Add more definition to the base of the ears and connect the nostrils to the sides of the nose. Add smaller circles overlapping the pupils to indicate highlights. Draw four slightly curved rows on the muzzle from the sides of the nose to help place whisker follicles. Connect the upper jaw to the inside corners of the eyes with a slanted line and block in the tan patches on the cheeks. Tuck in the lower jaw a little. Add the neck and a curved line to indicate the chest. Note that the neck is slightly concave and slopes inward at the center on either side.

4 Finish the drawing. In this case I used a brush pen to ink in the drawing, then erased the pencil lines.

The Doberman Pinscher has a sleek, muscular, square-proportioned build with a deep chest and powerful hindquarters. The tail is often docked in countries where it is allowed.

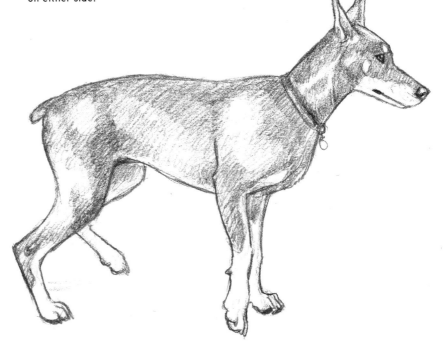

GREAT DANE

The Great Dane is one of the tallest dog breeds. It originated in Germany as a guardian and hunting dog for large game. It may have resulted from crossing the ancient and now extinct Molossian dog with other breeds. Dependable, courageous, and good with children, the Great Dane makes a gentle giant.

The Great Dane's coat is short, glossy, and thick. It may be brindle, harlequin (white with black patches), black and white, blue, or fawn with a black mask.

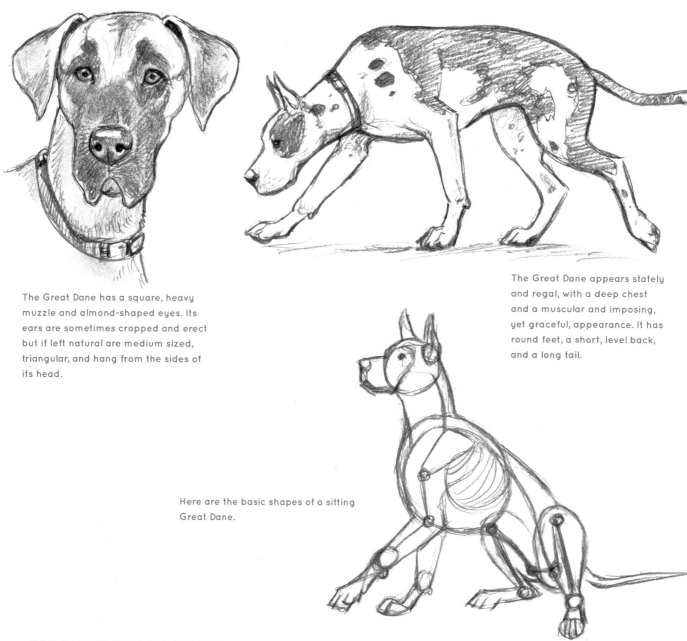

The Great Dane has a square, heavy muzzle and almond-shaped eyes. Its ears are sometimes cropped and erect but if left natural are medium sized, triangular, and hang from the sides of its head.

The Great Dane appears stately and regal, with a deep chest and a muscular and imposing, yet graceful, appearance. It has round feet, a short, level back, and a long tail.

Here are the basic shapes of a sitting Great Dane.

GREAT PYRENEES

The Great Pyrenees originated in France as a guard dog during ancient times, a job it continues to do to this day. It also enjoyed some time as a dog of the French royalty, being declared the "Royal Dog of France" in 1675. This breed, also known as a Pyrenean Mountain Dog, resembles the sheep it protects as it travels with its flock. It looks imposing and tends to be reserved around strangers, whether human or otherwise. It is aggressive toward predators but gentle toward its flock and children. Around those it knows, it is serious, calm, fearless, and sometimes stubborn. This breed is noted for having double dewclaws on each of its hind legs.

This breed has a weather-resistant, double coat that consists of a wooly undercoat and long, flat hairs in its outer coat. It is white or white with some tan, reddish brown, or gray markings called badger.

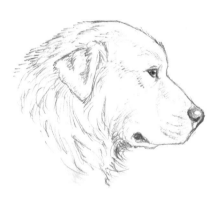

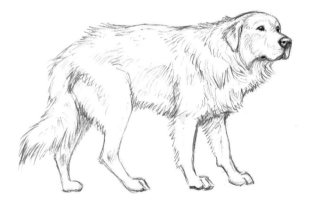

The Great Pyrenees muzzle is the same length as the rest of its skull. The head, including muzzle, is somewhat square with a slightly rounded top. Its eyes are medium sized and almond-shaped and its ears are V-shaped with rounded tips. Its expression is contemplative.

This dog is slightly longer than tall and has a sturdy build that combines strength with agility. It has round feet and its hind feet tend to toe out slightly. Its tail is well plumed.

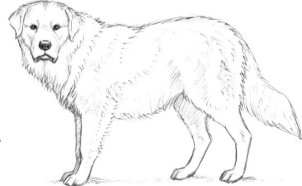

SIMILAR BREEDS There are several other similar breeds. These large, white guard dogs of European origin include breeds such as the Kuvasz, Akbash Dog, Polish Tatra Sheepdog, Slovak Cuvac, and the Italian Maremma Sheepdog. This is a Maremma Sheepdog, which is slightly smaller than the Pyrenees.

NEAPOLITAN MASTIFF

This breed originated in Italy as a guard dog during ancient times, working with livestock, protecting homes, or fighting. Today the dog is a gentle giant if socialized properly. Neapolitans are loyal and devoted to their family but reserved toward strangers.

The Neapolitan Mastiff has a very wrinkled appearance and loose skin. Its short coat comes in several colors, including gray, black, tawny, or mahogany.

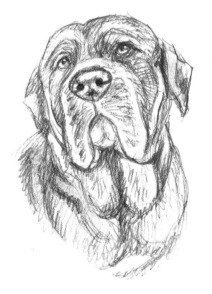

The Neapolitan Mastiff's massive head has pendulous lips and an ample dewlap (flaps of skin hanging from the throat or jaw). It has deep-set eyes and ears that may be cropped or uncropped.

This breed is powerful and rectangular in body, with a level back and round feet. Its tail may be docked by one third. This drawing shows some of the basic shapes of the dog's body.

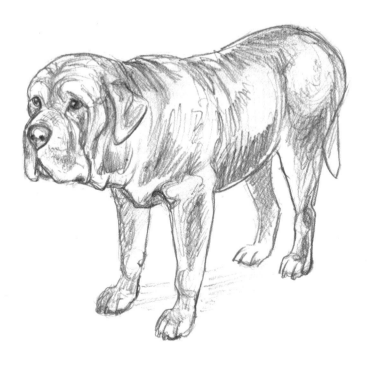

Here's the finished drawing of a Neapolitan Mastiff.

NEWFOUNDLAND

The Newfoundland (Newfie) is an all-purpose water dog that was developed in Canada to haul heavy fishing nets and do other work for fishermen both on land and in the water. This large, strong dog is known for its calm demeanor and its loyalty. It is friendly and easy-going unless its family is threatened; then it will act protectively. It has webbed feet that help it swim with powerful strokes in the water and strong lungs for swimming great distances. Newfies have rescued many people from drowning.

The Newfoundland has a waterproof double coat consisting of a soft, dense undercoat and a thick outer coat. Colors include black, brown, gray, or a black and white spotted pattern called the Landseer for artist Sir Edwin Henry Landseer, who often painted them. Some consider the Landseer a separate breed.

The Newfie has a powerful, big-boned body. The tail is held down when relaxed.

The Newfoundland has a broad head and small, deep-set eyes. Its ears are triangular with rounded tips. It may drool due to droopy lips and jowls. Here I've blocked in the basic shapes of a Newfie's head.

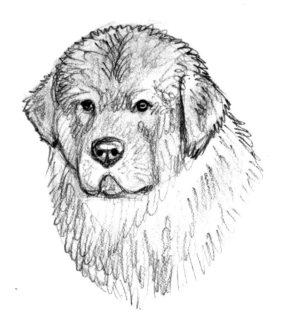

Here's the finished Newfie drawing.

DRAWING A NEWFOUNDLAND

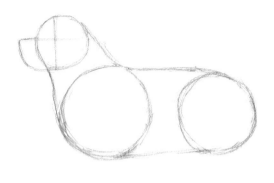

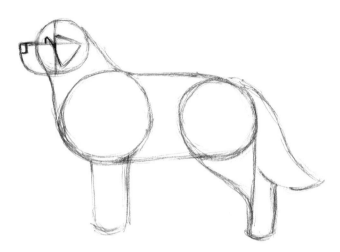

1 Draw a circle for the head, chest, and hips. The chest is largest of the three. Draw intersecting lines on the head, one horizontal and one vertical, keeping the intersection slightly left of center. Draw the muzzle using the horizontal line as a guideline and keep the muzzle deep and short. Connect the head, chest, and hips with back, belly, and neck, keeping the body and neck fairly thick.

2 Add a nose and an eye, using the middle horizontal line of the head to help place them—below for the nose and above the line for the eye. The eye at this point is sort of an upside-down check shape. Add a slightly tilted triangular ear, using the middle vertical line of the head for the front edge. Bring the top left corner of the ear slightly above the horizontal dividing line but still right along the vertical line. Slope the top of the ear down to meet the horizontal dividing line farther back on the head, almost to the back but not quite, as shown. Add a somewhat round-bottomed rectangular shape for the front leg. Draw the hind leg, creating a fairly straight line that slopes from the rump down to the front of the hind foot just above the toes. Draw the heel and rest of the hind leg. Draw the tail.

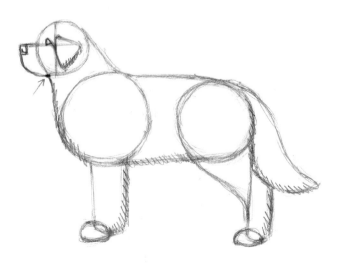

3 Draw the feet as ovals that overlap and slightly jut out in front of the legs. Start adding more details, such as defining the bottom of the eye, adding the nostrils, and beginning to add a shaggy look to the ear. Draw the mouth, which is somewhat obscured by low-hanging flews, or the upper lips, but the mouth's corner is visible at the bottom of the muzzle (see arrow). Begin adding some of the heavy fur on the legs and chest.

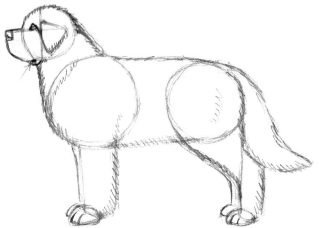

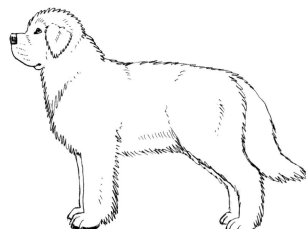

4 Add the jowls, or hanging corner of the mouth, where the arrow points. Draw the highlight in the eye. The pupil will go just behind it. Add whisker follicles on the muzzle, toes, and define some of the elbow, overlapping ruff of fur on the neck, and along the haunch, or upper thighs and rump. Begin drawing the shaggy fur on top of the head, letting it indent slightly at the very back of the head. Draw the legs on the opposite side of the body, echoing the front lines of the front and hind legs to indicate their counterparts.

5 Finish the drawing. In this case I inked it in, then erased the pencil lines once the ink was dry. Use squiggly, short, back and forth strokes that indicate shaggy fur on the dog's outline. Make sure to add the pupil and let the white highlight overlap it slightly. Add heavier lines to draw paw pads underneath as you define the toes.

ROTTWEILER

The Rottweiler probably originated as a drover dog, responsible for driving and guarding cattle in Germany. A center for this was the town of Rottweil, which is how the dog earned its name. Today it is popular with many as a security, police, or guide dog, for dog sports like Schutzhund, or as a companion. It can be headstrong, protective, and is intelligent and self-assured.

The Rottweiler's coat is short, dense, and is black with tan markings.

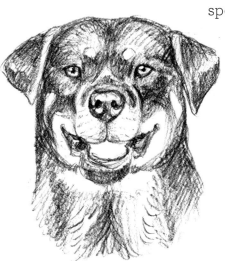

The Rottweiler has a broad, powerful head, with medium-sized, triangular ears set high on the head. Its nose is broad and always black. The stop, or place where the top of the muzzle meets the forehead, is well-defined. Its forehead may appear slightly wrinkled at times.

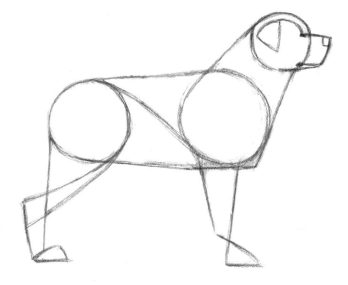

These are some of the basic shapes of the Rottweiler's head. Note the tan around the lips and the tan cheek patches as well as the tan eye spots and throat patch.

The Rottie is a muscular dog with a thick neck, a straight, strong back, and may have a docked tail. The chest is deep and broad and front legs are straight. The hind legs are muscular. Here are some of the basic shapes that make up the Rottie's body.

Here's a finished drawing of a Rottie with a docked tail. The full tail can be seen on right. There are tan patches on the front of the shoulders and tan just under the tail as well as the legs.

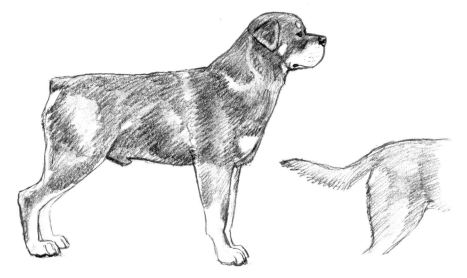

SAINT BERNARD

The Saint Bernard originated in Switzerland. Several of these immense canines served as search and rescue dogs near the St. Bernard Hospice, a stay for travelers going between Switzerland and Italy. This gentle giant has saved thousands of people lost in the alpine mountains. One dog named Barry, born in 1800, is credited with saving at least forty people's lives, including that of a young boy he found by himself and brought back to safety on his back.

This dog's coat may be smooth (short, dense, and flat hair) or rough (long, straight, or wavy hair). Colors include red or brindle with white.

White should appear on the muzzle, neck, a stripe between the eyes, chest, feet, tail tip, and possibly elsewhere. There may be dark coloration on the face and ears.

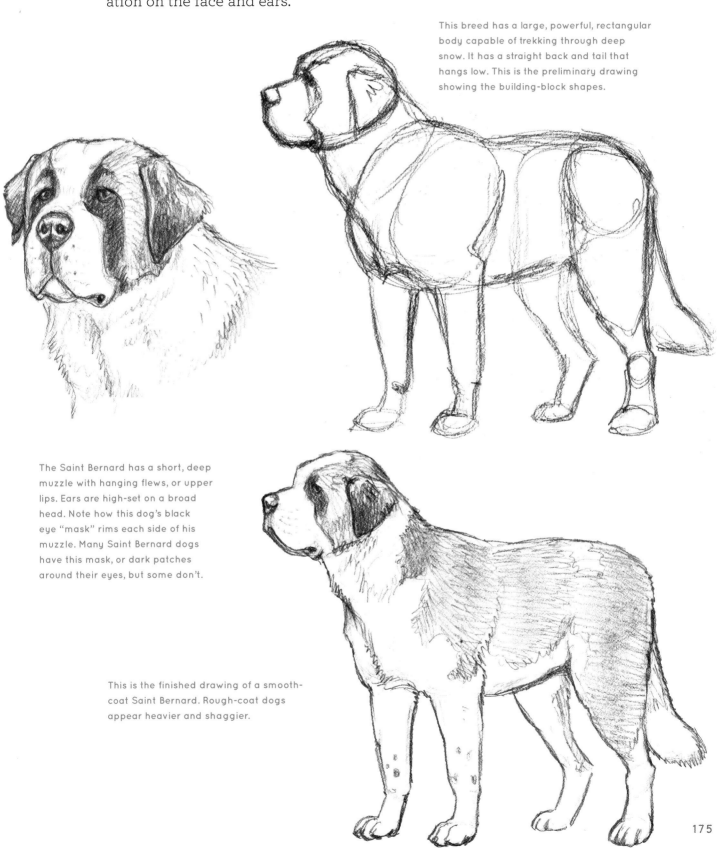

This breed has a large, powerful, rectangular body capable of trekking through deep snow. It has a straight back and tail that hangs low. This is the preliminary drawing showing the building-block shapes.

The Saint Bernard has a short, deep muzzle with hanging flews, or upper lips. Ears are high-set on a broad head. Note how this dog's black eye "mask" rims each side of his muzzle. Many Saint Bernard dogs have this mask, or dark patches around their eyes, but some don't.

This is the finished drawing of a smooth-coat Saint Bernard. Rough-coat dogs appear heavier and shaggier.

SIBERIAN HUSKY

The Husky is an ancient breed that originated in Russia as a sled-pulling dog, a function it continues to serve today. It is a hardy, tireless dog capable of traveling long stretches through harsh winter conditions. It is smaller than the Alaskan Malamute but an equally hard-working sled dog. Balto was a famous Siberian Husky who helped deliver life-saving serum to the town of Nome, Alaska, and surrounding areas in 1925. The 1925 Serum Run to Nome included 20 mushers and about 150 sled dogs. The Husky's coat is thicker than most dog breeds, offering protection from the elements with a dense double coat. It can come in a variety of patterns and colors. It usually has a white face, paws, and tail tip.

The Husky is slightly longer than tall, compact, and combines strength with agility. It has a tireless pace. The back is level and tail is well furred, carried in a curve when alert or hanging down when relaxed. The feet are oval and also well furred.

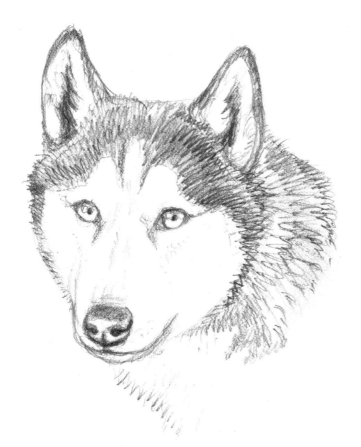

The Siberian Husky has almond-shaped eyes that may be brown, blue, or any combination of the two. The top of its head is slightly rounded and its ears are erect, furry, and have slightly rounded tips. Nose color may vary from black to liver to splotches of pink (snow nose).

DRAWING A RUNNING SIBERIAN HUSKY

1 First draw a circle for the head. Then draw a vertical line on its left side extending down for a bit. Measure three head lengths vertically down, starting with the head as the first of the three (as shown by the numbers 1, 2, 3). Then draw a similar, parallel line at the back of the head circle. From that, draw the larger chest circle to its right. Measure one more chest length (as shown by the numbers 1, 2). Then draw the circle for the hips, slightly above and smaller than the chest. Have it reach just a little bit beyond the right of the second chest-length measurement.

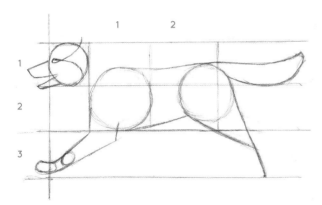

2 Draw the muzzle and lower jaw, letting the top tip of the lower jaw hit the second horizontal dividing line (or first head width). Place the eye near the top outline of the muzzle, using a sort of teardrop shape to not only draw the eye, but also sweep up toward the back top of the head as well as sweep down to define the cheek patch. Use the second vertical head line (the one at the back of the head) to draw down to the third horizontal line and indicate the shoulder. Continue the leg line, drawing the front leg sweeping forward and placing the center of the front paw on the left vertical line. Draw the rest of the front leg, bringing the elbow up into the chest at about the center. Draw the hind leg, sweeping down from the rump and continuing to the bottom horizontal line. Draw the front of the hind leg, sweeping to meet the back of the hind leg you just drew. Draw the belly and back, sweeping on to draw the bushy tail. The bottom of the tail should curve along the second horizontal line.

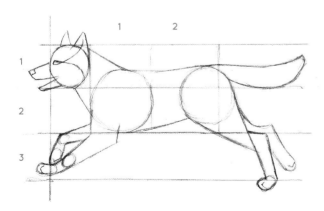

3 Add the ears, using the line sweeping up from the eye to help place the inside of the ear. Draw the other ear and add the nose. Draw the neck and finish the hind leg, using the third horizontal line to place the hock, or ankle, of the dog's foot. Add the hind paw, placing its top along the bottom horizontal line. Add the opposite front and hind legs. The opposite front leg's wrist joint meets the third horizontal line. The bend of the wrist forms slightly squished triangles in the negative, or empty, space both in front and in back of it. Add V-shaped toes.

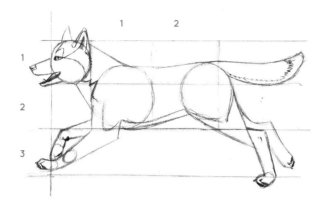
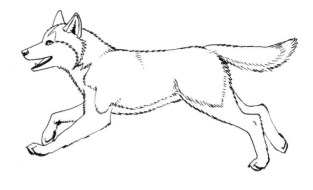

4 Finish drawing the details, adding an arch over the eye and then a line traveling up the forehead until it tapers to the top of the head. Draw the inside rims of the ears and a smaller rectangular shape for the highlighted top of the nose. Add the nostril visible in the nose and draw the pupil in the eye as well as the dark tear duct in front of the eye. Indicate the canine tooth, draw the tongue, and darken the lips on the lower jaw. Also add toe pads on the toes, which are thin ovals sweeping down from the forward point of each toe. Add short nails jutting out from the tips of the toes. Draw the dewclaw and pad behind the wrist of the farthest front leg. Go back and indicate the rest of the dog's markings, using the second vertical line to help you draw the more jagged line along the neck and using the third horizontal line to help draw the place where darker coloration meets white along the shoulder. Draw the white belly and the white "stockings" on the hind legs that come to a point just below the original circle of the hip. Draw a white rim under the tail and the white tail tip.

5 Finish the drawing, inking in the final lines and then erasing the pencil marks if needed.

STANDARD SCHNAUZER

The Standard Schnauzer is larger than the Miniature Schnauzer (see page 147). Like the Miniature, the larger Standard originated in Germany as a ratter. It is the smallest and most popular of the Schnauzers and a playful, alert, well-mannered, and aristocratic companion.

The Standard Schnauzer has a rough double coat consisting of a wiry, harsh outer coat and dense undercoat. Color is typically salt and pepper, black and silver, or simply black.

The head of a Schnauzer should be long and rectangular, with deep-set, small oval eyes. The ears may be cropped to stand erect or left natural, small, and triangular, pointing forward at the tips. The dog often appears to have eyebrows and a beard.

DRAWING A STANDARD SCHNAUZER HEAD

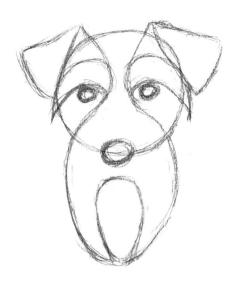
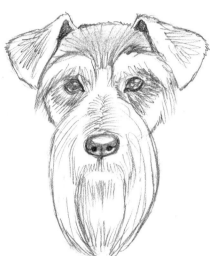
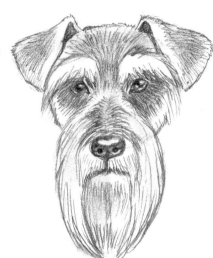

1 Sketch in some of the basic underlying shapes of a Standard Schnauzer's head.

2 Here I began penciling in the fur of the dog's head, paying attention to the direction of the hair. I smudged the top of the dog's forehead but haven't done it to the rest of the head yet. I also began shading the eyes and nose.

3 Next, I smudged the pencil lines, creating a soft shading over most areas of the Schnauzer's face. Then I went back and added more lines, including shorter lines along the forehead and more shading in the eyes and nose.

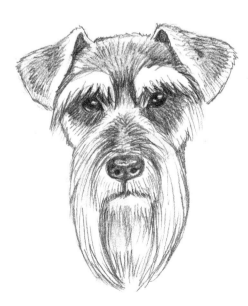
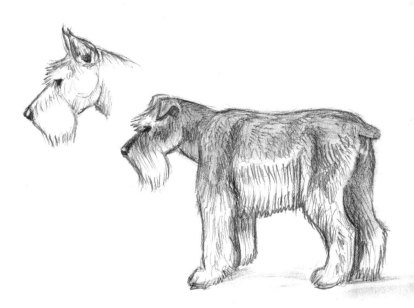

4 Finally, I went back with more lines, darkening areas like the fur below the eyes, on the top of the muzzle, and sides of the forehead as well as the eyes and nose.

This breed has a robust, square build. Its tail is often docked and carried high. The back top line slopes a little from the shoulders. The Standard Schnauzer is often used in competitive dog sports such as agility, obedience, and tracking as well as things like therapy work.

Chapter Nine

TOY GROUP

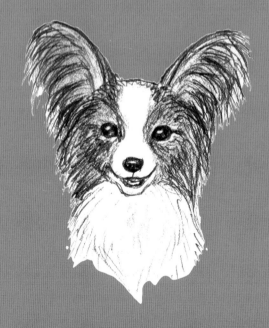

Dogs in the Toy Group tend to be small and were mostly bred for human companionship. They have all the attitude (and then some) of larger breeds, however.

CAVALIER KING CHARLES SPANIEL

This dog derives its name from King Charles II of England, who was a devoted fan of the breed. The Cavalier was a lapdog and companion and its popularity continues to this day. This small spaniel is friendly, gentle, playful, and good with children and animals. It is eager to please and seeks human attention. Best as an indoor dog, it still enjoys romps and exercise outside.

The Cavalier King Charles Spaniel has a medium-length, silky coat that may have a slight wave to it. There is long feathering, or fur, on the feet. This breed comes in four colors: ruby (red), Blenheim (white with red markings and sometimes a red spot on the top of the forehead), black and tan, and tricolor.

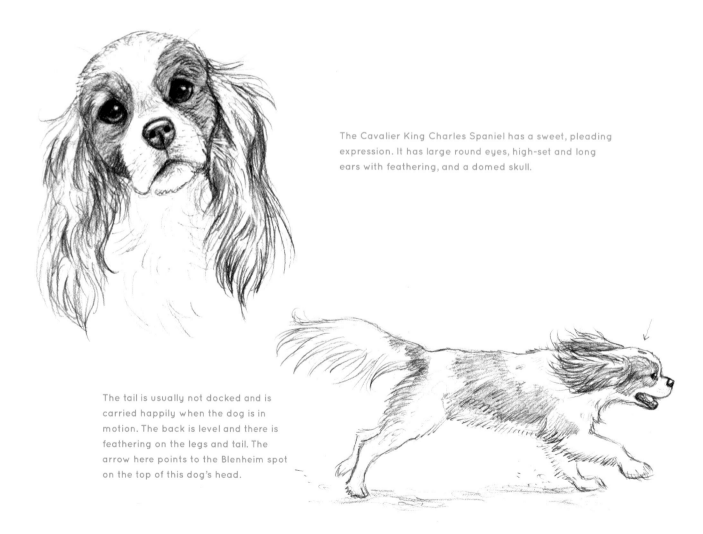

The Cavalier King Charles Spaniel has a sweet, pleading expression. It has large round eyes, high-set and long ears with feathering, and a domed skull.

The tail is usually not docked and is carried happily when the dog is in motion. The back is level and there is feathering on the legs and tail. The arrow here points to the Blenheim spot on the top of this dog's head.

CHIHUAHUA

The smallest dog breed is certainly not the tiniest in terms of personality. This loyal, feisty, protective companion is named for the state of Chihuahua in Mexico, its country of origin. Once a dog of the Aztecs and Toltecs, the Chihuahua of today lives life in modern households as pet and watchdog. It can be extremely devoted to one person and requires socialization in order not to be overly protective or shy around strangers and other animals. This breed tolerates heat well but not cold and needs to be an indoor dog. Both American and British breed standards state that a Chihuahua should not weigh more than six pounds (2.7 kg) to qualify for the show ring. Some pet dogs are slightly larger.

The Chihuahua comes in either a smooth (short) coat with glossy, possibly rough hair or a long coat that may have wavy or straight fur and feathering or fringes on the ears. The long coat is often softer to the touch. It comes in a wide variety of colors and patterns.

The Chihuahua comes in two recognized head types. The apple-head Chihuahua has a rounded skull, close-set eyes, and shorter ears and legs. The deer-head Chihuahua has a flatter skull, wider-set eyes, and comparatively longer ears and legs. Many American registries specify a preference for the apple-head variety. Any Chihuahua will have large eyes and large, erect ears.

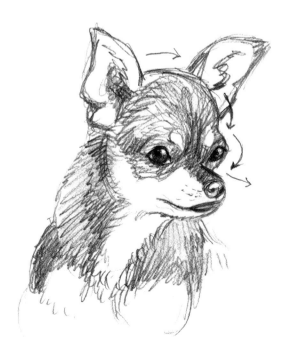

Note how high and rounded the forehead is and how the eyes and their surrounding bony ridges protrude from the skill. (See arrows.)

DRAWING A CHIHUAHUA HEAD

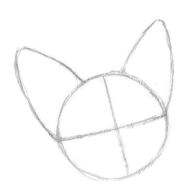

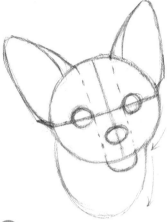

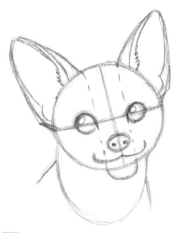

1 Draw a circle for the head and add a plus-shaped mark to divide it into four equal parts. Angle it slightly to the side because the dog will be tilting its head in this drawing. Add the large, triangular ears using the horizontal dividing line as the base for the outside edge.

2 Add the eyes, making sure that the inner corners of the eyes line up with the inside corners of the ears on the top of the head (see dotted lines). You can use these dotted lines to measure the lower jaw as well, drawing a U shape under the head circle to indicate its placement. Draw the nose about halfway between the horizontal dividing line and the bottom of the head circle. Further define the outside corners of the ears, cutting a tiny bit away from the bottom outside base and adding a tiny bit just above it. Draw the inside ridge of the ears and draw the neck. The arrows show how the neck should tuck in just a little from the bottom of the head, then drop downward.

3 Add the nostrils and continue defining the inside ridge of the ears. Draw the inner part of the outside rim and tuck it in just a little toward the inside base before sweeping it back out toward a thinner outline. Draw the inner part of the inside ridge, too, adding a few squiggly strokes to indicate fur. Draw small circular highlights inside the eyes. Add the top outline of the open mouth with an upside-down, rounded M shape, like a cartoon cat's mouth. Draw the shoulders.

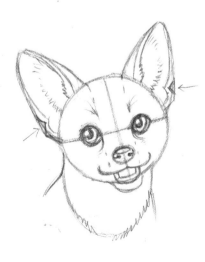

4 Add the pupil and irises. The iris should be large, with little white of the eye showing. Draw detail inside the ear to separate the most recessed part heading down to the ear canal from the rest of the ear along the outside rim. Draw the ear pockets by adding a wide V shape on each outside rim (see arrows). Draw a small oval for the highlight on the nose and connect the nostrils to the sides. Draw some of the muzzle where it angles down from the inside corners of the eyes and onto the top of the muzzle. Indicate the whiskers above the eyes (they align with the dotted line). Draw the inside of the mouth, adding a slightly square shape for the outside of the lower lips and teeth, then another smaller, somewhat square shape to define the inner edges and tongue. Add a few squiggly lines for the fur on the neck.

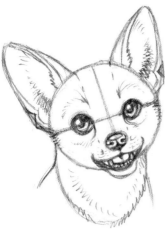

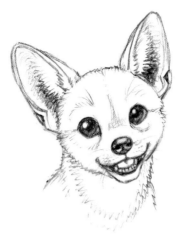

5 Add more details to the face, like some short strokes that shade in the bony ridges formed just above and below the eyes as well as other fur details. Shade in some of the ear canal and the lower, somewhat triangular shape on the bottom of the nose pad. Indicate a slight indentation where the sides of the head meet the horizontal dividing line. Add whisker rows and define each tooth, including the canine teeth, and tongue. Shade in the top part of the irises.

6 Finish the piece by first erasing the guidelines and drawing in the final lines. Shade the irises in so that the eyes are mostly dark but the pupils and top part of the irises are slightly darker. Shade the front of the nose, keeping it slightly lighter than the dark patch on the bottom of the nose and around the rim. Draw the short fur on the neck and around the head and darken the lips on the lower part of the mouth. Shade the inside of the ears and the very top of the muzzle between the eyes, leading to an indentation going up the forehead. Draw or reinforce the whisker rows and draw the whiskers.

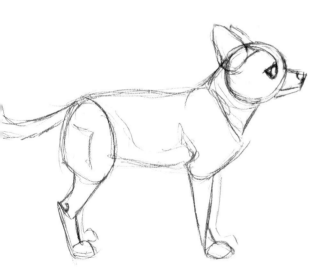

The Chihuahua is slightly longer than tall, with dainty feet and a tail that is carried up, out behind, or over the back. Here some of the basic shapes of a Chihuahua's body have been blocked in.

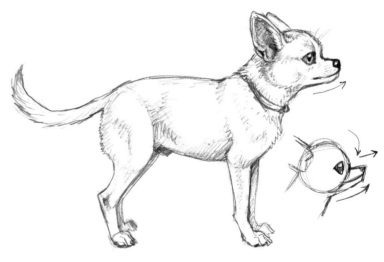

In this finished drawing, note that from a profile view, the Chihuahua's muzzle may have a slightly upturned angle to it. This is exaggerated a little in the simplified drawing showing the muzzle's upward slant.

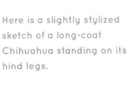

Here is a slightly stylized sketch of a long-coat Chihuahua standing on its hind legs.

Here a Chihuahua stands with its head down, giving it a meeker and more vulnerable appearance.

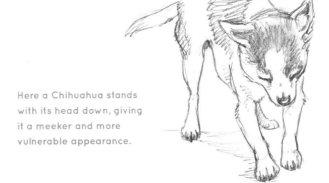

185

CHINESE CRESTED DOG

This unusual, often nearly hairless breed originated long ago as a ratter and lapdog. Its exact origins are unclear but it has roots in China, Africa, and possibly other places. The Chinese Crested is a graceful, alert, sensitive companion that is good with other animals and people. Like the Chihuahua, it doesn't do well with cold and needs to be an indoor dog. The exposed skin of this dog is smooth and soft. The affectionate and playful Chinese Crested is also a good hypoallergenic breed for those who suffer allergies.

Many individuals of this breed are mostly hairless except for silky fur found on the head (crest), tail (plume), feet, and lower legs. There is a variety of this dog called a Powderpuff, which has medium-length, silky fur all over its body.

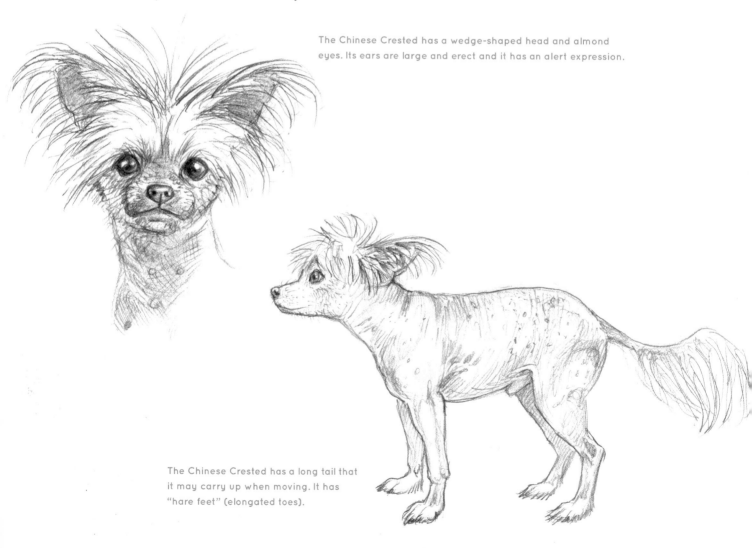

The Chinese Crested has a wedge-shaped head and almond eyes. Its ears are large and erect and it has an alert expression.

The Chinese Crested has a long tail that it may carry up when moving. It has "hare feet" (elongated toes).

HAVANESE

The Havanese originated in Cuba as a lapdog and companion and today is designated as the national dog of Cuba. It is believed to be from a line of dogs (that included the Bichon Frise) that developed in the Mediterranean in ancient times and was brought to Cuba by boat. It was popular in Cuba, Europe, and America as a pet and performing dog. It declined in numbers and at one point was almost extinct in Cuba and Europe. Three families moved from Cuba to America in the 1950s, bringing their Havanese with them, and most of the breed outside Cuba today is descended from them. Also known as the Havana Silk Dog (or a Velcro Dog), the Havanese is a happy, curious, friendly, alert, and non-shedding dog that needs ample attention. It is energetic but with enough exercise it easily lives as an indoor dog. It has a unique lively, springy gait.

The Havanese has a soft, light, usually double coat. The outer coat is long and may be wavy, straight, or curly. The undercoat is sometimes absent. As the name Havana Silk Dog implies, its fur feels like silk. It comes in a variety of colors and patterns, including all white. Show dogs often have long fur and a "beard" on the face but pet owners may keep their dog in a shorter and more easily maintained cut.

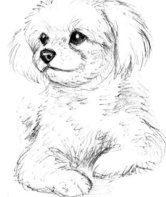

Here's a Havanese with a closely clipped face for easier pet care.

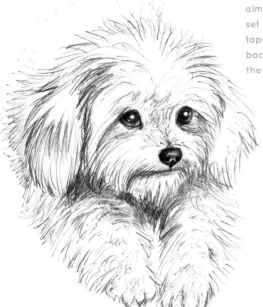

The Havanese has large, almond-shaped eyes and high-set hanging ears. The muzzle tapers slightly at the nose. The back of the skull is rounded but the top of it is fairly flat.

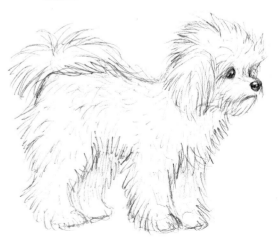

The Havanese is slightly longer than tall and has a pronounced chest. The build is sturdy more than delicate. Its back is fairly straight but raises up toward the hips and tail. The tail is set high and arcs over the back. It has round feet.

MALTESE

The Maltese is likely one of the oldest dog breeds still in existence. It originated in ancient times on the Mediterranean island nation of Malta and was often a favored companion of noble women. Greek art depicts what appears to be Maltese-like dogs, and writings from over two thousand years ago mention the Maltese. Today it is a popular companion dog that is known for its playfulness and gentleness. It is often reserved with strangers but cuddly with those it knows. This is a breed that is considered hypoallergenic.

In ancient times the Maltese came in different colors but today it is exclusively white. It has long, silky, flat fur and lacks an undercoat. In some breed standards, slight ivory coloration around the ears or light lemon markings are permitted.

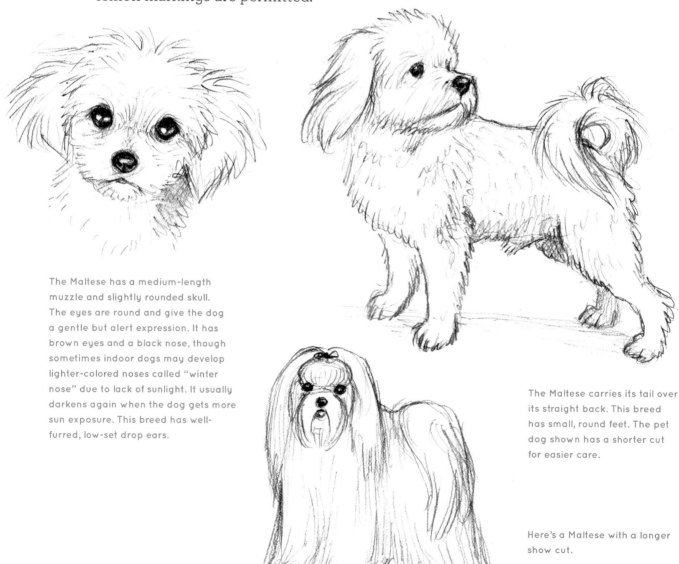

The Maltese has a medium-length muzzle and slightly rounded skull. The eyes are round and give the dog a gentle but alert expression. It has brown eyes and a black nose, though sometimes indoor dogs may develop lighter-colored noses called "winter nose" due to lack of sunlight. It usually darkens again when the dog gets more sun exposure. This breed has well-furred, low-set drop ears.

The Maltese carries its tail over its straight back. This breed has small, round feet. The pet dog shown has a shorter cut for easier care.

Here's a Maltese with a longer show cut.

MINIATURE PINSCHER

The Miniature Pinscher, or Min Pin, originated in Germany. It is not a miniature Doberman Pinscher but is actually the older of the two breeds. Feisty and fearless, the Min Pin combines elegance and grace with a compact, sturdy build. This energetic breed is almost constantly in motion. Bold, brash, curious, assertive, and outgoing, it needs an owner with some experience and the willingness to provide training and exercise. It has a high-stepping gait.

The Min Pin has a short, sleek, hard coat. It may be black or chocolate with tan or rust markings, red, stag red, or other less common colors such as blue or fawn and tan.

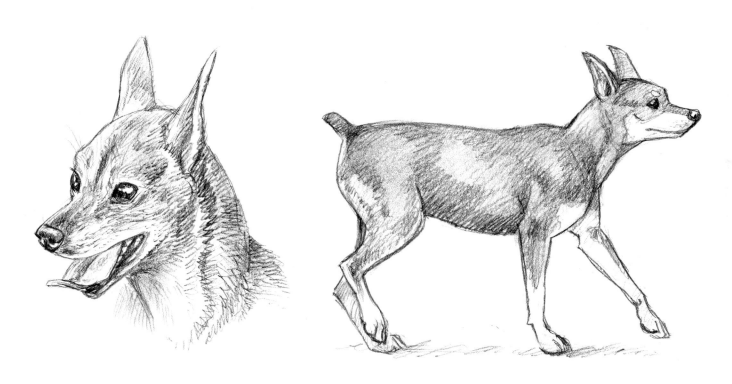

The Miniature Pinscher has a narrow, tapering head. Its ears may be cropped and erect or natural and either perked up or floppy. This drawing depicts an older dog.

This breed has a well-balanced, athletic, and square build with straight legs. The tail is held high and often docked and short.

PAPILLON

The Papillon is named for the French word for butterfly and looking at one of these dainty dogs when they are on alert and their ears are perked up, it's not hard to see why. The large rounded ears give this breed its distinctive look. Originating in France as a companion, the Papillon was popular with nobility, including the court of Louis XIV. Today the Papillon is beloved as a gentle, playful, intelligent, and inquisitive dog that takes readily to training and agility. It needs to be an indoor dog, though it is energetic and enjoys walks and other outdoor exercise.

The coat of the Papillon is abundant, silky, and long. It should be white with patches of color. Often this includes two patches around either eye, continuing to the ears, and divided by a blaze of white along the muzzle and middle of the forehead. The patches may be one or two different colors.

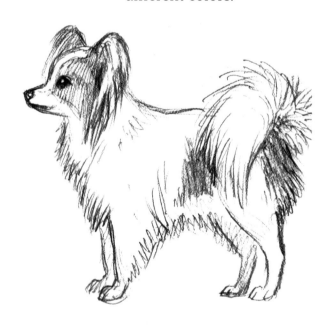

The Papillon is an elegant, dainty breed with a body slightly longer than tall and a long, well-furred tail carried in an arch over its back.

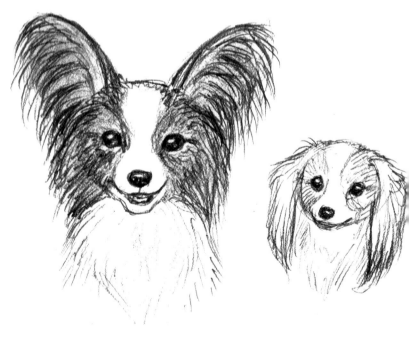

The Papillon is most well-known for having erect ears reminiscent of a butterfly's wings when spread out. These ears are large and somewhat round and feature a fringe of fur along the edge. Some Papillons have floppy ears instead of erect ones. These individuals are sometimes referred to with the French word for moth, Phalène. All Papillons have round eyes, a delicate muzzle, and a rounded head. On the left is a Papillon with "butterfly ears." On the right is a floppy-eared Phalène.

PEKINESE

The Pekinese originated in China long ago, as a companion and lap-dog. It is sometimes called a lion dog due to its resemblance to Chinese guardian lions (the Shih Tzu is also referred to by this name). At one point around 700 to 1000 A.D. Pekinese were treated as royalty themselves and pampered by servants. In 1860, the Imperial Summer Palace was looted by the British, who took some of the dogs back to England, where they became very popular. Today the Pekinese reigns in households around the world as an independent, courageous, sometimes aloof, but loving companion that can be on the stubborn side.

The Pekinese's coat is thick, with a long, coarse outer coat and dense undercoat. Most Pekinese are red, sable, or gold, though other colors do occur. They often (but not always) have a black muzzle or face mask and their eye rims, nose, and lips are black.

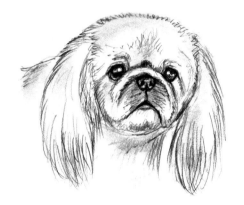

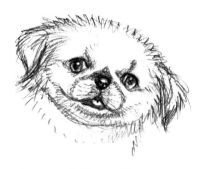

A younger Pekinese with a short cut showing its almost football-shaped head.

The Pekinese has an extremely short muzzle, giving it a flat face, and comparatively large eyes. The nose is placed between the eyes and it has a very broad skull. The ears are hanging and heart-shaped.

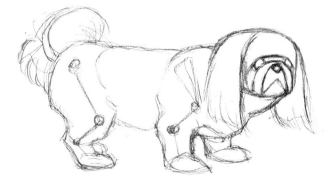

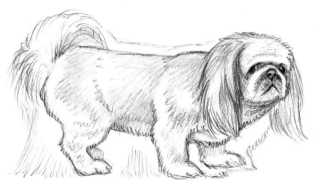

The body of this breed is very compact and low to the ground. Its shoulders are wider than its hips, giving it a somewhat rolling, lumbering, yet still dignified gait. The breed standard calls for a lion-like look and expression. Here are some basic shapes of the dog's short-legged, wide body.

The finished drawing. Show dogs are given a longer hair style and I've indicated an outline of where the long, flowing fur would be if this dog didn't have a short pet cut.

POMERANIAN

The Pomeranian gets its name from the Pomerania region of Germany and Poland. It is descended from the German Spitz and has become smaller over the years as smaller Poms have been favored by fanciers of the breed. Today this small puffball of a dog is a popular house pet and show dog. It is a small, sturdy dog that is friendly, cheeky, and playful but may not always get along with other dogs. They are intelligent and respond well to training.

The Pom has a luxurious double coat consisting of a harsh outercoat and thick undercoat. It gives the dog a puffy, fuzzball appearance. This breed comes in a wide variety of colors and patterns. Red, orange, black, or cream with white are common colors.

The Pomeranian has a rounded skull with a large forehead and small muzzle, giving it a pixie-like, foxy face. Its eyes are almond-shaped and it has small, erect ears placed high on its head. This breed has a thick ruff of fur around its neck.

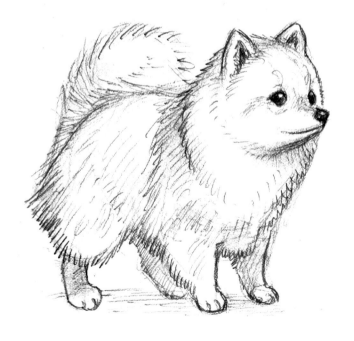

The Pom has a small, compact, square body and a tail set high and curled over its back, appearing almost flat against its body when groomed for show. It has small feet.

DRAWING A POMERANIAN HEAD

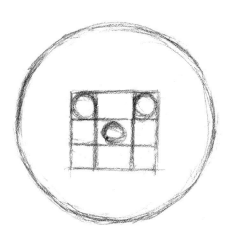

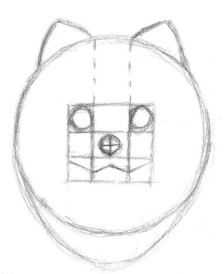

1 First draw a circle, then place a smaller square inside. Divide it with three equally spaced horizontal lines. Draw two circles on each side of the top section, making sure the space between them is wider than an eye's width. Use the inside corners of the eyes to draw two vertical lines going downward. Draw a nose in the center, making sure it is about one eye width.

2 Use the measurement of the inside corners of the eyes (see dotted lines) to begin drawing the inside corners of the ears on top of the head. Draw the triangular ears, keeping them small and short and place the outside corners so that they are wider than the outside corners of the eyes, but not quite as wide as the head itself. I also defined the eyes a little more. Divide the nose into four equal measurements. Add a rounded shape below the head for the neck. Finally, add the mouth in the bottom horizontal section, using the vertical lines to help create a flattened W shape.

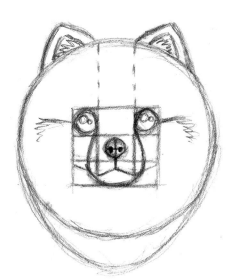

3 Add two highlights to each eye, one smaller than the other. Add nostrils along the center horizontal line on the nose. Connect the nose and mouth. Draw the muzzle, creating a rounded, upside-down horseshoe shape that is a little wider than the center vertical (nose) section. The jaw should line up with the bottom of the face square. Draw a crease in the thick fur on the outside of the Pom's eyes. Add the inside of the dog's ears and draw some shaggy fur there, coming from its head.

4 Finish the drawing, erasing the guidelines and putting in the final lines to define the features and fur.

TOY POODLE

The Toy Poodle originated in Germany and was developed as the breed we know today in France. This popular breed is highly trainable and intelligent, people-oriented, sensitive, and playful. It can excel at obedience, agility, and other activities. Especially small Toy Poodles are sometimes called Teacup Poodles.

The Poodle has a curly, dense coat that can be trimmed in fancy show cuts or in simple lamb cuts that keep the fur moderately short all over the dog's body, save for places like the face and/or feet, which may be cut short. The Poodle may come in any solid color.

The Poodle has intelligent, dark, oval eyes and an alert expression. Its ears are set about eye level and hang from either side of the head. The muzzle is long and narrow. It has a moderate stop, or angle, from the top of the muzzle to the forehead.

The Poodle has a square build, level back, and often has a docked tail that is held high and straight with a pom-pom of fur at the end. Its feet are slightly pinched looking.

DRAWING A TOY POODLE, SIDE VIEW

1 This first drawing breaks down the simplest basic shapes of a Toy Poodle. Draw a square, then add circles in the top half of that square for the chest and hips. Connect them with a line for the belly sloping up from the slightly larger chest to the smaller hips. Continue the left side vertical line of the square up, and draw a head circle slightly above the upper left corner so that it is evenly divided by it. Draw the throat connecting the head and chest.

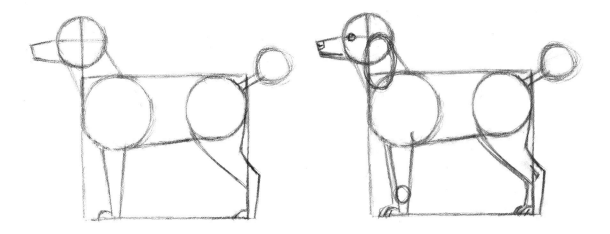

2 Add a horizontal dividing line inside the head circle to divide it equally into quarters. Draw a muzzle, using the horizontal line to guide where the top of the muzzle will go. Add the rest of the neck, a short tail and another small circle at the tip for the ball of fur at the end of the poodle's tail. Draw the legs and feet. The front leg is fairly straight down and thins toward the bottom. Use the right side of the square to help you place the front of the hind foot.

3 Add the eye, including a small highlight, the nose (divided in half for the nostrils and highlight), and draw an oval for the ear that connects on the horizontal dividing line of the head. Draw the mouth. Draw a circle for the wrist that is slightly wider than the rest of the front leg where it is placed. Add an indentation where the hollow of the heel is. Draw the opposite legs and add toes on the visible paws.

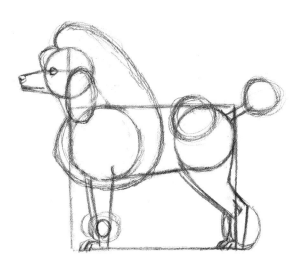

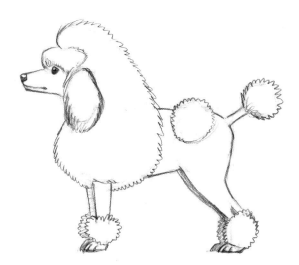

4 At this point you can add the fur cut any way you like. I chose a show cut known as the Continental Clip.

5 The Toy Poodle final drawing.

PUG

The Pug originated in China as a lapdog and became even more popular in Europe, often currying favor with royalty both in China and beyond. The Pug was recognized as the official dog of the House of Orange in the Netherlands after one saved the life of Prince William by alerting him to would-be assassins in 1572. Sometimes described with the motto "Multum in Parvo," Latin for "Much in Little," the Pug is a popular breed today for its combination of playful gentleness and stubborn dignity.

The coat of the Pug is short, smooth, and glossy. Colors include fawn (the most common), apricot fawn, silver, or black.

The Pug has large eyes set in a round head. Its muzzle is short, flat, and square, with a slight under bite. Ears are thin and either rose (folded to the sides with the front edge on the side of the head) or button (folded forward, this is the favored look in shows). It has a well-defined chin and deep wrinkles along its forehead. Here are some of the basic shapes in a Pug's head.

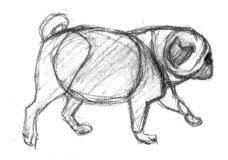

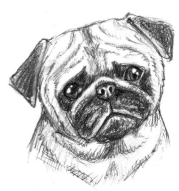

Here's the finished drawing.

The body of the Pug is square-proportioned and cobby (stocky). Its tail curls tightly over its hips, often in a double curl. Its chest is deep and neck short and relatively thick. There are sometimes a few wrinkles along its back. On top is a stylized, walking Pug and a more detailed standing Pug at bottom. Note how the Pug's body can be like a thick oval or a rectangle.

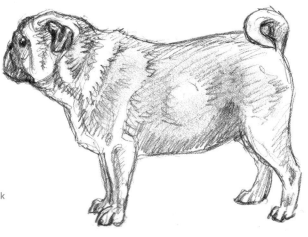

SHIH TZU

The Shih Tzu, which like the Pekinese is sometimes called the Lion Dog, was probably originally from Tibet, and then developed in China. This breed was a favorite of royalty in China, and for many years, Shih Tzu were not traded, sold, or given away outside the country. Today it is a popular breed across the world, enjoyed for its loyal, happy, alert, and affectionate nature. It is small but tough for its size and good with children and other animals.

This breed has a long, fast-growing coat that requires frequent grooming. Its double coat is silky, fine, and straight. It comes in a variety of colors. Many dogs are white with some shade or combination of black, brown, or gold.

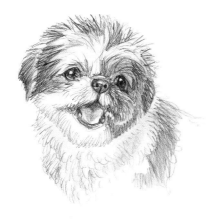

The Shih Tzu has a short, square muzzle, large eyes, an undershot jaw, and a round skull with a high forehead. It has high-set, hanging ears.

The Shih Tzu is slightly longer than tall but otherwise fairly compact. Its well-furred tail is carried over its back.

DRAWING A SHIH TZU

1 To draw a Shih Tzu with a show cut, make a circle for the head, dividing it into four even quarters. Draw a fairly large oval in the bottom two quarters for the muzzle. Measure one head width down and to the right. Draw a slight arch for either side of the front legs, a horseshoe shape for the space in between them, and a rounded but angular line for the rear.

2 Add eyes along the horizontal dividing line and the nose just below them. Then block in the "moustache," which in this case drapes over the nose for now. Draw a circle to indicate the forehead hair tied up in a bow just above the eyes and then draw the bow. All this should stay inside the head circle, with the top of the bow reaching the top of the head. Draw the feet. Now add the hind leg if you wish, though most of it won't show in the final drawing. Continue the shape up over the back to indicate the tail, using the sweep of the front of the hind leg to show where the tail flows down the side of the body.

3 Add the dog's mouth and the hair on its chin. Draw the poof of fur on top of its head sprouting from the top of the bow. Add the long, floppy ears on either side of its face. Indicate the flowing hair coming down its shoulders and some of the hair touching the ground. Draw some of the shaggy fur of the tail, completing its form.

4 Finish the drawing, erasing the guidelines and shading in the dog's long, silky fur.

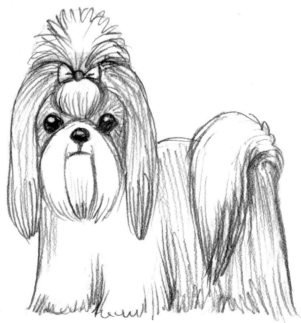

YORKSHIRE TERRIER

The Yorkshire Terrier, or Yorkie, originated in the area of Yorkshire, England, as a ratter. This little Terrier has modest roots but lots of spirit, and today is a very popular dog among both pet owners and dog show fanciers. It is alert, curious, active, feisty, and can be vocal. It needs ample attention and is easily trained. Especially small Yorkies are sometimes known as Teacup Yorkies.

The Yorkie's coat is long, silky, and straight. It is tan or gold with a darker-colored saddle on its back from the base of its neck to the base of the tail. The saddle is usually blue but may be black. Puppies start out as black with tan and gradually lighten as they grow older, reaching their final color at about three or four years old.

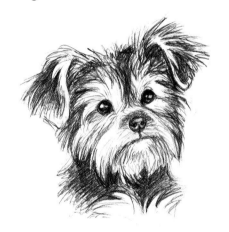

The Yorkshire Terrier has comparatively medium-sized, dark eyes. The AKC breed standard calls for small, triangular ears that are carried erect. Pet dogs may have erect ears or floppy ears. Its skull is fairly flat and its nose black. Its head is comparatively small in relation to its body.

DRAWING A YORKSHIRE TERRIER HEAD

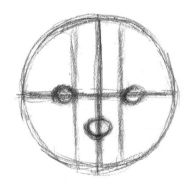

1 First draw a circle and divide it with a plus shape into equal quarters. Add the eyes and nose, making the inside corner of the eyes slightly wider than the nose but leaving greater than an eye width in the distance between the outside of the eyes and the sides of the head. Draw vertical lines to help you measure this, as shown.

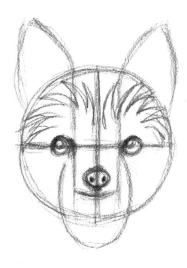

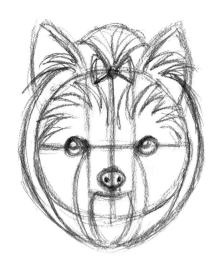

2 Add highlights to the eyes and nostrils to the nose. Draw the ears, lining up the inside corner of the ears with the width of the inside corners of the eyes. Draw the mouth and add bushy "eyebrows" raising up above the eyes and hitting the top of the head circle. Add a horseshoe shape around and under the muzzle.

3 Like the Shih Tzu demonstration, this dog is wearing a bow tie. Draw the bow at the top of the head and the tuft of hair sprouting above it. Draw the inside lines of the "moustache" draping down from the corners of the mouth. Draw the inside rim of the ears, and fur springing up from in front of the ears and flowing down onto the sides of the head. The outline should curve down to meet the bottom of the "moustache."

4 Finish the drawing, erasing guidelines as needed and drawing in the long hair sprouting around the face. Shade the eyes and nose, leaving highlights in both. Add small pencil strokes to indicate things like the chin and the bony ridge under the eye.

The Yorkie may have a docked tail, carried higher than the back, and its dewclaws removed, depending on breeder and country. It has round feet and a level back. This is a pet Yorkie with a short cut that shows more of its anatomy than when the dog has longer fur.

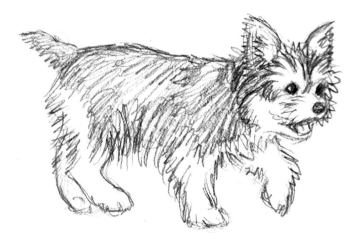

Another Yorkie with longer fur and the basic shapes of its body depicted underneath. This Yorkie has erect ears.

Chapter Ten

NON-AKC BREEDS AND MIXED BREEDS

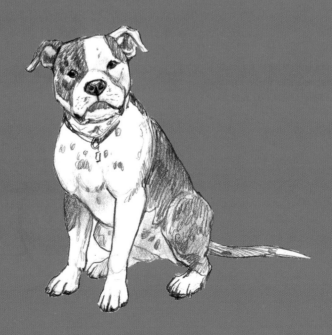

In this chapter, meet some of the dogs that don't fit into American Kennel Club breed standards. This includes unofficial breeds that are bred to type but not recognized by the AKC and so don't fit into the groups showcased so far. This chapter also includes one of the most ubiquitous and hardy of all dogs: the mixed breed, aka the mutt. Each country's registration club differs as to which breeds it recognizes and what category those breeds may compete in (or not). The dogs we'll draw in this chapter may not be official AKC breeds, but they are at least as amazing and lovable.

NON-AKC BREEDS

Here are just a few of the many breeds that are bred true to type but are not officially recognized by the American Kennel Club. Each country's registration club differs in which breeds it recognizes and what category those breeds may go with. The following were some interesting dogs I had some reference of but that don't fit the AKC standard.

AMERICAN MASTIFF

The American Mastiff is a large, powerful dog with a deep chest, straight front legs, and a long tail. It is protective but gentle, calm, and good with kids.

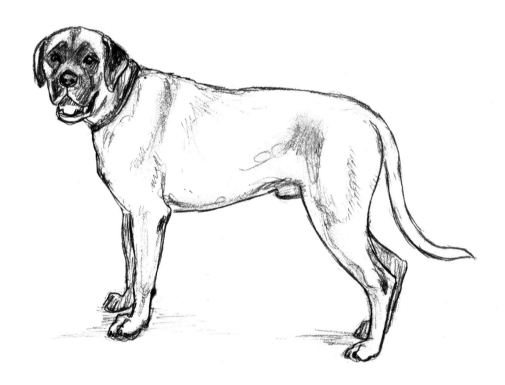

The American Mastiff can be brindle, beige, or apricot colored with some white on the chest, feet, and muzzle. Its muzzle, face, and nose are black. Puppies may be born darker and lighten in color as they age.

KLEE KAI

The Klee Kai was developed by Linda S. Spurlin in Alaska in the 1970s and 1980s to create a dog that looks like a small Alaskan Husky, a mixed breed used in sled racing.

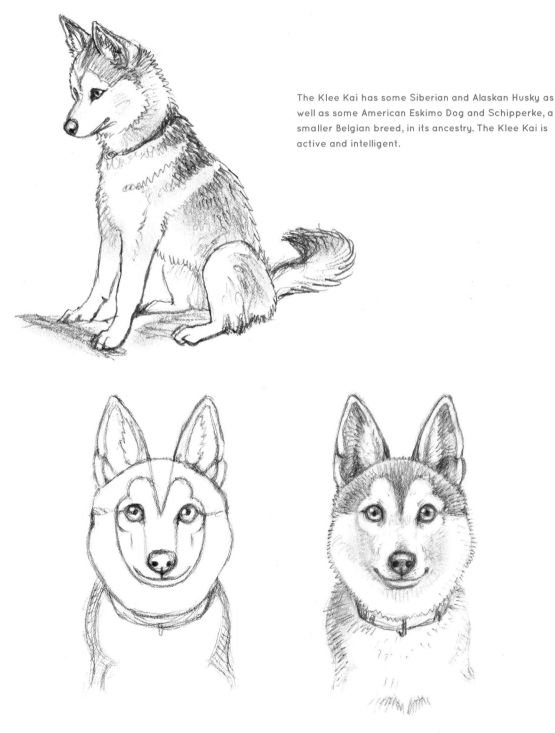

The Klee Kai has some Siberian and Alaskan Husky as well as some American Eskimo Dog and Schipperke, a smaller Belgian breed, in its ancestry. The Klee Kai is active and intelligent.

Here I've highlighted some of the basic shapes of a Klee Kai's head.

Here's the finished Klee Kai drawing.

NORTHERN INUIT DOG

The wolf is a beautiful animal. The idea of living with one can seem intriguing but wild animals do not make good pets. The Northern Inuit Dog is an attempt to create a breed that looks like a wolf but has the domesticated temperament of the dog. It is still not a dog for a novice owner, however, being both intelligent and sometimes stubborn.

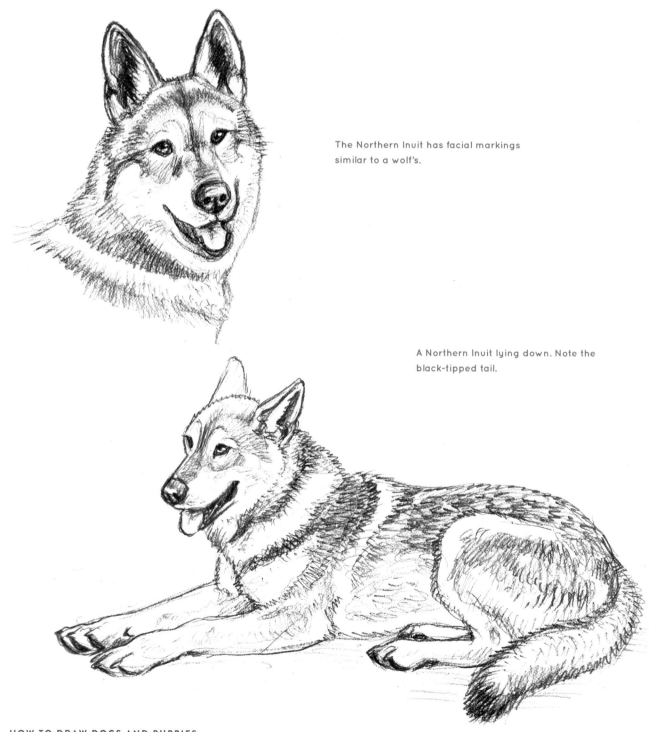

The Northern Inuit has facial markings similar to a wolf's.

A Northern Inuit lying down. Note the black-tipped tail.

PITBULL

The term "pitbull" is a sometimes confusing term used to describe a muscular, round-headed dog with powerful jaws. These dogs may also be called "bully breeds." Some people speak of pitbulls as if they are a breed of dog but pitbulls consist of several breeds, most of which do not actually have the word pitbull in their name. The only one that does is the American Pit Bull Terrier. Other breeds sometimes classified as pitbulls include the American Staffordshire Terrier, American Bully, American Bulldog, Bull Terrier, and Staffordshire Bull Terrier. "Pitbulls" can have a reputation as vicious dogs but are no more or less aggressive than other dog breeds. In fact, some "pitbull" breeds are well known as great dogs for families with children. Their jaws are powerful but do not "lock up."

AMERICAN BULLDOG

This is a stocky, muscular breed that is confident, active, and becomes highly attached and loyal to the people it lives with. It has a smooth, short coat and comes in a variety of colors. It was developed in the American South as a ranch and farm dog, and was used as well in pest and feral pig control.

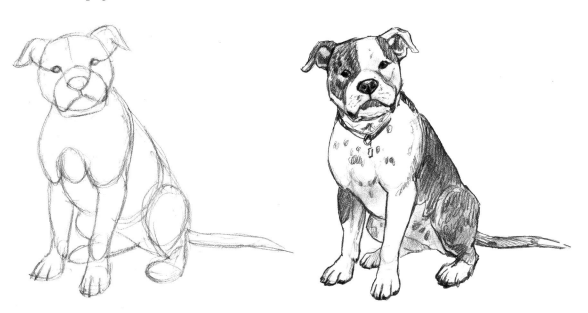

I drew some of the basic shapes of a sitting American Bulldog in this sketch.

You can still "see" the underlying shapes in the finished drawing.

THE AMERICAN PIT BULL TERRIER

The American Pit Bull Terrier is a strong, athletic, enthusiastic dog that loves children and makes a great family dog. It tends to be friendly even with strangers. It can be aggressive toward other dogs, however, and needs training and socialization from a young age. American Pit Bulls can excel in various dog sports as well as working as search and rescue, police, and service dogs.

This breed has a short, shiny coat and can be solid colored, spotted, or brindled. Merle is not accepted as a color in some breed registries. A dog with a reddish coat and a red/brown nose is called a red nose and a dog with a blue-gray coat and matching gray nose is called a blue-nose pitbull.

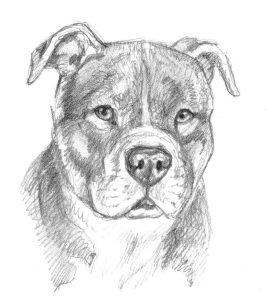

Like most "pitbulls," the American Pit Bull Terrier is a square-headed, powerful-looking dog. Its ears may or may not be cropped. The eyes are round or almond-shaped. Uncropped ears are small to medium and may be half-pricked or rose-eared.

This dog is a solidly built breed that exudes power. The chest is wide and deep and neck is heavily muscled. The tail tapers to a point and is somewhat thick.

DRAWING AN AMERICAN PITBULL HEAD

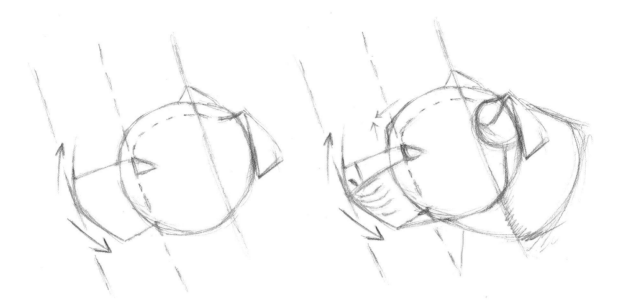

1 Here I've sketched in some of the basic shapes of an American Pitbull's head from a side view. Note how the length of the muzzle to the inside corner of the eye is about the same length as the distance from the inside corner of the eye to where the ear attaches to the head.

2 I've added details, including the lower jaw, the jutting ridge above the eye, and rows of whisker follicles. I added more of the ear and neck, too.

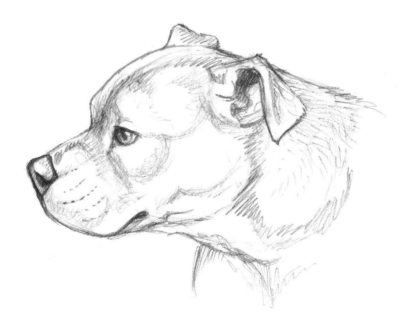

3 The finished drawing of the dog's head.

MIXED BREED

Numerous people have a favorite breed, a dog that tends to look and behave a fairly predictable way from one generation to the next. Mixed breeds don't always get the same recognition as AKC-recognized purebreds because the result of the breed mixing is far less predictable, making each dog more unique. However, mixed breeds are every bit as loving, loyal, fun, and rewarding to know as any purebred. Mixed breeds, or mutts, came from all kinds of situations, backgrounds, and environments and therefore can be healthier, smarter, and more talented due to their genetic diversity. Some people deliberately cross one breed with another to create "Designer Dogs" or crossbreeds, but most mixed breeds are unplanned. Unfortunately, there are countless abandoned and orphaned animals in need of a home and not enough homes available. Because of this, spaying and neutering your dog (either purebred or mixed) is highly encouraged unless you are committed to being a responsible breeder.

Here, we will take a look at just a few of the mixed breeds one might encounter. There is an endless combination. Any feature that can be found in any breed may pop up in a mixed breed, sometimes in striking and eye-catching ways. As an artist, it can be fun to take features you like in various breeds and combine them together to "create your own."

DRAWING A MALTESE/YORKIE MIX

1 This dog is a mix of Maltese and Yorkshire Terrier. To begin, draw a circle for the head; add a similarly sized circle for the chest, letting the head overlap on top of the chest circle by almost a quarter. The head is slightly tilted to the right. Add an upside-down, skinny teardrop shape underneath (this will be the space between the front legs) and then add the outside of the front legs. Make sure the front legs are about the same length as the head circle, leaving about half a circle's length in between (see spaces 1 and 2 on right). Finally, draw a smaller circle inside the head circle that attaches on the top.

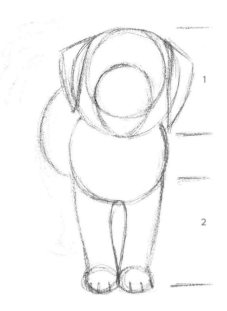

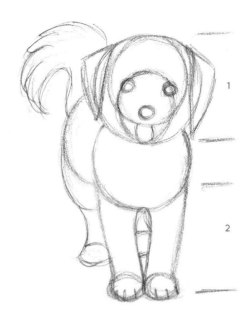

2 Add ears, making sure they stay outside of the smaller circle inside the head. Again keep in mind the head is very subtly tilted to the right. Add an even smaller circle inside the main head circle that touches the bottom part and overlaps the other inside circle. Draw small straight lines for the toes (3 each for 4 toes) on each paw. Draw a circular shape behind the chest and head for the hips.

3 Draw eyes and a nose inside the center of the smallest circle inside the head. The top inside circle should be used as a guide to the top of the mouth. Draw the tongue directly under it and the nose. Add a curly tail and the rest of the hind legs and feet.

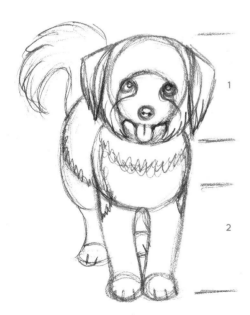

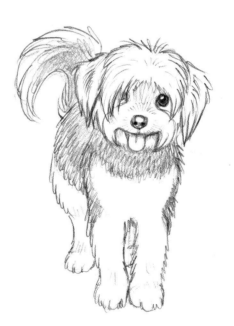

4 Draw highlights in the eyes and nostrils and a highlight on top of the nose. Add the crease in the tongue and draw the muzzle starting from the inside corners of the eyes and putting in a "moustache." Use the smallest, lowest circle inside the head as a guide to drawing the inside tufts of the "moustache." Add toes to the hind feet and draw some lines to indicate patches of color on the chest and legs. Draw some of the shaggy fur on the head and ears.

5 Finish the drawing, erasing the guidelines and going back over them with long, shaggy strokes to indicate the fluffy hair. This dog has long tufts of hair partially covering one eye. Shade in the darker hair along the back and top of the chest and add some fur to the top of the nose. Indicate the toes but don't make them too detailed because they are largely obscured by the fur.

DRAWING GREYHOUND MIXES

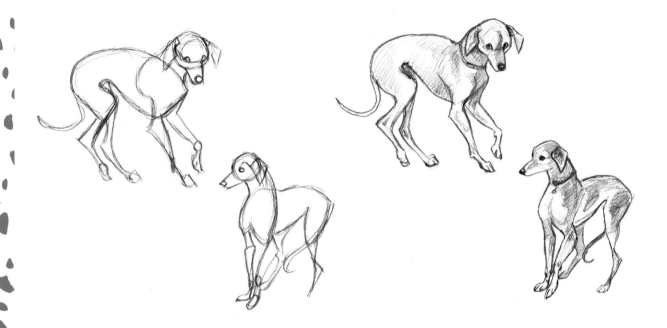

Some mixed breeds still show a strong resemblance to one or more of their genetic background. These greyhound mixes all have the long, curved, and graceful bodies one would expect of a greyhound.

And here's the same group, finished.

DRAWING A GREYHOUND/SCOTTISH DEERHOUND MIX

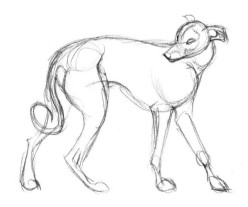

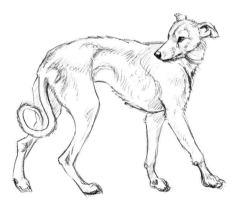

1 This is a cross of a Greyhound and the Scottish Deerhound, another hound breed once used for hunting deer. First I sketched the basic underlying shapes of the body.

2 Here I started adding some more musculature and basic shading, using various pencil strokes.

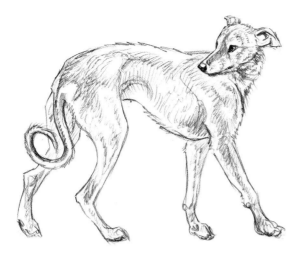

3 At this point I began adding more of the fur and some of the stripes in the dog's brindle coat, using more intense strokes and a darker, deeper application of shade.

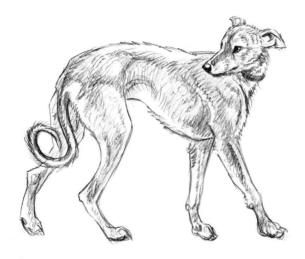

4 I shaded over much of the body, unifying it with light pencil strokes and leaving some areas bright with sun (like on the back) or lighter in color. I erased some pencil strokes along the dog's jaw because it blended too much with the dark shading of the collar.

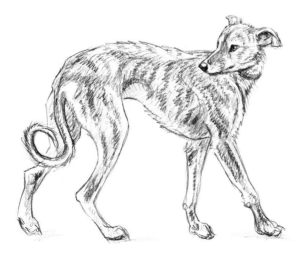

5 I finished the drawing by adding more stripes and detail to the fur and features.

DRAWING A MIXED BREED PUPPY

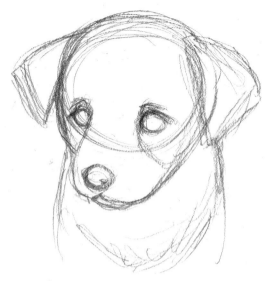

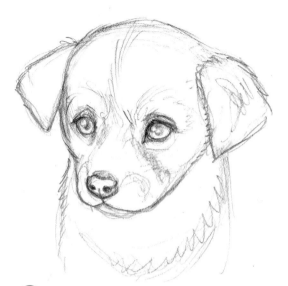

1 For this demonstration, I decided to show some of my own process in constructing a drawing. It's not as simple as many of the step-by-step demonstrations in this book, but may be helpful.

Here I penciled in the basic shapes of the puppy's head, eyes, nose, muzzle, and ears. I indicated the neck and some of the shoulders. At this point I'm just blocking in shapes and figuring out proportions.

2 I lightly erased some of the lines I used to block in the head, then started adding solid details to the face and outline, including the pupils and highlights in the eyes.

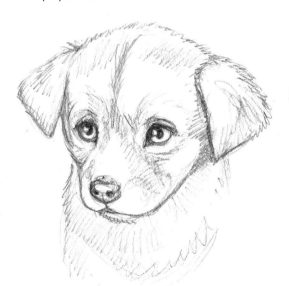

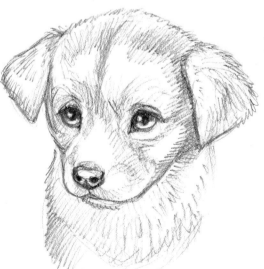

3 Erasing a little of the circular lines I blocked in on top of the head, I drew some of the fur along the outline to replace it. I shaded in the pupils and started adding pencil strokes to indicate hair and shadow on the form. I added details and some shadow to the nose.

4 I continued penciling in the fur and shading in the form. I added shadow to the puppy's eyes under the eyelids and darkened the nose even more, adding the crease coming up the center of it.

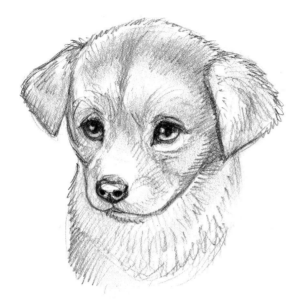
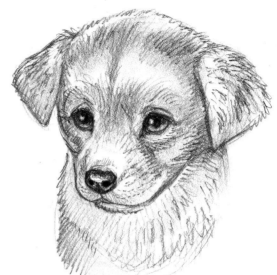

5 At this point, I smudged the pencil strokes all along the puppy's head and neck.

6 I began drawing details and pencil shading over the puppy's fur again, using short squiggles and longer strokes for shading. Returning to the eyes and nose, I added more shading and texture as well as the whisker follicle rows on the snout.

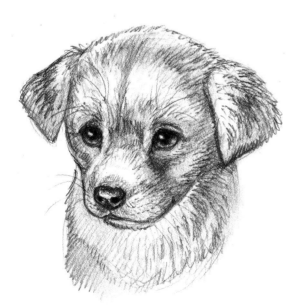

7 To finish, I used a kneaded eraser to take out the slight smudging of the highlights in the puppy's eyes. I also used the pointed edge of the eraser to take out some areas I felt were a little too dark above the eyes, using strokes as if I was drawing fur. I added a few more details, like the whiskers, and smudged and darkened a little more of where the muzzle connects to the rest of the head.

DRAWING A RECUMBENT MIXED BREED

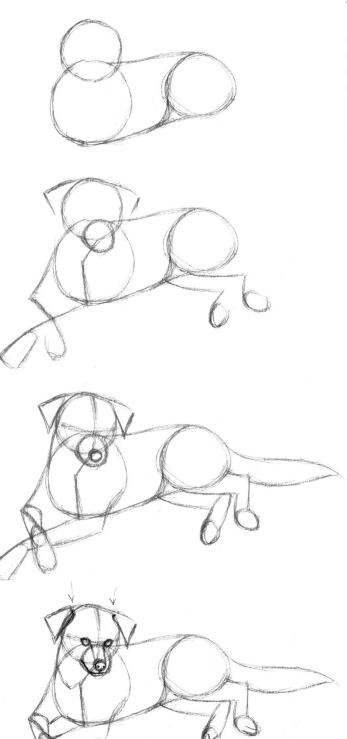

1 First, draw a circle for the head and then a somewhat larger circle directly under it and stacked sort of like a snowman. This will be the chest (bottom circle) and head (top circle). Draw a circle to the right (and less than a head length away) that is in between those sizes. This circle indicates the hips. Connect this (hip) circle to the chest and head, as shown, to indicate the back and belly. I drew another line sweeping down the front of the hips to the chest and belly to indicate volume.

2 Add a smaller oval overlapping the head circle to indicate the muzzle. It overlaps the chest circle as well, extending down about one-third of it. Continue the line along the top of the head to indicate where the ears are placed. Start drawing the legs. I drew the closest front leg first, bringing the line of the shoulder down in the center of the chest circle. I added an almost bell-shaped front paw. Then I drew the basic gesture of the farther front leg crossed over and resting on top of the other leg. The line shows where the top of that (farther front) leg is. Draw the top line of the hind legs and feet.

3 Finish the outline of the ears and add the nose right under the outline of the head circle on the muzzle. Draw a plus-shape mark to divide the head into vertical and horizontal quarters, angling and curving it so that the center of the face points a bit to the right and down. Flesh out the rest of the legs, drawing the paw and adding some volume on either side of the original top line of the farthest front leg (giving the front leg depth on either side). Sketch in the tail. Connect the chest and head by drawing the neck.

4 Using the nose width as a guide, draw lines that move parallel along the top of the muzzle toward the center of the head. Then draw the eyes on the horizontal dividing line of the head circle, using the nose width to measure the location of the inside corners of the eyes. Add nostrils, mouth, and draw the inside corners of the ears overlapping the rest of the head (as shown by arrows). Connect the missing part under the dog's farthest leg, attaching the leg to the body, and draw the toes. Note how the toes of the hind leg that is resting on the ground are indicated with V-shaped marks. You can define the neck more as well. Add dewclaws on the front legs.

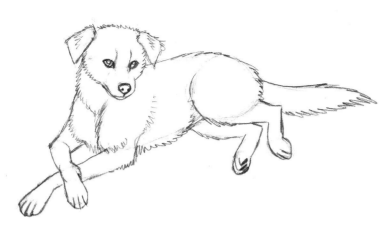

5 At this point, I lightly erased the shapes I'd built up before and penciled in the final outline, adding shaggy fur along the edges of the dog's body. I added paw pads under the V shapes on the hind foot angling toward the viewer. I also drew the pupils and highlights in the dog's eyes and markings running up from the inside corners of the eyes. Fur and form were added to the dog's shoulders as well.

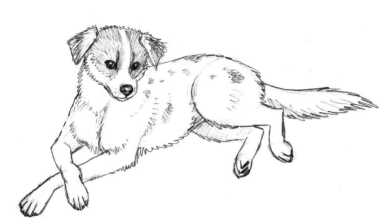

6 To finish the drawing, go in and shade in the dog's markings, whisker follicles, and pupils. This mutt has a white stripe running up the center of its forehead but two dark streaks coming up from the corners of the eyes. The rest of the body is white with tan patches here and there. I added toenails to the toes and tiny hints of paw pads where needed.

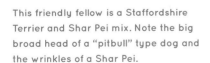

This friendly fellow is a Staffordshire Terrier and Shar Pei mix. Note the big broad head of a "pitbull" type dog and the wrinkles of a Shar Pei.

A BREED OF THEIR OWN

There are some "breeds" best discovered on your own terms. In order to find them, a little imagination and a sense of humor is required. The following mixed breeds are not actually purebred but they certainly have traits that many dog lovers will recognize. Each dog here has earned an affectionate nickname as they left their paw prints in my home—and my heart.

COUCH POTATO Here we have a Couch Potato, a dog that enjoys the more comfortable things in life. In reality this is my dog, Teddy, who a genetic test revealed to be a Chow Chow and Staffordshire Bull Terrier mix. We got her at two months of age, huddled and shivering all alone in the corner of a kennel at an animal shelter, one of far too many unwanted or neglected animals. Now those days are far behind her.

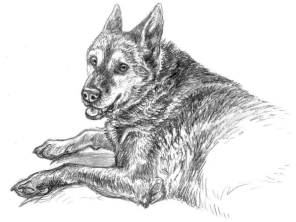

HOUSE PONY Jake, pictured here at about thirteen years old, seems to be a German Shepherd and Labrador Retriever mix. Solid back in his youth, his face has turned white. This is especially apparent around his eyes and sides of his muzzle. Many dogs turn grayer around their face and belly as they age. Labradors are well known for this trait.

HOUSE PONY RELAXING Jake soaking up the sun. In old age, his legs tend to be stiffer and it's harder for him to get up and down. His calm dignity remains, however. He was found wandering the streets when he was six months old and so starved he was almost literally a skeleton with fur. You could see every bone. Like so many rescued animals, he was grateful for a second chance.

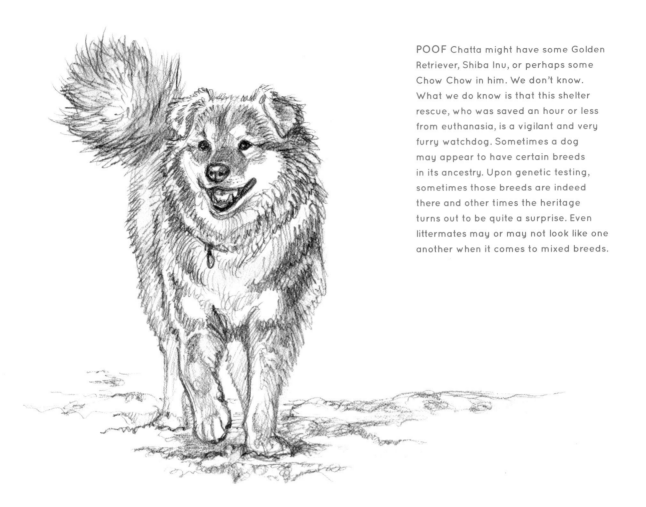

POOF Chatta might have some Golden Retriever, Shiba Inu, or perhaps some Chow Chow in him. We don't know. What we do know is that this shelter rescue, who was saved an hour or less from euthanasia, is a vigilant and very furry watchdog. Sometimes a dog may appear to have certain breeds in its ancestry. Upon genetic testing, sometimes those breeds are indeed there and other times the heritage turns out to be quite a surprise. Even littermates may or may not look like one another when it comes to mixed breeds.

TOUGH MUFFIN Once just an ordinary muffin, this little dog was run over by a pickup truck when she was one year old—and survived. She spent the rest of her years known as "tough muffin." One hind leg healed a little bit shorter than the other but that never slowed her down. Jazz was a cross between a Poodle and a Papillon called a Papipoo.

IN CLOSING

Now we come to the end of the book. And like the end of a book, so, too, our time with our dogs eventually must come to a close. These dogs change us, and we them, and our lives are forever enriched with their memories. We mourn when we lose them and how can we not? Perhaps the best tribute to these dogs is to keep trying to be the kind of good person they always thought we were. Also inevitable for many is the time a new wagging tail and pair of bright eyes joins us for another adventure under the sun and the enduring cycle between human and dog begins anew.

OPPOSITE: MACK THE MONSTER AND SPENSER THE GIANT
WAGGLE Mack (left) was born deaf and was likely an American Eskimo
mix. Spenser (on the right), possibly a Cardigan Welsh Corgi mix,
became his hearing ear dog. They were inseparable. They both earned
their nicknames in their youth. Mack was a handful and Spenser's
companionship (in addition to our training and socialization) helped
him focus and become the wonderful dog he was. Spenser's whole
body twisted in a joyful waggle that was a delight to see. I spoke of
them in my last book on drawing pets, but here they are again. Spenser
enjoys a delicious treat as Mack worms in close for a lick or two.

ABOVE: GOLDEN RETRIEVER WAITING
TO GO FOR A CAR RIDE

INDEX

LIV
April 2017